Digital SLR Photography
FOR
DUMMIES®
eLEARNING KIT

by Mark Holmes

WILEY

John Wiley & Sons, Inc.

Digital SLR Photography eLearning Kit For Dummies®

Published by
John Wiley & Sons, Inc.
111 River Street
Hoboken, NJ 07030-5774
www.wiley.com

Copyright © 2012 by John Wiley & Sons, Inc., Hoboken, New Jersey

Published by John Wiley & Sons, Inc., Hoboken, New Jersey

Published simultaneously in Canada

For general information on our other products and services, please contact our Customer Care Department within the U.S. at 877-762-2974, outside the U.S. at 317-572-3993, or fax 317-572-4002.

For technical support, please visit www.wiley.com/techsupport.

Wiley also publishes its books in a variety of electronic formats and by print-on-demand. Not all content that is available in standard print versions of this book may appear or be packaged in all book formats. If you have purchased a version of this book that did not include media that is referenced by or accompanies a standard print version, you may request this media by visiting http://booksupport.wiley.com. For more information about Wiley products, visit us at www.wiley.com.

Library of Congress Control Number: 2011945565

ISBN 978-1-118-07389-6 (pbk); ISBN 978-1-118-16036-7 (ebk); ISBN 978-1-118-16037-4 (ebk); ISBN 978-1-118-16038-1 (ebk)

Manufactured in the United States of America

10 9 8 7 6 5 4 3 2 1

WILEY

About the Author

Mark Holmes is a professional photographer and photography instructor based in San Diego, California. He has over 20 years experience as a photographer and instructional designer and has developed many instructional texts, workshops, and online classes devoted to photography, technology, and media-related subjects. His experience covers commercial photography for leading technology companies, including Hewlett-Packard, while his interest in portrait photography has led to assignments in Japan, Korea, and Qatar.

Mark runs regular workshops on digital photography and also teaches new photographers and other professionals individually. He has a love of sharing the art of photography with others and a passion for his subject. For more information, visit him on the web at markholmesphoto.com.

Dedication

For Pippa

Author's Acknowledgments

I really could not have attempted this project without the support of some very professional and dedicated publication professionals including executive editor Steve Hayes; project editors Kim Darosett and Paul Levesque; copy editors Jen Riggs and Virginia Sanders; and technical editor Lyle Mannweiler. They all worked very hard and skillfully to turn my thoughts into a finished eLearning course and book.

I'd like to thank established *For Dummies* author Julie Adair King for some sound help and advice that got me going and also Serge Timacheff, who stepped in with valuable help towards the end. I also owe a big thank you to everyone who acted as photography models, especially Angela Levy, who applied herself and her camera to the cause. Thank you also to my agent Margot Hutchison of Waterside Productions.

Lastly, I'd like to thank my wife Barbara who, as usual, was my biggest supporter and source of strength throughout this whole project.

Publisher's Acknowledgments

We're proud of this book; please send us your comments at http://dummies.custhelp.com. For other comments, please contact our Customer Care Department within the U.S. at 877-762-2974, outside the U.S. at 317-572-3993, or fax 317-572-4002.

Some of the people who helped bring this book to market include the following:

Acquisitions, Editorial, and Vertical Websites

Project Editor: Kim Darosett

Executive Editor: Steven Hayes

Copy Editors: Jennifer Riggs, Virginia Sanders

Technical Editor: Lyle Mannweiler

Editorial Manager: Leah Cameron

Vertical Websites: Jenny Swisher

Editorial Assistant: Amanda Graham

Sr. Editorial Assistant: Cherie Case

Cover Photo: ©iStockphoto.com/Christine Glade

Cartoons: Rich Tennant (www.the5thwave.com)

Composition Services

Project Coordinator: Katherine Crocker

Layout and Graphics: Andrea Hornberger, Sennett Vaughan Johnson, Jennifer Mayberry

Proofreaders: Laura Albert, Susan Moritz, Linda Seifert

Indexer: Estalita Slivoskey

Special Help: Paul Levesque, Rebecca Senninger

Publishing and Editorial for Technology Dummies

 Richard Swadley, Vice President and Executive Group Publisher

 Andy Cummings, Vice President and Publisher

 Mary Bednarek, Executive Acquisitions Director

 Mary C. Corder, Editorial Director

Publishing for Consumer Dummies

 Kathleen Nebenhaus, Vice President and Executive Publisher

Composition Services

 Debbie Stailey, Director of Composition Services

Contents at a Glance

Table of Contents

Introduction

If you've been thinking about taking a class online (it's all the rage these days), but you're concerned about getting lost in the electronic fray, worry no longer. *Digital SLR Photography eLearning Kit For Dummies* is here to help you, providing you with an integrated learning experience that includes not only the book and CD you hold in your hands, but also an online version of the course at www.dummieselearning.com. Consider this introduction your primer.

About This Kit

Each piece of this eLearning kit works in conjunction with the others, although you don't need them all to gain valuable understanding of the key concepts covered here. Whether you pop the CD into your computer to start the lessons electronically, follow along with the book (or not), or go online to see the course, *Digital SLR Photography eLearning Kit For Dummies* teaches you how to

- ✔ Find your way around the many buttons, dials, and controls on your camera.

- ✔ Add a "wow factor" to your pictures with simple rules of composition.

✔ Take your camera out of Full Auto and control exposure settings for different types of shots.

✔ Set the white balance in your camera for different lighting situations and change the color settings creatively.

✔ Focus your camera accurately even when the subject is moving.

✔ Properly incorporate flash into your exposures.

✔ Choose the right lens for your camera.

✔ Display, print, and share your pictures with friends and family.

How This Book Is Organized

This book is split into eight lessons, which I describe in this section. Find more information about using all pieces of the multimedia kit together in the later section, "How This Book Works with the Electronic Lessons."

Lesson 1: Getting to Know Your dSLR — This lesson details the basics: You will learn how to get your camera ready to take pictures, shoot with your camera in Full Auto, review pictures on your camera, and use the various scene settings to capture many different types of shots. You'll also find some useful tips on composing better pictures.

Lesson 2: Understanding and Mastering Exposure — In this lesson, you'll find out how you can manipulate shutter speeds, apertures, and ISO settings using programmed autoexposure, shutter-priority autoexposure, aperture-priority autoexposure, and manual exposure modes. You will use these advanced exposure modes to create properly exposed pictures that contain creative elements, such as motion blur or a shallow depth of field.

Lesson 3: Working with Color — One of the big advantages of digital photography is that you can manipulate the way your camera renders colors. In this lesson, you'll learn how to set the white balance so that colors look right in different lighting situations, select a working color space for your camera, and use the picture styles to adjust the way colors look.

Lesson 4: Getting Fancy with Focus — Your dSLR contains a sophisticated autofocus system that allows you to capture a sharp image in any shooting situation. This lesson will help you focus your camera on any autofocus point in the viewfinder and stay focused on your subject whether it's stationary, as in a landscape shot, or moving quickly, such as the players in a basketball game. You will also learn more about how you can put the background in focus or out of focus by manipulating the depth of field.

Lesson 5: Using Your Camera Flash — Flash photography brings a whole new dimension in creativity to your photography. It allows you to take sharp pictures in low light, fill in shadows on sunny days, or add special effects into your pictures. In this lesson, you'll learn how to use your camera's built-in flash to get the best results in your portraits.

Lesson 6: Learning about Lenses — One of the big advantages of your dSLR is that you can change the lens for different kinds of photography. This lesson introduces you to different types of lenses and explains standard lens terminology. You'll also learn about some of the many lens accessories available that enhance your photography and allow you to capture the shot you want.

Lesson 7: Transferring, Sharing, and Printing Your Photos — After you've captured some great pictures, you'll want to share them with friends and family. This lesson teaches you how to set up slideshows for viewing your pictures on a TV. You'll also find out how to best prepare your image files for e-mailing, printing, or uploading to a photo-sharing website.

(Bonus) Lesson 8: Capturing the Shot — The enormous flexibility of your dSLR camera opens up a lot of potential for creativity in your photography. Now that you've mastered the basics of your camera and digital photography in general, you'll want to use your camera in many different situations. In this bonus lesson, which is available only in the book, you'll find examples of the types of shots you may want to capture, and you'll get advice on how to set up your camera. With your new knowledge, and using the examples as inspiration, you'll be ready to go out into the world to capture some stunning images!

About the CD appendix — The appendix briefly outlines what the CD at the back of this book contains and what you'll find in the online course (available at www.dummieselearning.com). The appendix also contains a few technical details about using the CD and troubleshooting tips, should you need them.

How This Book Works with the Electronic Lessons

Digital SLR Photography eLearning Kit For Dummies merges a tutorial-based *For Dummies* book with eLearning instruction contained on the CD and in an online course. The lessons you find in this book mirror the lessons in the course, and you can use the two together or separately; either way, you gain

the tools needed for a productive and self-guided eLearning experience. Both the book and the course feature self-assessment questions, skill-building exercises, illustrations, examples, and additional resources. In each lesson in the book, you'll find these elements:

- ✔ **Lesson opener questions:** To get you warmed up and ready for class, the questions quiz you on particular points of interest. If you don't know the answer, a page number points you in the right direction to find the answer.

- ✔ **Summing Up:** This section appears at the end of the lesson and briefly reiterates the content you just learned.

- ✔ **Know This Tech Talk:** Each lesson contains a short glossary of related terms.

Conventions Used in This Book

A few style conventions will help you navigate the book piece of this kit efficiently:

- ✔ Terms or words that I truly want to emphasize are defined in Lingo sections.

- ✔ Website addresses, or URLs, are shown like this: www.dummies.com.

- ✔ Numbered steps that you need to follow, and characters you need to type (such as a user ID or a password) are set in **bold**.

Foolish Assumptions

For starters, I assume you know what eLearning is, you need to find out how to use your dSLR (and fast!), and you want to get a piece of this academic action the fun and easy way with *Digital SLR Photography eLearning Kit For Dummies.*

I'm assuming that you not only want to find out how to use your dSLR, but also want to get the best out of it. Most likely, you've used cameras before to take holiday snaps or capture fun moments, maybe with a point-and-shoot camera. Now you've purchased a dSLR because you want to improve your photography by bringing technical precision and creativity to the pictures you take. In making this assumption, this eLearning kit will introduce you to the terminology and practice of digital photography in general and apply it to using your dSLR like a pro.

Because digital photography is computer-based, I assume that you have at least a basic knowledge of computers. You'll need to know how to use the programs on your computer, how to navigate the World Wide Web, and how to use your e-mail application.

Icons Used in This Kit

The familiar and helpful *For Dummies* icons point you in the direction of really great information that's sure to help you as you work your way through assignments. Look for these icons throughout *Digital SLR Photography eLearning Kit For Dummies,* in the book and in the electronic lessons.

 The Tip icon points out helpful information that's likely to make your job easier.

 The Remember icon marks an interesting and useful fact — something you probably want to remember for later use.

 The Warning icon highlights lurking danger. When you see this icon, pay attention and proceed with caution.

In addition to the icons, the book includes these friendly study aids that bring your attention to certain pieces of information:

- ✔ **Lingo:** When you see the Lingo box, look for a definition of a key term or concept.

- ✔ **Go Online:** Serving as your call to action, this box sends you online to view web resources, complete activities, or find examples.

- ✔ **Extra Info:** This box highlights something to pay close attention to in a figure or points out other useful information related to the discussion at hand.

- ✔ **Coursework:** Look to this box for homework ideas that help you further hone your skills.

Class Is In

Now that you're primed and ready, it's time to begin. In case you're altogether new to digital photography, this course starts at the beginning (see Lesson 1) by getting you comfortable using some of the automatic features of your camera. If you're already familiar with shooting in Full Auto or Scene modes, you can speed through the basics to dive into more advanced techniques, but don't forget to check out Lesson 1 for some useful tips on composing pictures. Whichever path you choose, you can use the book in tandem with the online course — the content of one reinforces the other.

Getting to Know Your dSLR

- Getting to know your dSLR allows you to *use it to its full potential* and create and produce exactly the images you want.

- Learn everything you need to *begin taking some great photos.*

- Holding your camera properly helps *reduce camera shake* and enables you to access camera controls with minimal fatigue.

- You can *take pictures in virtually any light or scene,* even with a longer shutter speed, by attaching a tripod.

- *Set your camera for different scenes* to increase the number of successful shots you take.

- *Improve the composition of your pictures* with the Rule of Thirds.

1 'm sure you want to start taking pictures with your dSLR camera as
soon as possible. In fact, I bet if you already have your camera, you've
taken lots of pictures already, at least in Full Auto mode. Maybe you've
played with some of the camera scene modes, or even experimented with
the advanced exposure modes. I'm guessing you've come to this eLearning
guide to improve the quality of your pictures and get more consistent results,
and that's exactly what I'm here to help you with.

Before I rush on with the technical photography mumbo-jumbo that helps
you capture stunning pictures consistently, I think it's important that I show
you around your camera. In this lesson, I introduce some terminology, point
out the main buttons and dials you'll find on your camera, set you up to take
pictures with automatic settings, and introduce you to some of the composi-
tion rules that help you capture great pictures.

Keep in mind that you'll almost always achieve better results with your
camera by operating it in a semi-automatic or manual mode, which I explore
later in the book. For now, getting to know your camera's operations and
seeing what it can do in a fully automatic mode is a good starting place.

Figuring Out Just What a dSLR Is, Anyway

A dSLR camera is a wonderful tool for widening your creative options in pho-
tography. dSLRs offer many advantages over smaller and cheaper point-and-
shoot cameras:

- Your dSLR camera is fast at taking pictures, so you don't miss the shot.
 It can be set for continuous shooting, allowing you to take several shots
 very quickly, sometimes up to ten shots in a second. You can capture
 a lot more action, such as a sporting event, with a dSLR compared to a
 point-and-shoot.

✔ Viewing your subject with a dSLR is different from using a point-and-shoot, where you look at a rendition of what the camera sees on an LCD screen. With a dSLR, you see what the camera sees because your camera's viewfinder uses the same lens that takes the picture. The viewfinder makes accurate framing easy, which means you're less likely to cut off the tops of people's heads.

✔ One primary advantage and difference between a dSLR and a point-and-shoot is that you can use multiple, interchangeable lenses. These lenses are typically much higher quality than on a point-and-shoot camera, and there are many from which to choose:

- *Telephoto lenses* that allow you to capture distant subjects

- *Standard lenses* optimized for portraiture and precise, non-distorted reproduction of your subject

- *Macro lenses* and lenses that include a macro feature that allow you to shoot close-ups of very small subjects

- *Wide-angle lenses* that let you shoot a larger area as well as *fisheye lenses* that provide up to 180-degree views in tight areas

These are just some of the possibilities offered by a wide range of lenses that camera manufacturers market. See Lesson 6 for more on lenses.

✔ The image sensor in a dSLR camera is usually larger than in a point-and-shoot camera, even though the megapixel size may be rated similarly. The sensor's physical size allows for capturing better-quality images, especially when linked with a higher-quality lens. (See Lesson 4 for more on image sensors.)

LINGO

If you have experience with a film **single-lens reflex** (SLR) camera, you know that most of the advantages of a dSLR that I list nearby are not new. The SLR camera has long been the preferred format of many professional photographers. When digital photography became affordable and high quality enough for everyone to use, the film in the SLR was replaced with an image sensor that turns the SLR into a dSLR. The d stands for **digital**, of course.

Looking inside your dSLR

Figure 1-1 shows how a typical dSLR viewfinder works. The light enters through the lens and is directed up into the top of your camera by a mirror. The light passes through a pentaprism and out through the viewfinder on the back of your camera.

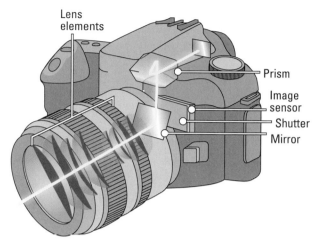

Lens
elements

Prism

Image
sensor

Shutter

Mirror

Figure 1-1

Figure 1-2 shows what happens when you press the shutter-release button fully. The mirror flips up so that light can pass through to the shutter, which opens to let light through to the image sensor for a set length of time, usually a fraction of a second. After the shutter closes, the mirror drops back into place. During the time that the shutter is open and the mirror is out of the way, the viewfinder in your camera is blacked out.

LINGO

The **pentaprism** is a specially designed prism that flips the image in the lens so it can be viewed the right way in the viewfinder. This eliminates the need for mechanically moving a mirror out of the way. Less-expensive dSLR cameras use a **pentamirror**, which is cheaper to manufacture but presents a slightly darker image in the viewfinder.

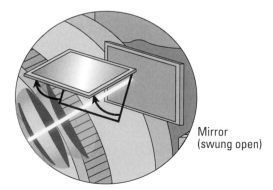

Mirror
(swung open)

Figure 1-2

A camera *aperture* is the opening in the lens that allows a measured amount of light to pass through the lens to the image sensor. Pressing the shutter-release button closes down the aperture of your camera, according to a setting you've specified or the camera has set automatically by metering light. The aperture ring controls the amount of light that enters your camera while the shutter is open by widening or constricting the lens opening in a similar way to how the irises in your eyes work. Figure 1-3 shows how the aperture and shutter work together.

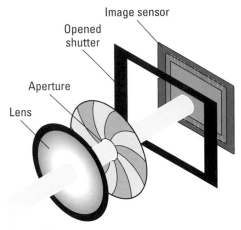

Image sensor

Opened
shutter

Aperture

Lens

Figure 1-3

Your aperture opening works in tandem with your camera's shutter speed, meaning how long it lets light pass through to the image sensor. While you can get virtually the same photo by having a wide aperture opening and a fast shutter speed, or a narrow aperture opening and a slower shutter speed, the choice of settings (by either you manually or the camera's automatic feature) affects the depth of field of an image and makes a big difference in how a picture looks. I go into more detail about aperture and shutter speed in Lesson 2.

Looking around your camera

At first, your dSLR camera might seem more complicated than any point-and-shoot camera you own. But don't worry: The principles of photography are the same no matter what kind of camera you use. Many features on your dSLR camera are also available on a point-and-shoot camera, but on a dSLR, they're much easier to access via buttons or dials. On a point-and-shoot camera, the range of functions is more limited, and controls are often hidden in camera menus.

Your dSLR might look intimidating with all those buttons and dials, but with a little practice, you'll soon master it and find that the controls are placed conveniently for use. Figure 1-4 shows the front view of a typical dSLR camera, and Table 1-1 describes the buttons and controls. These buttons and controls vary by camera, so be sure to check your manual for more on which ones are offered with your particular model.

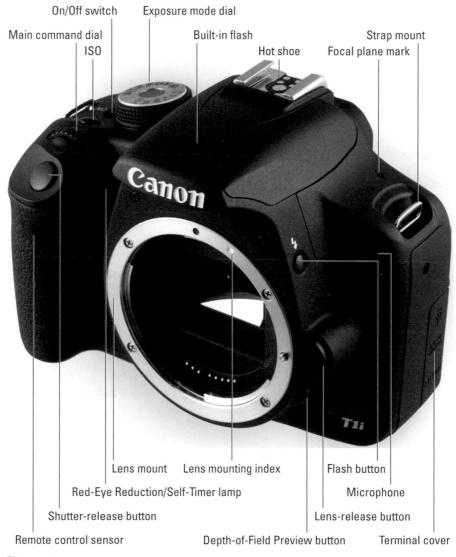

Figure 1-4

Once you've gotten to know your camera and are comfortable with how it operates and how exposures work, you'll be far more adept at taking cool photos than if you simply leave the camera in automatic mode. dSLRs might look big and mean, but they're actually far more optimized for helping you get the precise image you want if you're willing to learn how to operate them.

In addition, most dSLRs can be customized to shoot for specific needs, such as if you're a sports photographer and you want to tweak the controls to get the best shots or if you're a studio portrait photographer and you want to get very creative yet consistent images in terms of skin tone and lighting.

Table 1-1	Camera Front View
Camera Controls and Features	**Description**
Shutter-release button	Press this button halfway down to focus and all the way down to take a picture.
Main command dial	This dial changes depending on whether your camera is in picture-taking mode or picture-review mode, or whether you're accessing the camera menus. From this dial, you can select shutter speeds and apertures and select the camera's focus point.
ISO Sensitivity	Use this button to optimize shooting in dark or bright conditions. You can make the camera more or less sensitive to light depending on whether you're shooting in dark or bright conditions. (See Lesson 2 for more on ISO.)
On/Off switch	Use this switch to turn the power on or off.
Exposure mode dial	Use this dial to choose a preset exposure mode, as well as to manually or semi-automatically control your camera.
Built-in flash	Most dSLRs have a built-in flash that pops up from the camera body when it's ready to use.
Lens mounting index	Line up this mark with the corresponding mark on your camera lens when you want to mount a lens on your camera.
Hot shoe	Mount external flashes or wireless flash controllers on the hot shoe so the camera can control them.

Camera Controls and Features	Description
Focal plane mark	Focus distances are measured from this mark, not from the end of your lens as you might think. If your camera lens has a minimum focus distance of 0.25m/0.8ft, the subject must be at least this distance from the focal plane mark.
Strap mount	Attach your camera strap to this mount. Always attach your camera strap and keep it safely around your neck whenever you use your camera without a tripod. Doing so can save you a lot of money in camera and lens repairs.
Microphone	If your camera has video capability, it has a microphone built in.
Flash button	Press this button to use the flash in non-automatic modes.
Terminal cover	The external connections for your camera are behind this cover. These connections include audio/video output, HDMI, remote control, and external microphone.
Lens-release button	Pressing this button releases the lens so that you can remove it from the camera.
Lens mount	Your lens fits flush against this plate and makes connections with the contacts so that the camera can control focus and aperture.
Depth-of-Field Preview button	In advanced shooting modes, this button closes down the aperture to the current setting so that you can preview the depth of field through the viewfinder. Not all dSLRs feature this capability.
Remote control sensor	Some cameras can be controlled by an infrared remote controller, usually purchased separately as an accessory.
Red-Eye Reduction/Self-Timer lamp	If red-eye reduction is set on your camera, this lamp lights prior to taking a flash photo to help reduce red-eye in portraits. This setting also flashes to indicate when the camera is ready to take a picture using the delayed timer function. dSLR models that do not have a pop-up flash still offer this feature, but it is used with an external flash. (See Lesson 5 for more on red-eye reduction.)

Figure 1-5 shows the camera controls on the rear of a typical dSLR, and Table 1-2 describes the buttons and controls. Check your camera manual to find out what controls are available on your dSLR model.

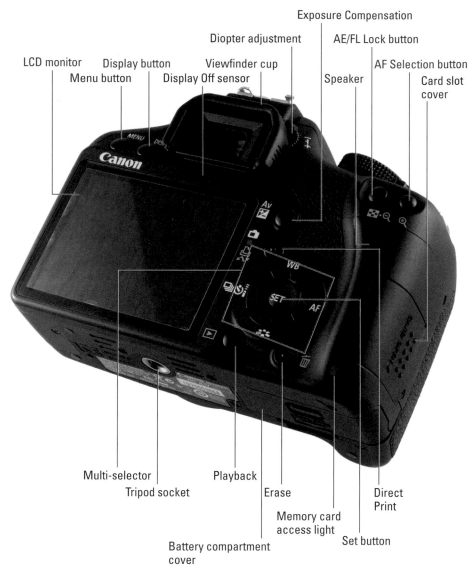

Figure 1-5

Table 1-2	Camera Rear View
Camera Controls and Features	**Description**
LCD monitor	This screen displays pictures for review, live view, and video viewing; camera menus; and current camera settings.
Menu button	Use this button to display the menus where you can customize the functions on your camera.

Camera Controls and Features	Description
Display button	This button displays the current shooting settings on the LCD monitor. If you use it while reviewing pictures, it cycles through the picture information displays, showing you shooting information for the picture being reviewed.
Display Off sensor	Some cameras have a sensor that automatically turns off the LCD monitor when you look through the viewfinder.
Viewfinder cup	The rubber cup on the viewfinder protects your eye when looking through the viewfinder.
Diopter adjustment control	Use this control to adjust the viewfinder focus if you normally wear glasses and you're not wearing them when you shoot.
AE/FL Lock button	Press this button to lock the exposure level or flash value for a shot if you need to reframe the image. If used while reviewing an image, on some cameras this button zooms out on the image displayed on the LCD monitor. On some dSLRs, these are separate buttons.
AF Selection button	Use this button to select the autofocus point in the viewfinder or to switch to autofocus point selection. If used while reviewing an image, this button zooms in on the image displayed on the LCD monitor.
Speaker	The speaker plays the sound while reviewing movies on your camera.
Card slot cover	Open this cover to access the camera memory card.
Memory card access light	This light blinks or lights up when the camera accesses the memory card. Do not remove the memory card when this light is lit or you could corrupt your picture files.
Battery compartment cover	Install your camera's rechargeable battery in this compartment. Replace your battery only with one manufactured for your camera's make and model.
Erase (Delete) button	Use this button to erase pictures from your camera's memory card.
Set (OK) button	Use this button to set the selected settings in camera menus and function displays. Some dSLRs also use this to start the video capture function.
Multi-selector buttons	Use these buttons to move the cursor around camera menu items or to access the individual functions printed next to each multi-selector cursor key. Use the right and left keys to navigate between pictures when reviewing them in playback.
Playback button	Use this button to turn on or off picture review on the LCD monitor.

continued

Table 1-2 *(continued)*	
Camera Controls and Features	*Description*
Direct Print button	Use this button to print directly from your camera to an attached compatible photo printer. On some cameras, this button displays the quick menu of camera settings on the LCD monitor.
Tripod socket	Attach your camera to a tripod via this socket.
Exposure Compensation button	Use this button to select the aperture setting in manual exposure mode or to select Exposure Compensation in other advanced exposure modes. Exposure Compensation makes your pictures darker or lighter (see Lesson 2). Higher-end dSLRs use separate buttons for this function.

Getting Ready to Take Pictures

Now that you've taken a look around your camera, you're ready to go through the basic camera setup to get ready to take pictures using the automatic exposure modes. This involves installing the camera battery, setting the camera date and time, choosing a file type, ensuring your camera is set to automatic mode, and attaching a lens. I also give you some general tips on using your camera.

Charging and loading the battery

Whenever I get a new camera, which is an all-too-rare occurrence, the first thing I do is to charge the battery. Charging the battery usually takes a couple hours, but when you're waiting to use your new camera, it seems much longer. While waiting, unpack the rest of your camera items, attach the camera strap, and read the camera manual. For most people, reading a camera manual is not a fun thing to do, but it's very useful.

To charge your camera battery, follow these steps:

1. **Remove the plastic protective cover from the battery.**

Always store your battery with the protective cover in place. Not only does this protect your battery, but it also prevents the battery from shorting out on metal objects.

2. Insert your battery into the charger, as shown in Figure 1-6.

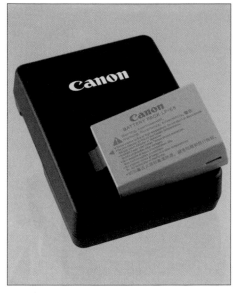

Figure 1-6

3. Plug the charger into an A/C power outlet.

The battery starts charging.

Depending on your camera, the charger either blinks red or displays a steady red light. When your battery is charged, a steady green light displays or blinks fast. (Check your camera manual to see how your specific battery charger operates.) Most batteries charge fully in around two hours; however, this time can be much longer in low temperature conditions. Some battery chargers, especially on higher-end dSLRs, allow you to reset your battery after it has been used extensively; this allows the camera to accurately measure how much power it has left and how many photos it has taken.

4. Unplug the charger and remove the battery after it's charged.

Try to charge your camera batteries right before you use them because they slowly lose their charge during storage.

A few tips regarding your battery:

✔ Your battery will last longer if you take it out of the camera and store it when you're not using your camera.

✔ Your battery will last longer if it isn't charged when it's not being used for a period of time. If you're not going to use the camera, simply don't charge it after using it, and then take it out of the camera for storage. Then the next time you want to use the camera, charge the battery first.

✔ When you notice that the battery discharges much quicker than it used to, it's coming to the end of its life, and you should purchase a new one.

To insert the battery into the camera, follow these steps:

1. **Open the battery compartment by sliding the lever, shown in Figure 1-7, and then insert your battery, battery contacts first.**

2. **Snap the battery compartment lid closed.**

 When you turn on the camera for the first time, your camera prompts you to set the date and time (and possibly, the interface language). Figure 1-8 shows typical screens for these settings. Press the multi-selector to scroll and select the settings.

Battery compartment slide lever

Figure 1-7

Note that various cameras have different ways of mounting batteries and have different types of batteries and chargers. Be sure to carefully examine your battery, camera, and charger and refer to the manual before charging, installing, or using them.

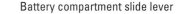

Date/Time

Set Date/Time

03 . 03 . 2011 14 : 51 : 09

mm/dd/yy

(03/03/2011)

OK Cancel

English	Norsk	Română
Deutsch	Svenska	Türkçe
Français	Español	العربية
Nederlands	Ελληνικά	ภาษาไทย
Dansk	Русский	简体中文
Português	Polski	繁體中文
Suomi	Čeština	한국어
Italiano	Magyar	日本語
Українська		

Figure 1-8

Inserting the memory card

After installing the battery and setting the date and time, follow these steps to insert the camera memory card:

1. **Open the card slot cover on the side of the camera (refer to Figure 1-5).**

 When you get a new card, you need to *format* it for the camera so it is set up for your exact camera model. You can find the option to format your memory card in your camera Setup menu. Figure 1-9 shows the Format menu item on a Canon camera. After you have used a memory card and safely downloaded photos from it to your computer, you should format it again to most-effectively delete the images and make sure the card is ready to store more photos captured by your camera.

LINGO

The **memory card** is where your dSLR stores your images. Your camera uses one of several types of memory cards, which you usually have to purchase separately from your camera. The two most common types of memory cards are SD (including SDHC, for higher-capacity storage) and CompactFlash. A few dSLRs support both at the same time, or two cards of the same type. Different cards have different speed ratings (important if you're shooting lots of fast shots or if you're capturing video) and storage capacities, typically measured in gigabytes (GBs). Consult your camera store or manual if you are unsure of what type to purchase for your camera.

Auto power off	30 sec.
File numbering	Continuous
Auto rotate	On
Format	
LCD auto off	Enable
Screen color	1

Figure 1-9

2. **Insert the memory card into the slot, as shown in Figure 1-10, and then push the card until it clicks in place.**

 The memory card access lamp blinks briefly to let you know that you've inserted the card correctly.

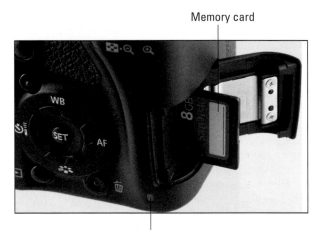

Memory card

Memory card access lamp

Figure 1-10

Choosing a file type (JPEG quality and size, TIFF, Raw)

Your camera stores images in any of two or more file types, or *formats* (not to be confused with the process of *formatting* your memory card). The most common image format file is JPEG, and dSLR cameras often also include a native camera format called Raw. JPEG is a universal format recognized by virtually any image software, social media (if you're uploading a photo to Facebook or Twitter), and virtually any application or online service where an image file is required. JPEG files are also produced by point-and-shoot cameras, as well.

Understanding standard file types

The file format you select determines how image data is recorded and stored on your camera's memory card. Here are the standard file formats:

✔ **JPEG:** JPEG is the default file format on most digital SLRs. It's a *lossy* format, meaning it sacrifices some image quality to reduce the file size. You can specify how much compression is applied by choosing either Fine or Normal for the JPEG image quality setting. Image files saved with Fine compression have less compression applied and offer better print quality than Normal compression, but they also take up more memory card space than Normal. You can also choose at least three different image size settings, which are Large, Medium, and Small.

✔ **Raw:** A Raw file is an image stored precisely as the camera sees it, in a native format distinct to each camera make and model. A Raw file

provides exponentially more tonality than a JPEG file and allows fine-quality editing to be performed to ensure the most optimal image — even if the image is ultimately converted to, used, and stored as a JPEG file. Unlike JPEG files, Raw files apply no lossy compression, so they offer the best image quality. Raw also gives you the most creative control over your images because the image processing is done on your computer.

The disadvantages to using Raw are that the files take up a lot of space on your memory card, every camera manufacturer has its own Raw format, and you have to process Raw files using computer software before you can print, edit, or display them on the web. Not all photo applications and image-editing software support Raw files, and, even if an application does, you need to make sure the application supports your specific camera (most application manufacturers frequently issue updates to support emerging camera models that offer Raw).

✔ **TIFF:** TIFF files are specialized image files used in commercial printing. The majority of dSLR cameras can't capture images in this format. TIFF files take up a lot of space on your camera memory card.

You can set your camera to shoot in JPEG, Raw, or both (generating two files). You might want to shoot both at the same time (JPEG + Raw) if you want to have JPEG files immediately accessible and usable, and Raw files to be able to edit in more detail later on. You can also choose various levels of quality for JPEG files, and some dSLRs offer a smaller-sized version of Raw, as well.

The settings you choose affect how many images you can capture on a card. For example, Table 1-3 shows the file sizes for different size and quality combinations on a Canon EOS Rebel T2i camera. Check your camera manual to find similar information on your camera model.

GO ONLINE

Be sure you have the latest camera firmware installed. After a camera has been on the market for a short time, manufacturers often issue a firmware release to fix any minor bugs or add functionality. You can find instructions for checking and updating firmware on the camera manufacturer's website.

Table 1-3	File Sizes for Image Quality/Size Combinations		
Image Quality	*Large*	*Medium*	*Small*
JPEG Fine	6.4MB	3.4MB	2.2MB
JPEG Normal	3.2MB	1.7MB	1.1MB
Raw	24.5MB	NA	NA
Raw+Fine	24.5+6.4MB	NA	NA

Setting image capture quality on your camera

How you set the image quality depends on your camera. On some cameras, you can set image quality using a button on the camera, as shown in Figure 1-11. On other cameras, you set the image capture quality by choosing the options Fine, Normal, Raw, and so on in the camera menus.

On Canon cameras, Fine is represented by a smooth-edge symbol, and Normal is represented by a stepped-edge symbol. The settings in the middle row of the menu in Figure 1-12 represent JPEG formats. The settings in the bottom row are the Raw options.

Image Quality button

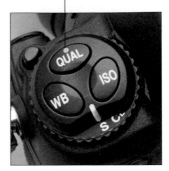

Figure 1-11

Deciding on the file format

What file format and quality settings you choose boils down to two things:

Normal

Fine

✔ **How fast you need to take pictures:** Your camera takes longer to write large image files to the memory card, which slows down the rate and number of pictures you can take in continuous shooting. If you're taking portraits or landscapes, you probably won't notice this because your camera will have finished writing to the camera memory card before you take the next shot. However, if you need to take pictures quickly — for example you're taking photos at a sporting event and using continuous shooting — large image files may not be the best choice.

Quality

⊿L 15M 4752x3168 [1257]

⊿L ⊿L ⊿M ⊿M ⊿S ⊿S

RAW+⊿L RAW

Figure 1-12

✔ **What you intend to do with the pictures you've taken:** If you intend to print no larger than 4 x 6 images, or want to use your images only on the web, you can shoot with the low size and quality settings for JPEG files. This can save you time in transferring the files to your computer and will also take up less space on your camera memory card and computer hard disk.

Keep in mind that you can always use a large file to print a small picture, but you can't blow up a small file to print a large picture without a loss of quality. I advise you to simply set the biggest JPEG file linked with the best quality compression on your camera and leave it there. I find that an enthusiast consumer-grade camera has no difficulty maintaining a high rate of continuous shooting when JPEG files are set to capture as Large+JPEG Fine. You can capture Raw files, too, if you can edit them.

Attaching a lens

To attach a lens to your camera body, follow these steps:

1. **Remove the lens cap from the rear of the lens and the body cap from the front of the camera.**

2. **Align the index marks on the camera lens and body, and then twist the lens into place, as shown in Figure 1-13.**

Align index marks

> **EXTRA INFO**
>
> Some cameras, such as Canon models, require you to turn the caps counterclockwise to unlock the caps; some cameras, such as Nikon models, require you to turn the caps clockwise to unlock.

Figure 1-13

3. **Set the auto/manual focus switch on the lens to autofocus, as shown in Figure 1-14, and then remove the front lens cap.**

Auto/manual focus switch

Image Stabilization switch

Figure 1-14

WARNING!

Twisting the lens into place should happen easily and smoothly. Do not force it! If it seems like it's not easily attaching, start over, make sure your mounting marks are aligned, and try again. If you still have problems, try another lens to ensure the mount is intact.

With the lens in place, you're beginning to look like a photographer!

Holding your camera

Hold your camera steady to make sure you obtain sharp images:

1. **Hold the camera firmly with your right hand.**

2. **Support the lens from underneath with your left hand.**

3. **Keep your arms close to your body, and brace your elbows against your body for added stability.**

4. **Breathe out slowly as you press the shutter-release button.**

Figure 1-15 shows how to hold your camera for landscape (horizontal) and portrait (vertical) orientation.

EXTRA INFO

Cameras are all designed to have the right hand control the shutter-release button and the left hand operate the lens (zooming, focusing). There are no right- and left-handed cameras, per se.

Landscape Portrait

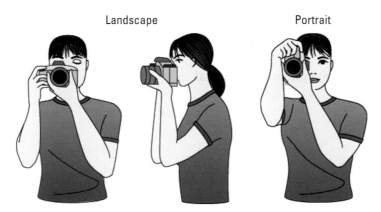

Figure 1-15

Setting Vibration Reduction

When your shaky hands cause the camera to move while the shutter is open, the resulting image looks smudged. Figure 1-16 shows the camera shake caused by moving the camera while taking a picture.

Figure 1-16

No absolute shutter speed allows you to hold the camera without getting camera shake. Hold your camera firmly to avoid shake and use a tripod or bean bag support at low shutter speeds. While you practice, keep the shutter speed at least 1/60 of a second with a 50mm lens. For longer focal lengths, consider the minimum shutter speed at which you can handhold your camera to be one over the focal length of the lens. For example, if you're shooting with a 200mm lens, your minimum handhold speed is around 1/250 of a second.

The Vibration Reduction function in newer lenses can help reduce camera shake considerably. Nikon claims its Vibration Reduction system allows you to hold a 50mm lens three stops slower than without it. So, if you can handhold your camera at 1/125 of a second without it, you can handhold your camera at 1/30 of a second. Canon makes similar claims for its lens image stabilization (IS) system. Longer focal lengths always require a steadier hand.

To turn on image stabilization for your lens, set the image stabilization switch to On (refer to Figure 1-14).

Attaching a tripod when necessary

Place your camera on a tripod when you use it with very slow shutter speeds that make it hard to handhold. Turn off image stabilization when you use your camera on a tripod. When the camera is stabilized with a tripod and the IS system is on, it can actually *cause* the camera to shake, blurring your image.

Your camera has a tripod socket on the bottom that allows you to attach it to the tripod heads. Some tripods come with a quick-release plate that attaches to the base of your camera and allows you to remove your camera from your

tripod without unscrewing it every time. Figure 1-17 shows an example of a camera fitted with a quick-release plate. Every tripod manufacturer uses a different plate design system, although a few are interchangeable (you can compare at a local camera store). Less-expensive and small tripods, and some monopods do not use the plate system, but let you directly mount the camera onto the tripod.

Figure 1-17

Shooting in Full Auto Mode

Now that you're familiar with your camera's basic functions and settings, you're ready to take pictures. To take pictures in Full Auto mode, follow these steps:

1. **Turn on your camera.**

2. **Turn the exposure mode dial on your camera to the Full Auto setting, as shown in Figure 1-18.**

3. **Look through the viewfinder, center the subject in the viewfinder, and press the shutter-release button halfway to set focus.**

Full Auto

Figure 1-18

You may hear a soft beep, and the focus points that are in focus may briefly highlight. At the same time, the focus confirmation indicator will light, as shown in Figure 1-19. (See Lesson 4 for the lowdown on focusing.)

Note: If the camera is in what Canon calls AI Servo mode, which allows for continuous focusing and is useful for focusing on moving things (such as in sports), you will not hear a beep.

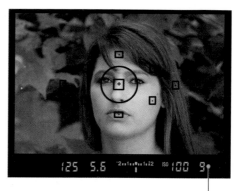

Focus confirmation light

4. **Keeping your finger pressed halfway on the shutter-release button, you can reframe your subject without altering focus on the subject.**

Figure 1-19

5. **Press the shutter-release button fully to take the picture.**

Reviewing Your Shots

To review your pictures on the camera's LCD monitor, follow these steps:

1. **Press the Playback button, which should look similar to the button shown in Figure 1-20.**

 The last image you captured displays on the LCD monitor. Remember that images on the LCD will not look nearly as crisp or high-quality as they will on your computer screen, especially when zoomed-in.

2. **Press the left and right multi-selector buttons to navigate between images.**

3. **Press the Display button or use the up and down multi-selector buttons to change the shooting information display for the image.**

4. **Press the Zoom In/Zoom Out buttons to zoom in and out on an image.**

 When you zoom in on an image, press the multi-selector buttons to navigate around it.

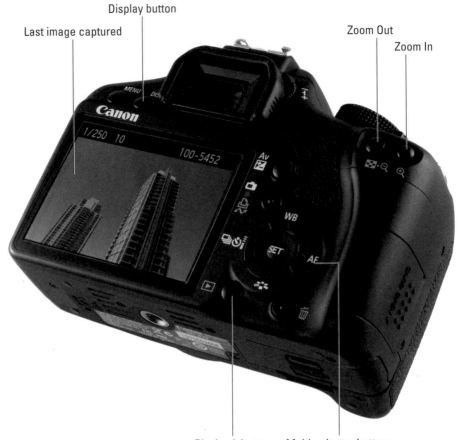

Display button

Last image captured

Zoom Out

Zoom In

Playback button Multi-selector buttons

Figure 1-20

5. **If you want to lock the current image so it can't be deleted, press the Protect button, which usually has a key icon on it. On some cameras, you have to select Protect Images from the camera menus. (See Figure 1-21.)**

Protect button

Figure 1-21

To unlock a protected image, press the Protect button again.

Deleting Images from Your Camera

You can delete images individually or in batches. You can also delete all the images that haven't been protected on your card. Keep in mind that it is difficult and sometimes impossible to retrieve an image after it's been deleted, so be very sure you don't want these images before you proceed.

To delete individual images, follow these steps:

1. **Press the Playback button and navigate to the image you want to delete.**

2. **Press the Delete button, which usually has a trash can icon on it, as shown in Figure 1-22.**

LINGO

Data recovery software programs are available, often from memory card manufacturers, that will let you recover images from a card that has been formatted or erased. While there's no 100-percent surefire way to retrieve deleted images, often you can recover photos using this type of software. If you accidentally delete images or format a card, be sure to not take any more photos on that card; otherwise, you might prevent being able to successfully recover your shots.

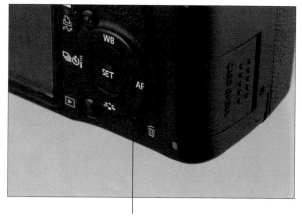

Delete

Figure 1-22

3. Using the multi-selector, choose the Erase option on the screen, as shown in Figure 1-23, and then press the Set or OK button to delete your selection.

On some cameras, you need to press the Delete button a second time to confirm deletion.

You can delete batches of pictures or all the pictures on your camera memory card through the camera menus. Deleting batches of photos is a risky business, however, and you should be doubly sure you want to erase all of them before doing so. Almost always, it's better to download all the photos to your computer and delete them there, where you can review them more effectively.

The batch deletion process varies by camera, but here are the general steps to follow:

1. On your camera menus, use the multi-selector keys to navigate to the option to delete or erase images.

Figure 1-24 shows the Erase Images menu items for a Canon camera.

2. Choose whether to delete selected images or all images, as shown in Figure 1-25. If you choose to delete selected images, you can mark the images in a batch by using the multi-selector keys.

3. Press Set or OK to delete the images.

Figure 1-23

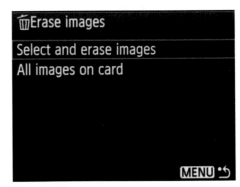

Figure 1-24

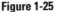

Figure 1-25

Getting to Know the Scene Modes

You can select the type of scene you want to shoot via the scene modes on your camera's exposure mode dial, as shown in Figure 1-26. These modes are an extension of the Full Auto setting that help your camera decide on the best combination of shutter speed and aperture for the type of scene you're shooting. Some scene modes may also affect the color settings in your camera and whether the pop-up flash is activated in low light.

Portrait

Landscape

Close Up

Sports

Night Portrait

Figure 1-26

LINGO

A **scene mode** is essentially several camera settings provide by the camera and optimized for shooting a specific exposure situation, such as nighttime, sports/action, landscapes, portraits, and so on.

Table 1-4 contains a list of typical scene modes and a description of how they work on most cameras.

Table 1-4	Camera Scene Modes
Mode	*Description*
Portrait	This mode uses large apertures that help blur the background (known as shallow depth of field) and create soft tones.
Landscape	This mode uses small apertures to produce sharp detail in both the foreground and background. Colors are rendered more vividly.

continued

Table 1-4 *(continued)*

Mode	Description
Close Up (Macro)	Use this mode to photograph close-up subjects with small apertures that bring the whole subject into focus. You may need a tripod to prevent camera shake. If you want to take pictures at very close distances, you need a specialized macro lens or a lens with a macro function attached to your camera. (See Lesson 6 for more on lenses.)
Sports	This mode uses fast shutter speeds for freezing action in fast-moving subjects, such as during a sporting event. Your camera, if it is set to AI Servo or Continuous-Servo focusing mode, stays focused on a moving subject and takes multiple shots as long as you keep the shutter-release button pressed. The pop-up flash is usually disabled because the typical distance to the subject makes it ineffective.
Night Portrait	Take portraits at night when you want the background to appear in the picture instead of just looking dark. This mode selects a shutter speed that leaves the shutter open after the flash has fired to gather the background details. You may need a tripod to prevent camera shake.

To shoot in a particular scene mode, follow these steps:

1. **Turn the exposure mode dial to the scene mode corresponding to the type of scene you want to shoot.**

2. **Look through the viewfinder and press the shutter-release button halfway to focus.**

3. **Press the shutter-release button fully to take the picture.**

 The scene mode stays set until you turn the exposure mode dial to another setting.

Your camera has several other modes available, including shutter-priority, aperture-priority, and manual, all of which are addressed in Lesson 2 since they are not automatic. Most cameras also offer a programmed autoexposure mode, which automatically sets your exposure (meaning shutter speed and aperture) but requires you to determine and set the focus, ISO sensitivity, color, and some other settings.

Scene modes offer some advantages:

✔ Using a scene mode is a step beyond Full Auto mode. It tells your camera more about the type of scene you're shooting and increases your chances of getting a good shot.

✔ You can adjust your camera's settings in a way that suits the type of scene you're shooting, without your having to understand the mechanics of how your camera is doing it.

Scene modes also have some disadvantages:

✔ You have no control over the settings, such as whether the flash will fire (unless you manually close the flash, if your camera allows you to do so).

✔ You may have difficulty deciding which scene mode to select.

✔ You can easily forget to select a new scene mode when the scene changes.

EXTRA INFO

The scene modes available on your camera depend on the make and model. Shooting in a particular scene mode is a step in the right direction for getting more control over your camera because you give it a little help by indicating the type of scene you're shooting. The problem with scene modes is that they don't always work exactly the way you think they will. Camera manufacturers make their scene modes perform in different ways, and they don't always tell you in the camera manual what settings a scene mode changes in your camera.

Composing Better Pictures

You now know the basics of your camera and can use it to capture some great pictures in the automatic exposure modes. Next, I want to share a few composition tips that can add some wow to your images.

Taking a great photograph depends in part on your ability to see a scene as your camera sees it. When looking at a scene through your camera's viewfinder, you generally see only the important elements and more or less ignore everything else. A camera, on the other hand, sees all the details in the scene, and everything in the background that is in focus has equal emphasis with the foreground subject. What often happens is that signs or objects that don't register with you mentally when taking the picture, such as a trash can or utility pole in the background, stand out when you view the picture later.

To compose better pictures, keep these tips in mind:

✔ When taking a picture, inspect the whole scene in your viewfinder, from background to foreground.

✔ Avoid lines, such as the horizon, intersecting people's heads or fussy backgrounds that draw attention away from the subject. For example, in Figure 1-27, a cluttered background and the horizon passing through the subject's head distract from the picture.

✔ Be careful about cutting off parts of the people when you're shooting, such as their legs, arms, or top of their head.

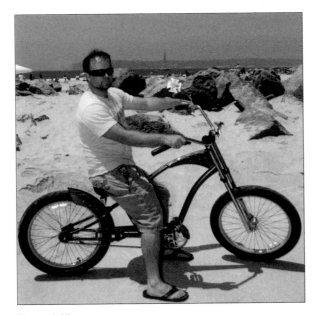

Figure 1-27

Another difference in the way you view a scene compared to the way your camera sees it is that you can see a greater range of light and dark in the scene. As a result, high tonal differences are hard to capture without dark areas looking black and light areas blowing out, as shown in Figure 1-28. The easiest solution to dealing with these scenes is to shoot when the light is more even, such as on a cloudy day or an hour around sunrise and sunset. Contrary to what you might think, bright overhead sunlight isn't what most photographers want.

TIP

After you've taken a photo and downloaded it to your computer, you may be able to bring out aspects of an underexposed image using image-editing software. It is typically easier to edit an image that is too dark, versus one that is too light.

Figure 1-28

Using the Rule of Thirds

Artists have observed over centuries what makes a picture pleasing to the viewer's eye, what feels more balanced, and what gives visual clues about where the viewer's attention should be drawn. The rules of composition are more like a series of observations than actual rules that must be followed. You can ignore any rule if doing so brings a little something extra to your photography, but how you compose your picture is always worth considering.

Figure 1-29 shows a picture of a field of flowers split with a pattern according to the Rule of Thirds. I placed the edge of the field on the top-horizontal third. The one flower that stands up, I placed on the intersection of the top-horizontal and left-vertical thirds.

LINGO

The **Rule of Thirds** is probably the most well-known and often quoted rule of composition; it involves splitting your viewfinder mentally into thirds horizontally and vertically like a tic-tac-toe game board. The vertical lines, horizontal lines, and places where they intersect have special significance to a composition.

Figure 1-29

Pictures you take according to the Rule of Thirds should be composed by following the lines:

- ✔ Place the horizon on the lower-horizontal line if you want to emphasize the sky.
- ✔ Place the horizon on upper-horizontal line to emphasize scenery.
- ✔ Place main subjects on left- or right-vertical lines. For example, place someone sitting on a bench on the left- or right-vertical line.
- ✔ Place important subjects on the intersections. For example, place the moon in a landscape shot where the left- or right-vertical lines intersect the top-horizontal line.
- ✔ Place the eyes of a portrait subject on an upper-horizontal line when holding the camera vertically, to get a *portrait* (taller than wider) image aspect ratio. To do so, pivot the camera counter-clockwise from your normal horizontal orientation so your right hand is on top (refer to Figure 1-15).

Exploring some other useful tips on composition

The way you take a picture can evoke a mood, tell a story, or capture a unique moment never to be repeated. Here are some tips on composition that you can use and combine to take better pictures:

- ✔ **Use diagonals for more dynamic shots.** Linear subjects look more dynamic when placed diagonally through the frame, as shown in Figure 1-30. If you take a picture of a line of people sitting on a bench, move to one side rather than take the picture from directly in front of the group. Doing so often creates a better look.

Figure 1-30

- ✔ **Use leading lines to point to a subject.** If you put your subject where lines are pointing to it, the viewer's eye is led in, as shown in Figure 1-31. Paths leading to houses, or tow lines leading to boats, can help strengthen the subject. The lines don't have to be solid, but can be implied.

Figure 1-31

✔ **Use layered subjects to create depth.** Because a photograph is a two-dimensional image, placing a subject in the foreground and background helps create a feeling of depth. Don't just stand by the edge of the ocean and take a picture of the sun sinking behind the horizon; instead, find something interesting on the beach to include in the shot, such as a bird or a surfboard. Your picture will look much better for it. Figure 1-32 shows an example of a layered scene.

Remember, however, that depth of field (how blurry or crisp things are around your subject in the foreground and background) is something you will need to control in a manual or semi-automatic mode (as described in Lesson 2). Your camera's automatic setting might get what you want, but it might not, meaning you need to control the settings. And that's just what I get into later in the book so you can achieve the precise image you want.

✔ **Use patterns to please the eye and create interest.** The human mind seems to love patterns and symmetry, and the simple symmetry of the old school house in Figure 1-33 is appealing.

Figure 1-32

Figure 1-33

✓ **Use viewpoint for emphasis.** An unusual viewpoint can make a subject or emphasize it. Explore ways to look at a subject from interesting angles and viewpoints, which might involve getting under or on top of something, lying down, or standing on a chair or ledge. But, for goodness sake, be careful out there!

For example, shooting buildings close up makes them seem to be falling over, but in Figure 1-34, the photographer was interested in the vents and the reflection of the sky in the glass tower.

✓ **Crop subjects for interest.** Concentrating on one part of a subject can make it more interesting. Many subjects benefit from being taken at close range, as shown in Figure 1-35. You can also crop photos later, in post-processing using your image-editing software, to make what might be an otherwise mundane photo more dramatic.

✓ **Frame subjects for strength.** Placing a virtual frame around your subject makes it stronger and draws in the viewer's eye.

COURSEWORK

Walk around a subject and shoot it from different angles, taking note of how the light falls from different directions.

Figure 1-34

You can use foreground branches or flowers to frame your subject, as shown in Figure 1-36. You can also frame a portrait of someone in a door or window, or frame a bride and groom in the arch of flowers. This photo is a good example of a narrow depth of field (notice the blurry leaves in the foreground), which your camera may or may not be able to shoot in Full Auto or the scene modes. I go into detail about how to control depth of field in later lessons, using semi-automatic and manual modes.

Figure 1-35

Figure 1-36

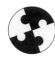 *Summing Up*

In this lesson, you learned the following:

- ✔ You know what the buttons and controls are on your camera.
- ✔ You have charged and inserted the battery into your camera.
- ✔ You know how to select a file type for your pictures.
- ✔ You can insert the memory card and attach a lens.
- ✔ You can shoot in Full Auto mode and with scene modes.
- ✔ You can review the shots you've taken and delete the ones you don't want.
- ✔ You've gleaned some tips for composing better pictures.

Practice using your camera and then come back to start on Lesson 2.

Know This Tech Talk

battery charger: The camera accessory that plugs into a 110/220 volt A/C connection in order to recharge the camera battery when inserted.

camera shake: The blurring of an image caused by movement of the camera while the shutter is open. Shake is usually the result of trying to handhold your camera with a slow shutter speed.

Full Auto mode: The point-and-shoot exposure mode that fully automates your camera. Although this mode often guarantees acceptable results, it allows for the least amount of creativity.

image stabilization or Vibration Reduction: Vibration Reduction and image stabilization are inventions that make micro adjustments in a lens element or image sensor to keep the image stabilized on the sensor and blur-free even when using the camera at relatively low shutter speeds.

interchangeable lenses: Lenses that can be mounted and interchanged, to provide you with the ability to use lots of different focal lengths and lens features. This is one of the most prominent features that distinguishes dSLRs from point-and-shoot cameras.

Lesson 2

Understanding and Mastering Exposure

✔ Getting out of the automatic exposure modes allows you to *be more creative with your camera.*

✔ Working with shutter speeds and apertures allows you to *freeze action or control the amount of background blur* (depth of field) in your pictures.

✔ Take properly exposed photos to *optimize the amount of detail captured by your camera* and improve the quality of your images.

✔ *Adjust your camera's light sensitivity* to maintain a fast shutter speed, shoot better photos in lower light, and prevent camera shake.

✔ You can *adjust exposures for different shooting situations* to increase the percentage of successful shots you take.

*I*t's time to get out of the automatic exposure settings that your dSLR camera provides and start taking more control. You'll find many advantages in using your dSLR in the advanced shooting modes. The automatic exposure modes (Full Auto and the scene modes) have their uses, but the advanced exposure modes provide greater flexibility, consistency, and accuracy in taking pictures.

By the end of this lesson, you'll be able to use your camera's exposure mode dial to choose the optimal settings for taking pictures, whether you're interested in shooting sports, landscapes, portraits, or wildlife. You'll understand how exposure works with all the available shooting modes and be able to make adjustments according to the lighting conditions. With a little practice, you'll be using your camera like a pro.

Good photographers can use their cameras to produce intentional results. In the automatic exposure modes, your camera allows you very little creativity, and it often messes up. Good photographs shouldn't be just a happy accident.

LINGO

Camera manuals often assume you already know about the mechanics of photography. They describe how to change settings without explaining what they're for or how they affect your pictures. I don't delve deeply into the laws of light and lenses, but I explain terms such as **shutter speed, aperture,** and **ISO.** I call them the **elements of control,** and they work together to bring different looks to your pictures.

Introducing the Elements of Exposure Control

Look on the top of your camera at the exposure mode dial. It probably looks similar to the one shown in Figure 2-1. Up until now, I've instructed you to use the camera with the mode dial set to Full Auto or to one of the scene

modes to take a picture. In these automatic exposure modes, your camera uses its internal light meter and selects all the exposure settings for you. In many cases, the automatic exposure modes work fine to set the correct exposure so your pictures aren't too light or too dark; however, they don't allow you access to the elements of exposure control — the shutter speed, aperture, and ISO, which I cover in detail in this lesson. By using the other settings available on the exposure mode dial — the advanced exposure modes — you can take command of the elements of exposure control and combine them in different ways to get creative with your photography.

Advanced exposure modes

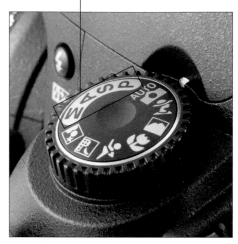

Figure 2-1

 When you choose an exposure mode, you instruct the camera to select shutter speeds and apertures depending on the exposure mode you selected.

Before I explain how to set shutter speeds and apertures using the exposure mode dial, I need to introduce you to shutter speed and aperture and how they can be combined for different effects.

Introducing shutter speed

Your camera's shutter speed controls the amount of time that light is allowed to reach your image sensor, usually measured in fractions of a second.

The range of shutter speeds you can set depends on the camera make and model. At the professional end of the dSLR range, a camera allows shutter speeds ranging from 30 seconds down to 1/8000 of a second.

LINGO

Most dSLRs contain an electro-mechanical **shutter** that controls when light is let through to the sensor. It can be open or closed so that it's either letting in light or not. **Shutter speed** refers to how long the shutter is open: It's measured in seconds for long exposures and, more commonly, parts of a second for shorter exposures.

If you make the shutter speed faster without changing any other camera settings, your camera lets in less light, and your picture darkens. If you slow down the shutter speed without changing any other camera settings, your camera lets in more light, and the resulting picture is lighter.

There's a simple, but direct, relationship between the shutter speed and the amount of light let into the camera:

- 1/1000 of a second is half the light of 1/500 of a second.

- 1/500 of a second is half the light of 1/250 of a second.

- 1/250 of a second is half the light of 1/125 of a second.

Figure 2-2 shows an example of a scene shot with different shutter speeds and the same aperture setting. As more light is let into the camera, the scene gets lighter.

In addition to varying the amount of light entering your camera, slow and fast shutter speeds have another effect on your pictures that allows you to get creative. Fast shutter speeds freeze action in a shot, whereas slow shutter speeds blur action.

EXTRA INFO

You can also find a setting called Bulb that appears either after you try to select an exposure greater than 30 seconds or as an option on the camera menus. The Bulb setting allows you to take very long exposures, perhaps of star trails at night, by keeping the shutter open for as long as the shutter button is kept fully pressed. This is normally accomplished with an electronic cable that has a remote shutter-release button on it so you don't jostle the camera while the shutter is open.

Figure 2-3 shows the effect of a fast and slow shutter speed on moving water. The picture on the left shows a fountain taken at a shutter speed of 1/30 of a second. The slow shutter speed blurs the water and shows motion in the photo. The picture on the right was taken at a shutter speed of 1/250 of a second, freezing the water so you can see individual droplets. Note that in order to achieve the same lighting in the second image, I also had to adjust the aperture setting. Otherwise, different shutter speeds without any other adjustment would have resulted in very different exposures.

Lesson 8 explains more about controlling the shutter speed for different effects.

1/1000 second 1/250 second

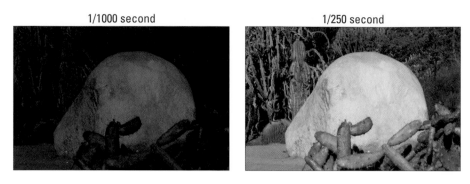

1/50 second

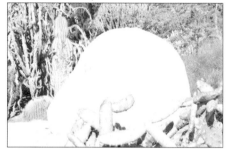

Figure 2-2

1/30 second 1/250 second

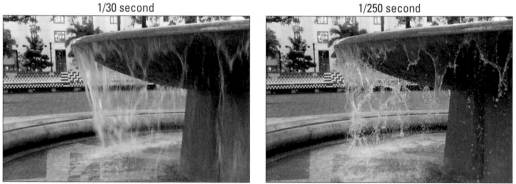

Figure 2-3

Introducing aperture

Before light hits the shutter and, ultimately, the image sensor, it passes through the aperture. Aperture, by definition, means *opening* or *hole*. The aperture ring is located just behind the camera's lens, and it controls how much light passes through the lens. The ring is made up of a number of

interlocking metal leaves that can be opened or closed in various sizes. Figure 2-4 shows a partially closed aperture ring inside a 50mm lens.

The aperture works like the iris in a person's eye, opening to let in more light or closing down to block light. When you set the aperture on your camera, you're telling the lens diaphragm how wide to open. The larger the opening of the aperture, the more light that can pour into your camera.

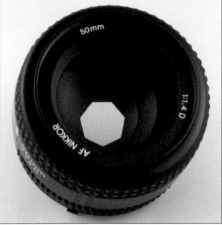

Figure 2-4

Unfortunately for us, photography was invented by scientists and engineers rather than artists. An artist might have used a straight numbering system for the stops, or called the stops something poetic, but being very precise and mathematical, the inventors of lens apertures quite correctly referred to the aperture by the diameter of the aperture opening in relation to the focal length.

The measurements of the aperture are referred to as *f-stops*. The f-stop numbers that refer to the size of the aperture can sometimes be confusing because it seems there is no relationship between the numbers. A small number, such as f/2.8, relates to a wide aperture, letting in more light. A large number, such as f/16, relates to a small aperture, letting in less light.

LINGO

On older lenses, users had to adjust the aperture on the lens itself by turning the aperture ring to one of the selectable settings called **stops.** The lenses had a number of standard stops, one whole stop representing half or twice the light depending on whether you opened up the aperture or closed it down (sometimes called **stopping down**).

Your aperture setting has a lot of effect on *depth of field,* meaning how much of your photo behind and in front of your subject is blurry. A wide aperture setting like f/2.8 will result in *narrow* depth of field where the subject is in focus, but other parts of the image that are closer or farther away will be blurred. A narrow aperture setting, like f/22, will result in *deep* depth of field and most of the photo being in focus. This is important if you're photographing, say, a football team on a set of bleachers. You want deep depth of field and a high f-stop number so all the players will be in focus from front to back.

Some common f-stops are shown in Figure 2-5. Each setting lets in half the light of the one preceding it. Many dSLRs today also allow half-stops and/or third stops, meaning there are even more numbers to play with!

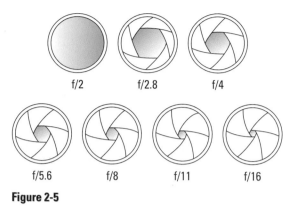

f/2 f/2.8 f/4

f/5.6 f/8 f/11 f/16

Figure 2-5

You can set the aperture by turning a dial on the camera, which instructs your lens to set the selected aperture just before the shutter is released. The maximum and minimum aperture settings available vary with the lens you have attached to your camera.

Typically, more expensive lenses can set a wider aperture (a smaller f-stop number). Also, less-expensive zoom lenses might not have a fixed widest aperture. If your camera came with an 18–55mm kit lens, it probably has a maximum aperture of f/3.5 at 18mm, but when you zoom in to 55mm, the maximum aperture becomes f/5.6. This means even if you've set your camera's aperture manually, it will still change the aperture if you zoom because the camera is physically unable to handle the same aperture size at the different focal length. The bottom line is that you might inadvertently end up with a darker photo than you intended if you don't pay attention. Professional-grade zoom lenses often have the ability to keep the aperture setting constant at any focal length (these are called *fast* lenses).

REMEMBER

If you make the aperture smaller (increase the f-stop number) without changing any other camera settings, your camera lets in less light, and your picture darkens. If you make the aperture larger without changing any other camera settings, your camera lets in more light, and the resulting picture is lighter.

Figure 2-6 shows an example of a scene shot at different apertures without changing the shutter speed. As more light is let into the camera, the scene gets brighter, just as it does when you slow down the shutter speed. The three example photographs were taken with a shutter speed of 1/60 of a second. The first example is normally exposed and taken with an aperture of f/14. The second is underexposed and taken an aperture of f/32. The third example is overexposed and taken with an aperture of f/6.3.

Normally exposed, 1/60 second, f/14 Underexposed, 1/60 second, f/32

Overexposed, 1/60, f/6.3

Figure 2-6

You can change the total amount of light gathered by your camera by adjusting the shutter speed, the aperture, or both.

I've touched on the concept of depth of field already, so you should have a basic understanding of how you can manipulate light to affect parts of an image that are in focus or blurred. As some of the key advantages of dSLRs, the aperture setting and depth of field are essential to letting your creativity soar.

To concentrate the viewer's attention on the subject, use a wide aperture (a small f-stop number) to create a shallow depth of field in your pictures, making only the objects close to the subject sharp.

Figure 2-7 shows a portrait of my friend Jeff taken in my kitchen with an aperture of f/1.4 using a 50mm lens. The shallow depth of field isolates the subject, and the cluttered background falls into a pleasing, soft, out-of-focus effect.

f/1.4, shallow depth of field

Figure 2-7

LINGO

Wide apertures (remember, that's a smaller f-stop number) help create a shallow depth of field in your pictures. **Depth of field** describes the parts of the photograph in front and behind the subject that also appear to be in focus. I use the term *appear* because only one part of the picture can be truly in focus; but in some photographs, the out-of-focus portion is almost as sharp as the rest of the picture. Of course, if you're shooting a landscape far away, the entire image will be in focus because all the depth is at an infinity distance for your lens.

Smaller apertures (remember, that's larger f-stop numbers) help create a progressively deeper depth of field in your pictures, extending the sharp focus zone over a greater distance. When you want to take that picture of your friend standing in front of the Leaning Tower of Pisa and pretending to push it over, use an aperture of around f/16 or smaller so that both friend and tower are in focus.

To understand how changing the aperture affects the depth of field, take a look at the two portraits in Figure 2-8. For the first photo, I used a wide aperture of f/9.0 to extend the range of sharp focus. For the second picture, I used a smaller aperture of f/2.8 to bring the subject into focus and blur the background. Note I had to change the shutter speed as well; if only the aperture were varied, the pictures would have differed in brightness. Lesson 8 explains more about controlling the depth of field using apertures.

Small aperture, deep depth of field Wide aperture, shallow depth of field

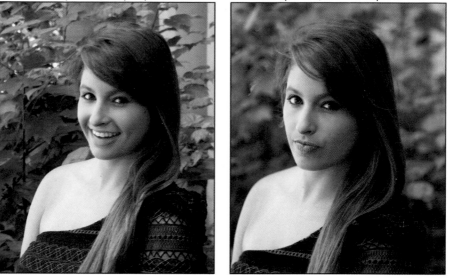

Figure 2-8

Combining shutter speeds and apertures

Shutter speed and aperture are two of the most important exposure controls because they affect how much light reaches your image sensor, making your photo brighter or darker. To make the image brighter, you can use either a slower shutter speed or wider aperture. To make the image darker, you can use either a faster shutter speed or smaller aperture.

Think of the relationship between aperture and shutter speed as a seesaw effect, as shown in Figure 2-9. A fast shutter speed with a wide aperture can gather the same amount of light in the camera as a slow shutter speed with a small aperture, and vice versa. As one setting changes to let in more light, the other setting must change to let in less light to keep the same brightness. For example, if you decrease the shutter speed and let in more light, you raise one side of the seesaw. Then by using a smaller aperture to let in less light, you lower the other side of the seesaw. The result is that the amount of captured light remains the same.

Figure 2-10 shows three pictures, each taken with different exposure settings. They're equivalent because each setting lets the same amount of light into the camera.

LINGO

These seesaw combinations are called **equivalent exposures** because although the settings are different, they're equivalent in that they let in the same amount of light.

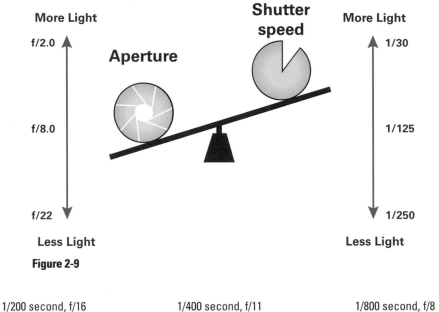

More Light
f/2.0

Shutter speed

Aperture

f/8.0

f/22

Less Light

More Light
1/30

1/125

1/250

Less Light

Figure 2-9

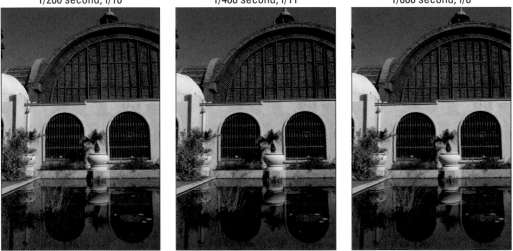

1/200 second, f/16 1/400 second, f/11 1/800 second, f/8

Figure 2-10

There is no single way to set an exposure. Instead, you have several ways to set an exposure that all collect the same amount of light in your camera. Your picture becomes darker or lighter only if you change the shutter speed without offsetting it with an equivalent change to the aperture, or only if you change the aperture without offsetting it with an equivalent change in shutter speed.

In addition to shutter speed and aperture, today's dSLRs also have increasingly wide ranges of ISO, or image sensor sensitivity to light. As a result, you can also change the ISO setting to allow you even more flexibility in adjusting shutter speed and aperture. I discuss ISO in more detail in the section "Choosing ISO Sensitivity," later in this lesson.

Knowing you have several ways to achieve a correct exposure frees you artistically. You can decide how you want the picture to look, allowing just the right amount of motion blur into action shots, for example, or blurring the background of a portrait by using a large aperture.

Setting Shutter Speeds and Apertures in Your Camera

You can set shutter speeds and apertures in different ways by rotating your camera's exposure mode dial (refer to Figure 2-1) to one of several settings, as described in Table 2-1.

Table 2-1	Exposure Mode Settings
Mode	*Description*
Full Auto	This mode sets the shutter speed, aperture, and all settings for focus, color, image quality, and sensitivity (ISO) automatically. (See Lesson 1 for details.)
Scene	The scene modes set the shutter speed and aperture for the correct exposure automatically depending on the type of scene you're shooting. (See Lesson 1 for more on scene modes.)
Programmed autoexposure (P)	This mode sets the shutter speed and aperture automatically for the normal exposure from a range of equivalent exposures. You can change the settings for focus, color, image quality, and sensitivity (ISO).
Shutter Priority autoexposure (S or Tv)	You set a desired shutter speed and ISO, and allow the camera to assign an aperture automatically for the correct exposure.
Aperture Priority autoexposure (A or Av)	You set a desired aperture and ISO, and allow the camera to assign a shutter speed automatically for the correct exposure.
Manual exposure (M)	You set the shutter speed, aperture, and ISO manually. Your camera will display a light meter to help you judge the correct exposure.

Measuring light with your camera's meter

Your camera has a built-in light meter that measures the available light and helps you set exposures. You can see it working by looking through the viewfinder when you're getting ready to take a picture.

You've already taken pictures in Full Auto mode, as described in Lesson 1. In Full Auto mode, you can see the meter operating, but you can't set the shutter speed or aperture yourself. Before you switch to using more advanced exposure modes, take a look at the light meter in operation in Full Auto mode:

1. **Turn on your camera and make sure the exposure mode dial is set to Full Auto.**

2. **While looking through the viewfinder, press the shutter-release button halfway and then release it again.**

 Your camera activates its meter, and you can see two numbers at the bottom of the viewfinder, as shown in Figure 2-11. One of the numbers is the shutter speed, and the other one is the aperture. How these settings are displayed depends on your camera make and model.

3. **Move your camera around, pointing at different scenes.**

 The numbers change as your camera selects different combinations of shutter speed and aperture depending on the available light. If the numbers disappear, press the shutter-release

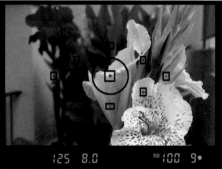

Aperture

Shutter speed

Figure 2-11

button halfway again to reactivate the meter. Note that you can't change these numbers because they are set for you automatically in Full Auto mode.

Using Programmed autoexposure mode

Programmed autoexposure mode (represented by a *P* on your exposure mode dial) is not quite a fully automatic exposure mode, because it allows you to select from a range of equivalent exposures.

Programmed autoexposure mode gives you more control over your other camera options than does Full Auto. Using this mode, you can change how the camera focuses, set the ISO, specify the Raw format for your picture files, change white balance, and even alter the color settings. The pop-up flash does not fire automatically in Programmed autoexposure mode.

To shoot in Programmed autoexposure mode, follow these steps:

1. **Turn the exposure mode dial on your camera to P for Programmed autoexposure, as shown in Figure 2-12.**

 You see the letter *P* appear either in the viewfinder or on your camera monitor screen, indicating that your camera is now in Programmed autoexposure mode.

2. **Look through the viewfinder or on your camera monitor screen to see the shutter speed and f-stop that the camera has selected for you, as shown in Figure 2-13.**

3. **If you want to select a different combination of shutter speed and aperture from a range of equivalent exposure settings, first press the shutter-release button halfway to start the camera meter.**

4. **Then turn the main command dial (refer to Figure 2-12) to the left or right.**

 Rotate the dial to the right for larger apertures and corresponding faster shutter speeds. Rotate the dial to the left for smaller apertures and corresponding slower shutter speeds.

5. **Press the shutter-release button down fully to take the picture.**

 On many cameras, in particular Canons, the exposure resets to the default shutter and aperture settings after the picture is taken.

Programmed autoexposure

Main command dial

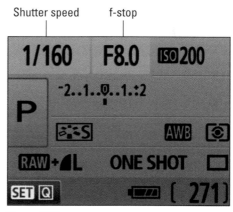

Figure 2-12

Shutter speed f-stop

Figure 2-13

Programmed autoexposure is a useful extension to Full Auto mode, mostly because it allows you access to some of the controls that can't be changed in Full Auto mode but still relies on the camera to automatically set the exposure. Which controls you have access to depends on the make and model of camera you own. I don't find Programmed autoexposure mode very useful in my own photography, because it doesn't provide the ability to lock in a shutter speed or an f-stop.

Here are some advantages Programmed autoexposure mode offers:

EXTRA INFO

On some cameras, you see an asterisk (*) next to the P mode indicator whenever you change the initial setting by rotating the command dial. To return to the default shutter and aperture setting, rotate the command dial until the asterisk (*) disappears, or turn the camera off and back on again.

- Exposures are set automatically for you, so you don't have to worry about setting the correct shutter speed and aperture. It is especially good if you have to take a lot of photos in a mixed-light environment, where you don't want to have to set the camera each time. It's no guarantee that all the images will be spot-on, but it can work quite well.

- You have access to most of the other settings on your camera that aren't available in Full Auto mode.

On the other hand, Programmed autoexposure mode also has its downsides:

- Sometimes it can select an unsuitable shutter speed or aperture, leading to blur in your pictures caused by camera shake or to a background that is out of focus.

- Depending on the light, Programmed autoexposure might not be "looking" at what you're seeing for a subject. For example, if there's a lot of light coming from behind a subject (backlight), the camera might expose for that light instead, making the subject dark.

- Programmed autoexposure mode doesn't give you full creative control of your pictures. Both shutter speed and aperture will change automatically as the lighting conditions change, affecting how your pictures turn out.

Using Shutter Priority autoexposure mode

In Shutter Priority autoexposure mode (usually represented by an *S* or *Tv* on a camera's exposure mode dial), you start down the path of controlling the elements of exposure for yourself by taking full control of the shutter speed. When you've mastered this mode, you'll have greater artistic control of your pictures through your ability to freeze action or create motion blur consistently.

Shutter Priority autoexposure mode allows you to select a shutter speed from the full range of settings available on your camera. After you select a

shutter speed, it's locked in, and your camera will set apertures to maintain the correct exposure as the light changes. This method gives you more creative control over your pictures because you can decide exactly what shutter speed you want to set.

To shoot in Shutter Priority autoexposure mode, follow these steps:

1. **Turn the exposure mode dial to S (Nikon or Sony) or Tv (Canon or Pentax).**

2. **Turn the main command dial to set the desired shutter speed.**

 The shutter speed displayed in your camera's viewfinder changes to the value you selected. Turn the dial to the right for faster shutter speeds, and to the left for slower ones. As you change the shutter speed, the aperture changes automatically to maintain the correct exposure, as measured by your camera's light meter.

3. **Frame your picture in the viewfinder and press the shutter-release button halfway down to attain focus.**

4. **Press the shutter button down fully to take the picture.**

After you've set the shutter speed, it remains fixed until you change it, but the aperture changes automatically to compensate for changes in the light. You therefore have no further interest in the shutter speed setting, but you must keep an eye on the aperture your camera sets automatically.

If you point your camera into a dark area, the aperture opens up to let in more light. If you set too fast a shutter speed, your camera can't open up the aperture far enough to let in sufficient light for a normal exposure, and your pictures end up being underexposed. Likewise, if you point your camera into a bright area with too slow a shutter speed, the aperture closes as far as it can to restrict the amount of light but probably still needs to close more. Your pictures will then be overexposed at the selected shutter speed.

If the shutter speed you selected is too fast or slow for the range of available apertures, Nikon cameras will replace the aperture display with "Lo" or "Hi," as shown in Figure 2-14, whereas Canon cameras will blink the aperture setting as a warning. If you see this warning, you need to adjust the shutter speed until "Lo" or "Hi" is replaced with an aperture setting, or if you have a Canon camera, until the aperture display stops blinking.

I use Shutter Priority autoexposure mode when I'm primarily interested in the shutter speed, but varied lighting conditions make using Manual mode impractical because I would have to keep adjusting my aperture between shots. (Manual mode is discussed later in this lesson.)

Figure 2-14

Shutter Priority autoexposure mode works well for scenes when you need to do the following:

- **Stop the motion of a fast-moving subject:** You can set a fast shutter speed and allow the camera to set the aperture for a correct exposure. For example, when shooting a car race, a fast shutter speed of 1/1000 of a second freezes the motion of cars on the track.

- **Create motion blur:** You can set a slow shutter speed and allow the camera to set the aperture for correct exposure. For example, to capture the image in Figure 2-15, I used a shutter speed of 1/60 of a second, which is fast enough to freeze the helicopter body, but slow enough to show movement in the rotor blades.

1/60 second

Figure 2-15

- **Maintain a certain shutter speed when the light is varied:** You can set the shutter speed and have your camera adjust the aperture

automatically so you don't have to readjust your camera between shots. For example, at a kids' soccer game where players are running around the field into sunny and shady areas, set your camera on Shutter Priority and select a high-enough shutter speed to freeze the fast action. As you point the camera into shady areas, the aperture opens up automatically to let in more light. When you point your camera into brightly lit areas, the aperture closes down to let in less light and maintain the correct exposure.

Shutter Priority autoexposure mode has its drawbacks. The shutter speed you can set while still attaining a correctly exposed picture depends on the available light. If you become distracted and stop watching the aperture, your automatic aperture setting could go out of range resulting in under- or overexposed pictures.

Using Aperture Priority autoexposure mode

In Aperture Priority autoexposure mode (frequently labeled *A* or *Av* on the exposure mode dial), you continue down the path of controlling the elements of exposure for yourself by taking full control of the aperture. When you've mastered this mode, you will have greater artistic control of your pictures through your ability to control depth of field.

Aperture Priority autoexposure mode allows you to set an aperture on your camera from the full range of available settings. After you've selected an aperture, the setting is locked in, and your camera automatically sets shutter speeds to maintain the correct exposure. This method gives you more creative control over your pictures because you can decide exactly what aperture to set to create different looks in your pictures.

To shoot in Aperture Priority autoexposure mode, follow these steps:

1. **Turn the exposure mode dial to A (Nikon or Sony) or Av (Canon or Pentax).**

2. **Turn the main command dial to set the desired aperture.**

 The aperture displayed in your camera's viewfinder changes to the value you selected. Turn the dial to the right for higher aperture numbers (smaller apertures). Turn the dial to the left for smaller numbers (wider apertures). As you change the aperture, the shutter speed changes automatically to maintain the correct exposure, as measured by your camera's light meter.

These instructions describe how to set the apertures on a Canon camera. Some cameras may have a separate dial for the aperture.

3. **Frame your picture in the viewfinder and press the shutter-release button halfway down to attain focus.**

4. **Press the shutter-release button down fully to take the picture.**

After you've set the aperture, it remains fixed until you change it, but the shutter speed changes automatically to compensate for changes in the light. You therefore have no further interest in the aperture setting, but you must keep an eye on the shutter speed your camera sets automatically. If you point your camera into a dark area, the shutter speed could slow down too much. You could then end up with blurring due to camera shake in your pictures. If the shutter speed needs to exceed its slowest setting, your shutter speed display will blink or display Lo. Pictures you take will be underexposed.

If you set a wide aperture and point your camera into too-bright an area, the shutter speed might reach its maximum. If the shutter speed needs to exceed its fastest setting, your shutter speed blinks or displays Hi, as shown in Figure 2-16. Your camera indicates that the light is too bright at the selected aperture, and your pictures will be overexposed. If you see this warning, you need to adjust the aperture until Hi or Lo is replaced with a shutter speed or, if you have a Canon camera, until the shutter speed display stops blinking.

Figure 2-16

I use Aperture Priority autoexposure mode when I'm primarily interested in the aperture, but varied lighting conditions make using Manual mode impractical because I would have to keep adjusting my shutter speed between shots.

Aperture Priority autoexposure mode works well for scenes where you're interested in the following effects:

✔ **An out-of-focus background:** You can set a small aperture number and allow the camera to set the shutter speed for a correct exposure. For example, when shooting a head-and-shoulders portrait, you might use a wide aperture of f/2.8 for a shallow depth of field that makes the background soft and dreamy-looking.

Depth of field is dependent on several factors, not just the aperture. Lesson 8 explains more about controlling the depth of field using apertures.

✔ **Deep depth of field:** You can set a large aperture number and allow the camera to set the shutter speed for a correct exposure. For example, when shooting a landscape with standard and wide-angle lenses, a small aperture of f/16 brings both the foreground and background into focus.

✔ **Maintaining a certain aperture when the light is varied:** You can set the aperture and have your camera adjust the shutter speed automatically so you don't have to readjust your camera between shots. For example, when you want to shoot several portraits, but the sun keeps going behind clouds, you can set the aperture and allow the camera to set the shutter speed for the varied lighting conditions.

The aperture you can set while still attaining a correctly exposed picture depends on the available light. If you become distracted and stop watching the shutter speed, your automatic shutter speed setting could go out of range, resulting in under- or overexposed pictures.

Setting exposures and shooting manually

For experienced professionals, there is no substitute for manual exposure mode, although even pros still use Shutter or Aperture Priority autoexposure mode when the shooting conditions are suitable.

Manual exposure mode gives you complete control over the exposure settings of your camera. If you increase the shutter speed, it's up to you to open the aperture more to compensate for the decreased amount of light entering your camera. Likewise, if you close down the aperture, you have to decide by how much you slow down the shutter speed to compensate. If you change one without a corresponding change in the other, your resulting pictures get lighter or darker.

When you select Manual exposure mode, your camera displays a representation of the light meter in the viewfinder. It's important that you frame your subject in the viewfinder *before* setting the final shutter speed and aperture at which to take the picture. You should frame your subject first because your camera measures light through the lens and bases the light meter reading on the scene in the viewfinder.

To shoot in Manual exposure mode, follow these steps:

1. **Turn the exposure mode dial on your camera to M for manual.**

2. **Look through the viewfinder to see the shutter speed and f-stop together with a scale showing the light meter reading, as shown in Figure 2-17.**

If the display isn't visible, press the shutter-release button halfway to start metering and turn it on.

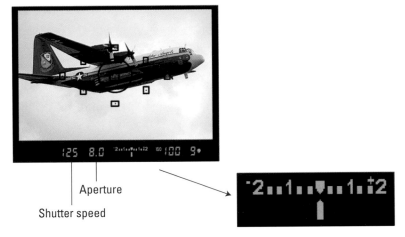

Aperture

Shutter speed

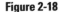

Figure 2-17

3. **Turn the main command dial to set the shutter speed.**

 The shutter speed displayed in your camera's viewfinder changes to the value you selected.

4. **Hold down the Av+/– button (shown in Figure 2-18) and turn the main command dial to select the aperture.**

 The control for setting the aperture varies quite a lot between camera makes and models. Some cameras use a separate dial from the main command dial. Check your manual if you're unsure how this works on your camera.

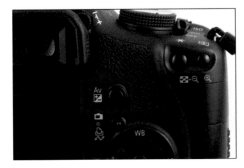

Figure 2-18

5. **Check the exposure using the scale displayed in the viewfinder, as shown in Figure 2-19.**

 You set the standard exposure level by adjusting the meter until the exposure-level mark is centered on the zero indicator. If you set the meter into the plus (+) area, the picture is lighter, depending on how far you set the exposure level mark into the plus side

Zero indicator

Exposure-level mark

Figure 2-19

of the scale. If you set the meter into the minus (–) area, the picture is darker, depending on how far you set the exposure-level mark into the plus side of the scale.

6. **Press the shutter-release button halfway to focus.**

7. **Press it fully to take the picture.**

TIP

I use Manual exposure mode when the light is constant, such as in my studio, or when I want to make critical exposure adjustments for a properly exposed shot. Using your camera in Manual exposure mode is a good way to become familiar with the mechanics of photography — in particular, how shutter speeds and apertures work together.

EXTRA INFO

Nikon cameras have the plus (+) side of the exposure scale to the left of zero by default. Canon cameras have the plus side (+) of the exposure scale to the right of zero by default. These, like many other functions on many dSLR models, can be changed in the camera's custom settings.

For the experienced photographer, using your camera in Manual exposure mode gives you the best control over your exposures. It allows you the freedom to quickly adjust either the shutter speed or aperture between shots and provides a visual display of what's happening to the light.

Manual exposure mode is also essential for setting exposures when using studio flash, because your camera's light meter can read only the available light and won't work with studio flash.

Manual exposure mode is not without its drawbacks, however:

✔ Working with it can be slow and confusing, especially until you become comfortable with how exposure and depth of field work, and intimately familiar with your camera's controls. You have to set both the shutter speed and aperture instead of allowing the camera to control one of them. Once up to speed, however, in Manual mode you can almost play your camera like a musical instrument and truly focus on the images you're creating instead of worrying about camera technicalities.

✔ Where the light conditions change constantly, such as when you're photographing a soccer game on a field that's half sunny and half shade, manual exposure mode can take too much time and concentration to use. You have to keep balancing your meter manually wherever you point your camera, by changing the aperture or shutter speed. In such conditions, Shutter or Aperture Priority exposure mode might be a better choice.

Locking exposure

An exposure lock allows you to set your camera's automatic metering on one area, but use that same metering on another area. For example, say you're not using your flash and you want to take a photo of a person with *backlighting* (light streaming from behind them, such as from a sunny window, making the subject look too dark in the photo). If you point your camera at a darker area of the room, similar to the darkness you're seeing in your subject's face, and you push the Exposure Lock button (typically identified by an asterisk symbol), your camera will remember that setting. If an asterisk appears inside your viewfinder, this feature is set.

This exposure lock stays active for one shot. That means after you set the exposure lock on the darker area, you can then refocus on your subject and take the photo. With backlight, your subject appears properly (or close to it) exposed, and the backlit area is probably overexposed.

For some cameras, the Exposure Lock button and *Flash* Exposure Lock button are the same, but the latter is operational only if the flash is engaged or mounted. On some dSLRs, especially pro models, these are separate buttons, and the Flash Exposure Lock is identified by the letters FEL, while the Exposure Lock button is marked only by an asterisk.

If you want to take another picture with exposure lock, you have to set it again on an area where you like the exposure setting. You can use exposure lock in Programmed, as well as Shutter Priority and Aperture Priority modes, but not in Manual mode.

In order to get both parts of the image — your subject and the light behind him — exposed correctly together, you'll probably want to use a flash with flash exposure compensation, which you find out about in Lesson 5.

Choosing ISO Sensitivity

You've now learned how exposures work by combining apertures and shutter speeds to get the shot you want. But what happens if you can't set the shutter speed or aperture you need for the shot because there isn't enough light? That's where ISO comes in.

In your digital camera, ISO refers to how sensitive your camera's image sensor is to light. What this means is the higher the ISO number, the less light is needed to create a normally exposed picture.

LINGO

ISO stands for **International Standards Organization,** which once brought together all the standards for film speed to create one standard. This has been directly transferred to digital photography.

In a film camera, you can insert film more sensitive to light on dull days and less sensitive to light on bright days to allow your camera to maintain a desired shutter speed or aperture — but changing ISO means changing film. With a digital camera, you simply set the ISO sensitivity setting you desire on the fly, even if you're changing it on every shot.

The ISO setting on your camera is shown as a number, often starting at 100 and going up to as far as your camera model allows. If you double the ISO setting from 100 to 200, you double your camera's sensitivity to light, meaning you then need only half the light to make the same brightness of picture as you do with ISO 100.

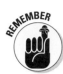

By raising the ISO setting, and thus increasing your camera's sensitivity to light, you can select a smaller aperture, use a faster shutter speed, shoot in dimmer lighting, or all three.

Table 2-2 shows an example of how shutter speed or aperture changes in relation to changing ISO, to get the same image. In each row of the table, you're doubling your ISO and therefore doubling your camera's sensitivity to light. For example, if you double ISO from 200 to 400, you can speed up your shutter from 1/125 to 1/250. Or you can keep the shutter speed unchanged but close down the aperture from f/5.6 to f/8 to halve the light.

Table 2-2	Relative Change to Shutter Speed or Aperture Based on a Change to ISO	
ISO	*Shutter Speed*	*Aperture*
100	60	f/4
200	125	f/5.6
400	250	f/8
800	500	f/11
1600	1000	f/16

In a darker lighting situation, increasing ISO allows you to achieve a faster shutter speed so you can handhold the camera with less chance of camera shake, or allows you to use a smaller aperture for a deeper depth of field.

For example, take a look at the three photos of a cricket ball in Figure 2-20. I took the first at ISO 200, which is the base ISO for the camera I used. At an aperture of f/8, I could achieve a shutter speed of only 1/30 of a second to get a good exposure but one that might be affected by camera movement. By boosting the ISO to 800, I was able to take the second picture using the same aperture at a shutter speed of 1/125 of a second. For the third picture, I kept

the same shutter speed used in the original photo, but this time I used an aperture of f/16 to bring more of the ball into focus by increasing the depth of field. Notice that there is no difference in the brightness of the three photos.

1/30 second, f/8, ISO 200 1/125 second, f/8, ISO 800 1/30 second, f/16, ISO 800

Figure 2-20

For your information, a cricket ball is just slightly smaller and heavier than a baseball. From personal experience, I can tell you it really hurts to have one bowled at your rib cage.

Keeping it on the down low

Unfortunately, increasing ISO involves a tradeoff resulting in an image defect known as digital *noise,* or graininess (a term more commonly used with film). Noise resembles white or colored pixels, especially in shadow areas, and isn't very attractive. The higher the ISO you use, the greater the potential for noise in your photos, as illustrated by the four photos in Figure 2-21.

To gain a correct exposure in difficult lighting conditions, you may have to use a higher ISO setting, which can increase the visible noise. To minimize the potential for noise, use as low an ISO as possible to attain the camera shutter speed or aperture you want. Sometimes that means, for example, if you're taking a night shot, you will have to use a tripod in order to be able to use a long shutter speed with a lower ISO setting (for good quality) and still get that brilliant image of the Milky Way.

Newer dSLR camera models are much better at reducing noise in images, and soon it may not be a concern at all. Meanwhile, I always discipline myself to keep the ISO turned down to the base level, usually ISO 100 for outdoors and ISO 800 or higher for indoors (without a flash). When I'm planning a shot, I decide if it's important to set a particular aperture and shutter speed or if I

can get away with a slower shutter speed or wider aperture. If I can, I change the shutter speed or aperture rather than increasing ISO.

ISO 200

ISO 800

ISO 1600

ISO 3200

Figure 2-21

Your decision to boost the ISO also depends on how you intend to use the pictures you're taking, and how good your particular camera is at producing low-noise shots with different ISO levels — something you'll learn from shooting images at various settings and then comparing them later. If you are using only small-sized pictures for the web or print, high ISO noise may not be as noticeable.

Looking at typical ISO settings

When you hand-hold your camera, some typical ISO settings allow you to attain a faster shutter speed in different ambient light conditions. Table 2-3 contains typical ISO settings. Remember if you don't need to increase the sensitivity of your camera above the base ISO to achieve a desired shutter speed or aperture, don't do it. You can find yourself walking around all day in the bright sunshine with the ISO set to 1600 and then be disappointed when you view the noisy pictures on your computer.

Table 2-3	Typical ISO Settings
Ambient Light Conditions	*ISO Setting*
Sunny beaches or snow	50 or 100
Bright sunny day	100 or 200
Heavy overcast	400
Deep shade	800
Indoors in artificial light	1600 or 3200

Setting ISO sensitivity on your camera

Some cameras allow you to set ISO directly through a separate dial or button in addition to choosing it from the camera menus. Check your camera manual to see how ISO is set for your camera, if necessary. Figure 2-22 shows a typical ISO menu.

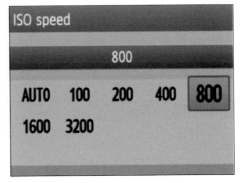

Figure 2-22

You will also find a setting, either as a separate menu item or as one of the ISO choices, enabling the camera to set ISO automatically. I strongly advise you to turn off this setting. If Auto ISO is turned on, your camera will change the ISO itself depending on camera-specific parameters. However, you may not notice when the camera increases the ISO, and that could lead to noisy pictures. For example, when using Aperture Priority exposure mode, you may have a comfortably fast shutter speed in darker lighting conditions because your camera has raised ISO automatically and you were unaware it had done so.

Auto ISO can be confusing, gives you less control over the exposure settings of your camera, and can lead to noisy pictures if you aren't careful. To avoid this issue altogether, you should turn off this setting and set ISO manually.

Reviewing and Making Exposure Adjustments

You now know enough to take almost complete control of the exposure settings of your camera. You can control shutter speed and aperture, capture a

normal exposure using any of the exposure mode settings, and know what to do when lighting conditions make it necessary to change the ISO sensitivity.

But what do you do if, after setting your camera as I described in the previous parts of this lesson, your pictures come out too dark or too light?

Yes, that's right, despite the high level of technology and all the wonderful exposure modes available, your camera still sometimes over- or underexposes your pictures. In the next part of this lesson, I show you how to review exposures, explain why your camera sometimes gets exposures wrong, and show you how to apply that new knowledge to fixing common exposure problems.

Reviewing pictures for exposure

Your camera has a couple of useful tools for helping you review your pictures for exposure issues. The first of these is the histogram, which is a graphical representation of the tones in your picture. Figure 2-23 shows how the histogram is represented on a typical dSLR.

Histogram

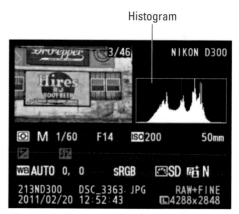

Figure 2-23

Accessing and reading the exposure histogram

To view the histogram for a picture, follow these steps:

1. **Press the Playback button and navigate to your picture on the LCD monitor.**

2. **Press the Display button (shown in Figure 2-24) to toggle through the image information pages for the selected photo.**

LINGO

A **histogram** is a graphical display of the tones in your image. Darker tones are to the left, and lighter tones are to the right. You can think of it as a representation of all the pixels in your picture, sorted into 256 piles of how bright they are starting on the left with the pile of darkest pixels at 0 and moving through the range of tones to the brightest at 255 on the right. The more pixels there are for a particular tone, the higher the stack of pixels. The stacks are close together, so they often resemble a single curve. Pixels that are just too dark or too bright to record an image are thrown into the stacks on the far left and far right of the histogram.

These instructions describe how to display the histogram on many Canon cameras. On some cameras, you can press the up and down multi-selector keys on the back of the camera to display the information screens.

3. **Keep pressing the Display button repeatedly until the histogram is displayed.**

Figure 2-24

If your picture contains a lot of dark areas, known as a low-key image, the histogram stacks up more to the left side of the graph, as shown in Figure 2-25. If your picture has more light areas than dark areas, known as a high-key image, the histogram will stack more to the right side of the graph. If your picture comprises mostly midtones, you will see a histogram stacked toward the graph's midpoint.

Low-key image High-key image

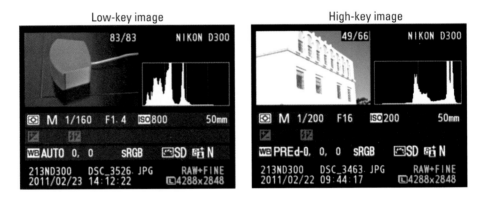

Mostly midtones

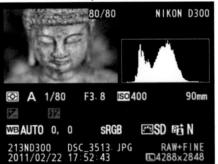

Figure 2-25

Watch out for spikes on either side of the histogram. This can mean that the picture has a lot of dark tones or very light tones that don't register detail, and the picture could be under- or overexposed. Figure 2-26 shows histograms for an underexposed, a properly exposed, and an overexposed subject.

Although useful for determining exposure, the shape of the histogram changes depending on what's in your photograph, so there's nothing immediately useful about reading the shape. Trying to determine whether a picture is good from the shape of the histogram is like trying to read tea leaves in the bottom of a cup to determine the future — something my grandmother claimed to have a talent for, but unfortunately she never got beyond seeing tall, dark strangers in every reading.

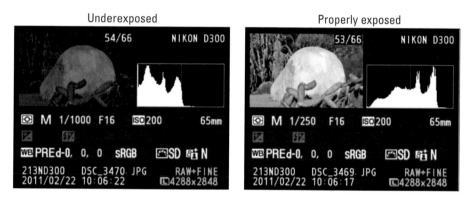

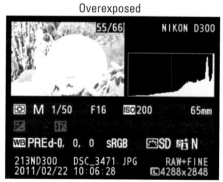

Figure 2-26

Here are a few tips to keep in mind about histograms:

✔ When a spike appears on the highlight side of the histogram, it doesn't necessarily mean the picture is overexposed. Highlights on bright shiny objects, such as cars in the sunshine, naturally overexpose. The rest of

your picture would be too dark if you brought down the exposure until you didn't see these highlights displayed against the right side of the histogram.

✔ Even with low- or high-key images, avoid exposing so there are spikes on the left or right side of the histogram because this represents a loss of detail.

✔ Some proponents of digital photography advocate "exposing to the right." This means that images are exposed so that the lighter tones in the picture are close to the edge of the histogram. This makes maximum use of the dynamic range of your camera, which is the range of tones it can record. When the overexposed image is brought back in post-processing, noise in the dark areas is reduced.

Seeing overexposed highlights

The histogram is very useful, but it doesn't tell you *which* parts of your picture are overexposed, just that some of it may be. This is where the second tool for reviewing exposures comes in handy. By viewing the Highlights display, your camera blinks the parts of the picture where the highlights are too bright. Many photographers refer to this display as the *blinkies*.

To view highlights, press the Display button to select the image information page for the image. (On some cameras, you can press the multi-selector up and down keys to display the information screens.) On the Highlights display, the blinking areas indicate the parts of the image that are overexposed.

Depending on the model of your camera, you may have to turn on the feature in the camera menus, an example of which is shown in Figure 2-27.

Figure 2-27

Some cameras are more conservative than others when it comes to what they show in the Highlights display. It may be that not all the detail is lost in the blinking areas and it can be recovered in post-processing. This is something you have to experiment with to learn how your camera performs.

Understanding your camera's light meter

Understanding how your camera measures light to give you a recommended
exposure is very useful when it comes to predicting scenes that might give
you exposure problems.

You might have heard before that your camera meter sees scenes as 18-
percent gray on average (it's the reflected halfway point of light, on aver-
age, between black and white) and will give you an exposure based on this.
I heard this a lot when I was first studying photography, but it wasn't until
I tried the following experiment that it became clear to me what it actually
meant and how it affected my exposures.

For the purposes of this exer-
cise, I assume your camera
is set to evaluative metering,
sometimes called *matrix meter-
ing*, which is the default meter-
ing method for your camera. I
discuss this metering method in
more detail in the next section.

1. **Gather three pieces of card
 stock, one black, one mid-gray,
 and one white, as shown in
 Figure 2-28.**

 I used a commercial 18-percent
 gray card I bought at the camera
 store and two pieces of card
 from the art store. They don't
 have to be different sizes, but
 the exercise is easier if they are.

Figure 2-28

2. **Photograph each card separately.**

It doesn't make a difference which exposure mode you use, but Aperture Priority is a good choice. Make sure you photograph all the cards in the same light. Fill the complete frame with the card. If your camera won't take the picture because it has trouble finding focus on the plain surface, turn the auto/manual focus switch on your lens to manual focus.

3. **Review the histograms for each image, as shown in Figure 2-29.**

> **EXTRA INFO**
>
> Your camera's autofocus works by finding contrast, lines, and edges of things, so when focusing on a purely white, gray, solid-colored, or black area, it might have a tough time focusing. For example, if you're spending a lazy day shooting the sky and some wispy clouds, your camera might have a hard time focusing — but of course you might, as well! (See Lesson 4 for the lowdown on focusing.)

Figure 2-29

They all look the same! Not only are the histograms virtually identical, but the image of the white card looks the same as the gray card, which looks the same as the image of the black card. Your camera got only one exposure out of three correct.

What happened? Because your camera sees the world as, on average, 18-percent gray, it turned up the exposure on the black card to make it expose as gray, which it assumed the scene to be. It turned down the exposure on the white card to also expose it as gray, which it assumed the scene to be. Only the gray card came out gray, because, on average, a gray card is, well, gray. Look at Figure 2-29 again to see the adjustments your camera made to the shutter speed between the cards to set these exposures.

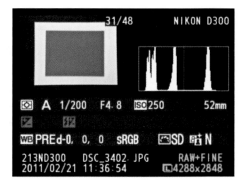

Figure 2-30

4. **Continue the three-card trick by stacking the cards on top of each other and take a picture of all three cards together.**

 The resulting histogram is shown in Figure 2-30. You can now see that the exposure shows three distinct spikes, one for the dark tones, one for the midtones, and one for the light tones. The picture of the cards also shows a much closer rendition of their true brightness.

 What happened this time? The scene is now much closer to mid-gray on average, because it contains an even spread of tones from black through to white. When your camera selected an exposure for the average brightness of the scene, it encompassed both the dark and the light tones and kept the gray tones in the middle.

To photograph the three cards separately and achieve an acceptable exposure for each, try the following:

1. **Set your camera in Manual exposure mode and take a picture of the gray card.**

 Fill the complete frame with the card and balance the exposure reading at the center zero point of the scale by adjusting the shutter speed and aperture. If your camera won't take the picture because it has trouble finding focus on the plain surface, turn the auto/manual focus switch on your lens to manual focus.

2. **Without changing the shutter speed or aperture, take pictures of the black and gray cards individually.**

 Make sure you photograph the cards in the same light as you photographed the gray card. Because you haven't changed any settings, your camera's exposure meter is on the negative side of the scale for the black card and on the positive side of the scale for the white card, indicating that you're underexposing the black card and overexposing the white card.

3. **Review the histograms for each image, as shown in Figure 2-31.**

This time, the histograms show a shift from dark to light, and the pictures of the cards look much closer to their true brightness.

I hope that through this three-card magic trick you have a better understanding of why some of the common exposure problems occur. Your camera does the best it can to provide you with a guide to the optimal exposure based on how it sees the scene, but under some conditions, you can't rely on the normal exposure. Fortunately, it's rare to photograph scenes with as extreme variations in tones as these three cards, but in some situations, you need to adjust the normal exposure for better results.

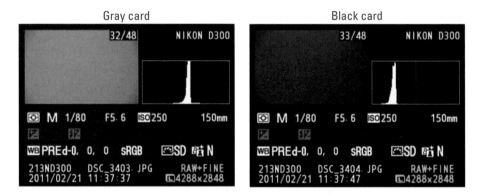

Figure 2-31

Scenes that are, on average, brighter than mid-gray will tend to be underexposed by your camera. This is why your camera turned lily-white snow from white to gray in your photo from that lovely ski trip. Scenes that are, on average, darker than mid-gray will tend to be overexposed by your camera, as in a night scene at a concert.

Selecting a metering mode

Cameras are becoming more and more sophisticated when it comes to measuring the available light and deciding on what an optimal exposure setting should be. This has certainly helped the average photographer take a higher percentage of well-exposed images. It also means that as different camera manufacturers build their proprietary metering methods into their cameras, their dSLR cameras perform differently when measuring and setting an exposure for the same scene.

Most dSLR cameras have three metering methods: evaluative or matrix; center-weighted; and spot metering. You can change the exposure metering mode through the camera menus. Some cameras also include the function as a dial or button on your camera. Figure 2-32 shows a typical menu for selecting the metering mode for a Canon camera.

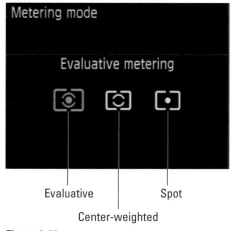

Figure 2-32

Evaluative or matrix metering

Evaluative or matrix metering is the default method on all dSLR cameras and can be used most of the time. It measures segments from the complete frame, as shown by the shaded area in Figure 2-33, and takes into account the brightness, distance, color, composition, and focus point to set the standard exposure. In some cases, it will even recognize backlit subjects and expose them normally — although you really need to review your exposure on the LCD monitor to be sure when shooting something tricky like that.

Evaluative or matrix metering uses many algorithms and an internal database of thousands of shooting situations to try to give you the best exposure for the scene. Camera manufacturers are quite secretive about what happens in their cameras during this process. The result is although this default metering method is very powerful and can be used with confidence most of the time, predicting what it will do isn't easy. I regularly use Canon and Nikon cameras in my workshops. Taking the same scene using these cameras can result in very different exposures using this default metering mode.

Some of the advantages of evaluative or matrix metering are the following:

Evaluative/matrix metering

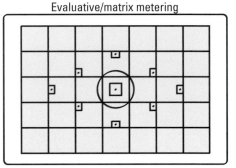

✔ It puts emphasis on the camera focus point, so even if your subject is not centered in the frame, it gives good results.

✔ It can sometimes recognize you're shooting a backlit subject, snow scene, night scene, and so on, and meter a correct exposure without the need for exposure compensation.

Figure 2-33

✔ It's easy to use and frequently results in properly exposed images.

There are also a few disadvantages of evaluative or matrix metering:

✔ It isn't easy to predict what evaluative or matrix metering will do in different situations.

✔ It sometimes gets exposure wrong, particularly when a subject is strongly backlit.

Center-weighted metering

Center-weighted metering measures the entire frame, but emphasizes the center portion of the frame when setting the exposure, as shown in the shaded area in Figure 2-34. This was the common default metering method before it was surpassed by evaluative or matrix metering. Some people still use it because it's a very predictable method of metering with consistent results.

Center-weighted metering

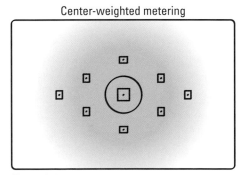

Figure 2-34

The advantages of center-weighted metering are the following:

✔ Center-weighted metering is consistent and predictable.

✔ It works well with subjects centered in the viewfinder where you don't care so much about the background. For example, you might use it to take a picture of a race car driving on a circuit.

There are also a few drawbacks to center-weighted metering:

✔ Center-weighted metering gives priority only to the center of the image in the viewfinder. If your main subject is set to one side, it could be underexposed.

✔ It can be quite inaccurate for multi-tonal scenes such as landscapes, resulting in your having to set exposure compensation more often.

Spot metering

Spot metering measures a very small section of the middle of the frame, around one to five percent of the total viewfinder area (see Figure 2-35). Some Canon cameras also have a partial metering mode, which is like spot metering but with a bigger spot (and especially effective with backlit subjects). Others allow you to increase the size of the spot metering area in the camera menus.

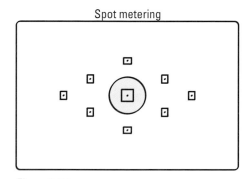

Spot metering

Figure 2-35

There are several pros to spot metering:

✔ It's a very accurate way of metering because it ignores everything except a very small area in the center of your viewfinder.

✔ It's useful for complex scenes where you need to be sure you are properly exposing an important part of the scene.

✔ It's useful for metering a subject that fills only a relatively small portion of the scene, such as a bird on a lake. With other metering methods, the bird can be underexposed, because the glare on the water is factored into the exposure. If you're photographing

EXTRA INFO

Some professional cameras also provide a multi-spot metering capability, where you can set multiple points in your image (up to eight, in some cameras), and then your camera will provide a relative exposure based on the points.

the moon, spot metering allows you to capture more detail, because the dark background of the sky doesn't factor into the exposure.

✔ When a subject's face is heavily backlit by the sun, you can also use spot metering effectively to meter on that person's face.

But there are a few cons to spot metering, as well:

✔ Spot metering requires you to choose the area you're metering carefully. If it isn't a neutral tone, the picture can be over- or underexposed.

✔ Spot metering works only when the subject to be metered is positioned in the center of the viewfinder.

In most cases, evaluative or matrix metering gives you the best results, and it's a good choice as a default metering mode. I often use spot metering when I'm taking portraits in dappled shade, such as under a grove of trees, but most of the time, I find the default metering mode is totally adequate for natural light pictures.

Applying exposure compensation

If you notice your pictures are coming out consistently under- or over-exposed, you can set a feature called *exposure compensation* to correct them. Exposure compensation overrides the camera's exposure, letting you lighten or darken the photograph the camera would have otherwise produced.

The exposure compensation meter is displayed in the camera monitor or viewfinder. Each small division represents one third of a stop. If you lower the value, your image gets darker, and if you raise the value, your image gets brighter, as shown in Figure 2-36.

Most cameras allow up to two f-stops of exposure compensation in the positive or negative direction. Some newer cameras allow five f-stops of exposure compensation, but I suggest if you need five f-stops of exposure compensation, you should work a bit harder on setting your initial exposure correctly.

Exposure compensation is available in Aperture Priority exposure mode, Shutter Priority exposure mode, and Programmed autoexposure mode. It isn't available in Manual exposure mode on Canon cameras, but it is available in Manual exposure mode on Nikon cameras.

EV 0.0 EV −0.3 EV +0.3

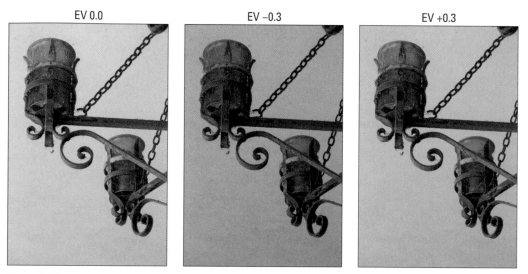

Figure 2-36

 WARNING!

If you're a Nikon user, be aware that in Manual exposure mode, exposure compensation affects the exposure indicator. Your pictures can be under- or overexposed even though your exposure indicator reads zero if you're unaware that exposure compensation is set.

To set exposure compensation on your camera, follow these steps:

1. **Hold down the Av+/− button (refer to Figure 2-18) and turn the main command dial.**

 These instructions describe setting exposure compensation on a Canon camera. There are similar buttons marked +/− on Nikon cameras.

2. **Turn the dial to the right to make the exposure brighter or turn the dial to the left to make it darker.**

 The compensation to the exposure level is displayed in the camera monitor or viewfinder, as shown in Figure 2-37. Each small division represents 1/3 of a stop.

3. **To cancel compensation, hold down the Av+/− button and turn the main command dial to set the exposure level back to zero.**

 Remember to cancel exposure compensation after you've finished with it; otherwise, it will remain set even if you turn off your camera.

I use exposure compensation when I'm shooting a lot of shots with Aperture or Shutter Priority and I need a consistent shift in exposure. I find one f-stop of positive adjustment is sufficient for snow scenes or bright beaches, whereas one f-stop of negative compensation gives me the look I want in cityscapes at night. When setting exposures manually, I simply adjust my exposure indicator away from the zero setting into the positive or negative area of the scale.

Exposure indicator

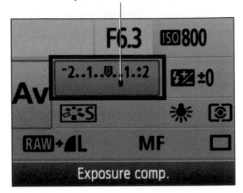

Figure 2-37

Using auto-exposure bracketing

If you aren't quite sure whether you're capturing optimal exposures or you really need to be doubly sure, auto-exposure bracketing is for you. Auto-exposure bracketing enables you to take multiple shots with different exposure settings without having to manually change the settings between shots. The default order of exposures is usually standard exposure first, followed by decreased exposure and increased exposure. Figure 2-38 shows a sample of three pictures taken with auto-exposure bracketing.

Most cameras that have an automatic exposure bracketing feature allow you to use it with the camera's continuous shooting mode. In this mode, you can hold down the shutter-release button to take three shots in quick succession at each of the three exposures. This is repeated for as long as you have bracketing turned on. Without this feature, you'll take three pictures separately at each of the exposures.

On some cameras, bracketing stays turned on until you cancel it, whereas on other camera models, bracketing is cancelled automatically when the camera is turned off.

Standard exposure Decreased exposure Increased exposure

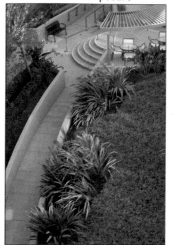

Figure 2-38

You usually set bracketing from your camera menus, as shown in Figure 2-39, but some cameras give you the ability to set it with a button on the camera. You can sometimes select the number and order of exposures to take, as well as how much exposure compensation you want to set.

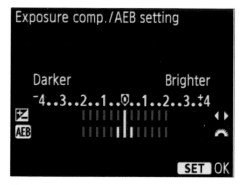

Figure 2-39

COURSEWORK

If your camera doesn't have an auto-exposure bracketing feature, you can still bracket manually by taking one shot at the normal exposure, one slightly darker, and one slightly brighter, typically by adjusting the shutter speed (if you adjust the aperture, you may affect the depth of field of your carefully composed shot). That's basically all that exposure bracketing is. Wedding photographers have been doing it for years, before they had the ability to review exposures instantly using the camera monitor and histogram.

Fixing Common Exposure Problems

Here are a few common exposure problems you may encounter and some tips on how to deal with them.

Dealing with high-contrast scenes

Your camera can't easily capture high-contrast scenes that have extreme light and shade in them. In these cases, the dark areas quickly fade to black, while the very bright areas can overexpose. Figure 2-40 shows a room interior where the extreme contrast between dark internal and light external areas creates a loss of detail and doesn't make a pleasing picture. The histogram shows an abundance of both dark tones and bright tones, showing that detail has been lost in the shadows and highlights.

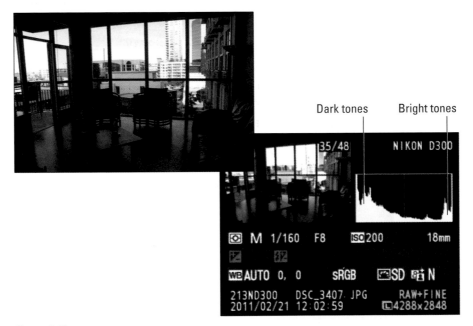

Figure 2-40

This drawback is caused by the limited dynamic range of your camera, which is the range of tones your camera can see before dark areas fade to black and light areas blow-out to white. Unfortunately, your camera can't see the range of visible light you can see. You can see approximately ten f-stops between light and dark areas, whereas your digital camera sees approximately five f-stops. If you present your camera with a scene that's outside of its range, your camera can't capture all the detail.

You can deal with high-contrast scenes several ways:

🗸 **Shoot in the early morning, before sunset, or on a cloudy day.** At these times, you have softer light, shadows are either less pronounced (when it's cloudy) or artistically manageable and desirable (long shadows early or late in the day, also known as the "golden hour"). In these conditions, your camera can capture more details from your subject. Strong sunlight with deep shadows make it difficult to do justice to many subjects and can often have numerous undesirable effects on your photo, such as a "raccoon" lighting effect on a subject's eyes with harsh overhead sunlight.

LINGO

High-contrast scenes are ideal subjects for a special technique called **high dynamic range (HDR)** photography that combines several exposures into one image, allowing a lot more detail to be shown in shadow and highlighted areas. It is usually performed in post-processing, although an increasing number of cameras include a form of HDR image processing in their firmware.

🗸 **Expose the subject to include the parts that are important by exposing the shadows or exposing the bright areas.** Set the exposure compensation or camera light meter into the plus area to bring up the shadows, or place it into the negative side to bring detail into bright areas. This setting doesn't give you more detail in the picture overall, and it may cause significant under- or overexposed areas of the image.

Figure 2-41 shows a scene of a room selectively exposed for inside and outside detail. The histogram for each shot shows how the exposure has been changed to capture inside or outside detail.

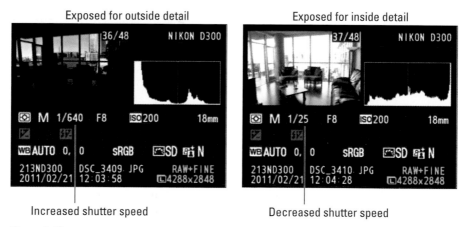

Exposed for outside detail · Exposed for inside detail

Increased shutter speed · Decreased shutter speed

Figure 2-41

Photographing backlit subjects

Backlit subjects, where the background is lighter than the foreground, can result in the subject turning out too dark. Figure 2-42 shows what can happen when you photograph someone where the background is too light.

The problem is the same as already described for high-contrast scenes in general. Your camera is taking into account the bright light of the background and averaging the scene to present an exposure that's too dark for the subject.

You can fix this exposure issue a number of ways:

Figure 2-42

- ✔ **Move your subject, if it's a person, into a situation where the subject has the same level of light as the background.** If the background is in sunlight, put the subject in the sunlight, but make sure you have your back to the sun to light the subject's face. Bright sunlight on faces isn't very flattering, so I try to select open shade.

- ✔ **Put the exposure compensation or camera light meter into the plus area, or use spot metering just on the subject's face.** This technique brightens your subject but also blows out the background.

- ✔ **Turn on your flash.** With the flash, the subject is lit up and exposed in a similar tonal range to the background. Some flashes let you attenuate their brightness with a manual mode of their own, so if yours does, you may want to try using a little less flash on the person when you're simply adding a bit of light — and especially if you're standing relatively close to the subject. (See Lesson 5 for more on flash.)

Exposing for high-key subjects

When taking a photograph of a light object on a light background, known as a *high-key* image, the picture turns out a dull gray. Just as I mention earlier in

the chapter, if you take your camera out in the snow, you might find your pictures look gray and everyone in them looks too dark. Take a picture of a bride in a white dress against a white background, and her dress comes out an unimpressive shade of gray. Figure 2-43 shows a light object photographed with a normal exposure on a white background.

Figure 2-43

This problem is caused by the scene being lighter than 18-percent gray on average. The normal exposure is therefore too dark for this scene. Set the exposure compensation or camera light meter into the plus area to compensate for the meter reading, but make sure you leave some space on the right side of the histogram to prevent loss of detail. Figure 2-44 shows a histogram of a high-key image with two stops of exposure compensation added.

Figure 2-44

Exposing for low-key subjects

Black objects against dark backgrounds, known as *low-key* images because they contain few light tones, can be overexposed and look gray. If you take a normal exposure of a city at night, the sky and buildings can show in your pictures as overexposed, looking almost like daylight with the lights on. Figure 2-45 shows how a black background can look gray when exposed normally.

Figure 2-45

This problem is caused by the scene being darker than 18-percent gray on average. The normal exposure is therefore too light for this scene. Set the exposure compensation or camera light meter into the negative area to compensate for the meter reading, but make sure you leave some space on the left side of the histogram to prevent loss of detail. Figure 2-46 shows a histogram of a low-key image with two stops of negative exposure compensation applied.

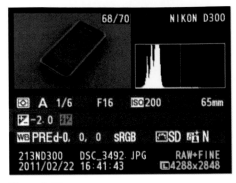

Figure 2-46

 Summing Up

After you complete Lesson 2, you should be a master of exposure:

- ✔ You can control the shutter speed and aperture and can use them creatively, which you'll build on later in Lesson 8.
- ✔ You can adjust your camera's sensitivity to different lighting conditions so you can maintain a fast enough shutter speed.
- ✔ You understand how your camera's meter works and know how it exposes pictures normally.
- ✔ You can tell when your pictures are under- and overexposed by reading your camera histogram.
- ✔ You know how to adjust exposures for different shooting situations and compensate for exposure errors.

Well done! Take time to practice on your camera what you have learned and then come back to start on Lesson 3.

Know This Tech Talk

ambient light: The light that already exists in the scene and surrounds the subject, and hasn't been added by the photographer.

aperture: The lens opening through which light travels to expose the sensor. Usually calibrated in f-numbers with smaller numbers corresponding to wider openings that let in more light, and bigger numbers corresponding to smaller openings that let in less light.

exposure: The quantity of light allowed by your camera's sensor. Exposure is a product of intensity (controlled by the aperture) and duration (controlled by the shutter speed).

ISO: The setting on your camera used to adjust the image sensor's sensitivity to light. A higher ISO setting is used for lower-light conditions, and frequently provides somewhat poorer image quality characterized by digital noise elements. The lower the ISO you can use, the better.

Lesson 3

Working with Color

- Set the white balance on your camera to *ensure your images' colors are true-to-life.*

- *Make sure your pictures are consistent and look great online or when printed* by choosing among color spaces.

- White balance can be adjusted manually to *add warm, natural-looking skin tones to your portraits* and adjust images after shooting in virtually any type of light.

- Picture styles *adjust contrast and color in your images* and reduce editing.

*I*n this lesson, I explain how you can adjust colors in your camera and how you can use settings to create different looks in your pictures. I also show you how to set the white balance so that colors look natural in different lighting conditions.

One of the things I really like about digital photography is how easy it is to manipulate color. With film, you can manipulate color only by using different types of film or by processing color in the lab, which is not within the realm of most photographers. With your dSLR, you can set your camera to compensate for different lighting situations as well as give you the look you want in your color or black-and-white pictures.

Before I tell you how you can use your camera to control color, remember that there is no right or wrong way to use color in your pictures. Some people like vibrant, saturated colors in their pictures, whereas other people prefer muted, de-saturated tones. You can make your pictures look exciting by using strong color, soothing with muted color, or gritty by choosing black-and-white. As an artist, the choice is yours.

Also, many variables are involved when taking pictures with your camera and seeing the exact colors you want represented in a printed photograph, as shown in Figure 3-1. How you perceive color, how your camera captures color, how the picture looks on your computer screen, how the picture prints on paper, and the light in which you view the print form a chain of variables that affect the way color looks in your pictures. In this lesson, I concentrate on how you can set up your camera to capture color.

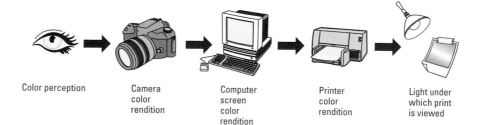

Color perception Camera color rendition Computer screen color rendition Printer color rendition Light under which print is viewed

Figure 3-1

By the end of this lesson, you will be able to set white balance to remove color casts from your pictures and use picture controls to adjust the colors in your pictures for your personal preference.

Setting White Balance

Different light sources produce different color casts when reflected off objects. A candle, for instance, produces warm, amber light. Fluorescent lighting can have a greenish or bluish tinge, which is far from flattering when it falls on a subject. The color of light is measured in degrees of Kelvin. Figure 3-2 shows where different light sources typically fall on the Kelvin scale.

The color temperature of light is the opposite of how photographers typically think of light. Red-yellow light is described as being a warming tint, while blue-green light imparts a cold look to subjects, as shown in Figure 3-3.

A person's eyes and brain are very good at determining white in different light, and people don't typically notice the change in light temperature. Digital cameras can automatically set white balance, but they don't always perform well. They sometimes need help, especially when a light source is mixed, such as a combination of various types of light bulbs and sunlight in a room, or if a light source varies (the color temperature of fluorescent bulbs, for example, fluctuates many times per second).

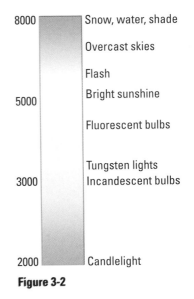

Figure 3-2

8000	Snow, water, shade
	Overcast skies
	Flash
5000	Bright sunshine
	Fluorescent bulbs
3000	Tungsten lights / Incandescent bulbs
2000	Candlelight

LINGO

The number of degrees Kelvin that a light registers is referred is its **color temperature.** Light in the red-yellow end of the spectrum has a lower color temperature than light at the blue-green end of the spectrum, which has a high color temperature. A light source you may typically think of as "warm" is a much lower temperature on the Kelvin scale than a "colder" light source, such as a fluorescent bulb.

White balance is the process of removing color casts so white objects look white and are not tinted by another color. By changing the mix of colors in an image, you neutralize the white, and all other colors shift to look correct.

High color temperature Low color temperature

Figure 3-3

For example, the top image of the orchid buds in Figure 3-4 was taken in natural window light. The bottom image has an additional compact fluorescent bulb light source illuminating it, which adds an unnatural-looking color tint to the orchid buds.

Using standard white balance options

Setting the white balance on your camera is easy, especially when you use one of the standard settings. Your camera selects the white balance automatically when it's set to Auto white balance, the default setting. Auto white balance does a fairly good job, depending on the light source. Most cameras do a better job of setting white balance in natural light than when trying to balance artificial

Figure 3-4

light. Scenes with more neutral elements balance the best. In addition to an Auto white balance setting, you also have options for various light sources (light bulb, sunlight, cloudy outdoor light, fluorescent, as well as a custom option where you enter the specific degrees Kelvin you want).

Many photographers prefer to ignore white balance because they shoot in Raw format and can change white balance when they edit the files on their computer. If doing that works for you, that's perfectly fine. However, keep in mind that when you use Auto white balance, it re-balances every time. You may find that when you're taking a lot of pictures, white balance moves around a lot, making it a headache if you edit a lot of pictures. For example, if you're photographing a bride in a white dress under fluorescent lights, using Auto white balance or even a fixed white balance setting on fluorescent, you may still have different shades of white in multiple shots.

Generally speaking, you can set a more consistent white balance by simply selecting one of the standard white balance options. Table 3-1 shows the white balance settings available for most dSLR cameras.

Table 3-1	White Balance Settings
Symbol	**Light Type**
AWB	Sets white balance automatically
☀	Direct Sunlight
⌂	Shade
☁	Cloudy
💡	Incandescent
🌢	Fluorescent
⚡	Flash
◿◺	Custom or preset
K	A color temperature by Kelvin value

Setting white balance on your camera can be done from the menus, but is usually also available from a button on your camera. To set the white balance for your camera, follow these steps:

1. **Press the White Balance button on your camera, as shown in Figure 3-5.**

 The White Balance screen appears, which should look similar to Figure 3-6.

2. **Choose the desired white balance setting.**

 If you're choosing a color temperature by Kelvin value, select the Kelvin option and then specify the number of degrees Kelvin.

3. **Press Set (or OK) to save your setting.**

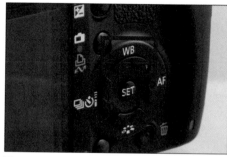

Figure 3-5

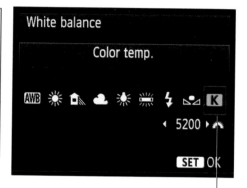

Specify degrees Kelvin

Figure 3-6

Setting white balance by Kelvin value

On many dSLR cameras, you can set the color temperature by dialing in the Kelvin (K) value (as described in the preceding section). On first impression, this seems great because all you have to do is select the temperature of the light source. In practice, setting the color temperature isn't that easy.

If you're using daylight fluorescent bulbs, rated at 5000K, you can select the closest Kelvin white balance setting to this. However, the color temperature of these

If you shoot Raw files, the white balance information is separate from the image data. Therefore, when you bring the files into an editing program that can read Raw files, you can reset the white balance to any value without degrading the picture. If you shoot JPEGs, the white balance data is part of the image and can be changed only by editing the colors in the image. Setting white balance is, therefore, more important if you shoot JPEGs.

types of bulbs varies many times per second, and, combined with any other ambient light source involved, it affects the color temperature of your pictures. If you don't know the color temperature of your light source, setting a neutral white balance by selecting the Kelvin value might not be so easy. Color temperature meters can measure the color temperature of a light source, but they're very expensive. Even then, your camera and the light meter may not be calibrated the same, so a reading on the meter may not completely remove tints when set on your camera.

Setting the white balance by Kelvin value is very useful when you want to get creative with white balance. When you set a white balance or your camera uses Auto white balance, colors are represented as they would be in daylight at 5500K. If your scene is a higher color temperature, you need to remove some blue light from the scene. If the scene is a lower color temperature, you need to remove red light from the scene. Therefore, if you shoot a scene with white balance set to 10000K, you're telling your camera that you're shooting in blue light, so the correction makes it look red, as shown on the left in Figure 3-7. If you shoot a scene at 2500K, you're telling your camera that you're shooting in red light, so the correction makes the scene look blue, as shown on the right in Figure 3-7.

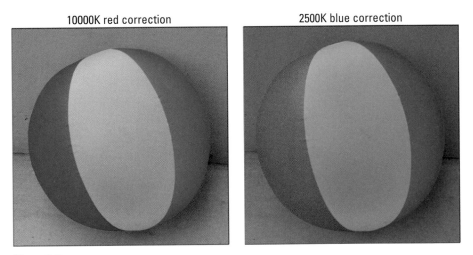

Figure 3-7

You can easily bring some atmosphere to your shots by setting the white balance using the Kelvin white balance option because sometimes correcting your white balance doesn't make your images attractive. Simply set your white balance to around 5500K, and then adjust the value lower if you want to cool down the look, or adjust the value higher if you want to warm up the look. Figure 3-8 shows an example of an image shot with a corrected, natural

color balance to make skin tones look correct, and one in the same lighting with a 2500K color temperature to create a colder, more ominous look.

Color balanced

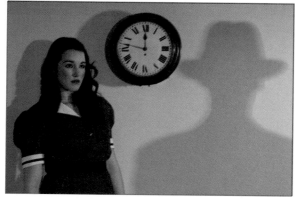

Color temperature of 2500K

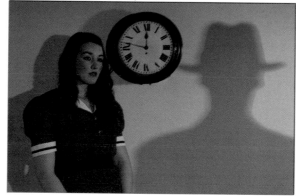

Figure 3-8

Setting a custom or preset white balance

When I shoot portraits or product shots in the studio, where I have control over my lighting, I like to set the white balance to a custom setting because that's the most accurate way of setting it in most cameras. Even though I mostly shoot Raw files, I still set the white balance in the camera. I prefer to capture my images as close as possible to the right exposure and color in my camera rather than relying on fixing it on my computer. If nothing else, setting a specific white balance saves a little time in post-processing.

Creating a custom white balance allows you to set the white balance for the current lighting conditions, and it can be more accurate than using one of the standard white balance options. The way you create and use a custom white balance varies slightly depending on your camera, but in essence, you take a picture of a neutral subject so your camera can use it to set the white balance for subsequent pictures.

After you take a picture of a neutral subject, your camera uses it to set the white balance correction, removing any color cast caused by the light temperature that you photographed the object in. Camera manuals usually instruct you to use a white card as your neutral subject.

Figure 3-9

To set a custom white balance, follow these steps:

1. **Place your neutral subject in the light you plan to shoot in.**

 Don't set a custom white balance in the sunlight and then shoot your pictures in the shade. If you're going to take a portrait, position the person where you intend to photograph him and have him hold the card in front of his face, as shown in Figure 3-10.

2. **Take a picture of the neutral subject.**

Make sure that the subject fills the frame of the picture. If you can't take a picture because your camera can't focus on the blank card, switch your focus to manual for this step by flipping the auto/manual focus switch on your lens to M.

3. **Choose the custom white balance setting in the camera menus and select the picture of your neutral subject, as shown in Figure 3-11.**

4. **Press the White Balance button on your camera (refer to Figure 3-5) and then set the white balance to the custom white balance setting.**

5. **Take another picture of your neutral subject and compare it with the one you just took to set the white balance.**

You see that the new picture has lost any color cast that the preceding one may have contained, as shown in Figure 3-12.

Figure 3-10

Figure 3-11

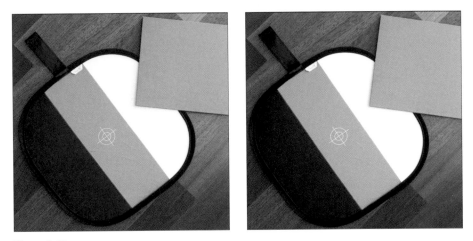

Figure 3-12

Fine-tuning white balance

When using the fluorescent bulb settings, some cameras allow you to refine your choice of bulb further by providing a submenu of bulb types, such as sodium-vapor lamps and daylight fluorescent, as shown in Figure 3-13. Experiment with these settings to find what works best in your particular lighting situation.

Figure 3-13

If you want the scene warmer or cooler than the colors appear with standard white balance, you can fine-tune the white balance by adding more red or blue into the picture.

To fine-tune the white balance,
follow these steps:

1. **On your camera menus, choose
 the white balance setting for
 your scene.**

 You can choose Auto, any of the
 standard settings, Custom, or
 Kelvin (refer to Figure 3-6).

2. **Choose the white balance
 shift menu option, as shown in
 Figure 3-14.**

 The steps for fine-tuning white
 balance vary by camera model.
 Check your manual if you're
 unsure what steps to follow for
 your camera.

3. **Use the right and left multi-
 selector buttons to move the
 square marker along the hori-
 zontal amber/blue axis to shift
 white balance, as shown in
 Figure 3-15.**

 Move the marker to shift white
 balance toward amber (A) for
 warming or blue (B) for cooling.

4. **Use the up and down multi-
 selector buttons to adjust
 along the vertical green/
 magenta axis.**

 Move the marker to shift white
 balance toward green (G) or
 magenta (M).

5. **Press the Set (or OK) button
 to save your white balance
 adjustment.**

 The amount of adjustment
 entered shows in your camera
 menu, and a WB+/– symbol
 shows on the LCD screen and
 in the viewfinder, as shown in
 Figure 3-16.

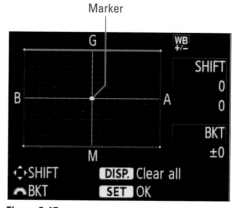

Figure 3-14

Figure 3-15

Figure 3-16

Bracketing white balance

If you're unsure what white balance setting to use for your scene, just like you can bracket your exposures, you can set your camera to record three different files with different white balances for each image shot. To set white-balance bracketing, follow these steps:

1. **Choose the white balance setting for your scene.**

 You can choose Auto, any of the standard options, Custom, or Kelvin (refer to Figure 3-6).

2. **Choose the white balance shift menu option (refer to Figure 3-14).**

 The steps for setting white balance bracketing vary by camera model, so check your manual for the procedure for your camera.

3. **Set the white balance fine-tuning, as described in the preceding section.**

4. **Turn the main command dial to the right to choose up to three increments of bracketing on the amber/blue scale. Turn the main command dial to the left to choose up to three increments of bracketing on the green/magenta scale, as shown in Figure 3-17.**

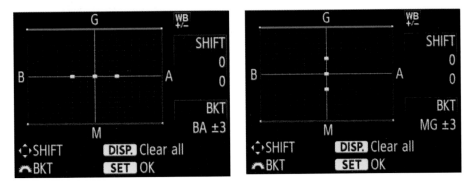

Figure 3-17

5. **Press the Set (or OK) button to apply your changes.**

 When you take a picture, it's saved to your camera memory card three times with different white balances, as shown in Figure 3-18.

Figure 3-18

Choosing sRGB or Adobe RGB Color Space

Your camera can capture images in one of two color spaces: sRGB or Adobe RGB (*RGB* means red-green-blue, the additive or primary light colors making up all light-based color; the *s* stands for standard). By default, your camera uses the sRGB color space. On a rainy day when you have nothing else to do, type into your Internet search engine *sRGB versus Adobe RGB*. The resulting articles will provide you with many hours of interesting reading and probably leave you just as confused as when you started. I'm

LINGO

A **color space** is made up of a subset of the visible spectrum of colors represented using different values of red, green, and blue light. The total colors in a color space are a **gamut** and, in digital terms, can be thought of as the red-green-blue lights you can sometimes see in older TVs that make up full-color images.

not going to add to this confusion by giving you a lot of theory on what color spaces are. Instead, I give you some useful tips so that you can decide on the color space that works best for you.

Adobe RGB chooses its box of colors from a wider range of the visible spectrum than sRGB, as shown in Figure 3-19. The Adobe sRGB range of colors is more closely based on the range of colors that digital devices can display.

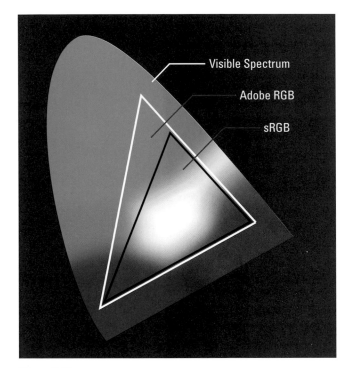

Figure 3-19

Adobe RGB can display more vibrant colors than sRGB because the gamut of available colors is wider. So, why not just set your camera to Adobe RGB and ignore sRGB? The answer isn't that simple. In the next two lists, I discuss the advantages and disadvantages of selecting Adobe RGB over sRGB (the default).

EXTRA INFO

Although Adobe RGB has a wider gamut of colors than sRGB, it does not mean there are more colors in Adobe RGB than in sRGB. Each color is represented by a numeric value in each of three channels — red, green, and blue. Eight-bit color allows 256 values for each channel. When the combinations of values are calculated (256 x 256 x 256), it results in 16.7 million colors available. Adobe uses these values to represent a wider range of colors.

Some advantages of using Adobe RGB are

- You can capture a wider range of vibrant colors in your images.

- Many desktop printers support the wider gamut of Adobe RGB, so if you print at home, you can benefit from using it.

- Commercial printers often prefer Adobe RGB files for images that will be printed.

- If you shoot Raw files, you can decide during editing whether to use Adobe RGB or sRGB, making your decision of which color space to use less critical.

Some of the disadvantages of using Adobe RGB are

- Converting sRGB JPEG files to Adobe RGB doesn't improve your images. If you shot your images using sRGB, you're stuck with the sRGB gamut.

- Most online photo-printing services use only sRGB, so you have to convert your files to send them to the printer.

- Most browsers can't handle Adobe RGB images. If you post your pictures on the web, the colors of your pictures will shift and look less vibrant.

- Working in Adobe RGB is more complicated and requires more management because most editing programs default to editing in sRGB and some can't handle Adobe RGB at all.

The bottom line is that unless you really know what you're doing, stick with sRGB.

If you never use Adobe RGB, your images will still look more than acceptable. Deciding whether to use Adobe RGB is one of personal preference and whether you're prepared to deal with the slight increase in complication it brings.

You can change the color space through your camera menus, as shown in Figure 3-20.

EXTRA INFO

RGB, whether Adobe or sRGB, refers to additive colors generated by a light source. When you print an image, the colors used are called *subtractive* colors. Instead of being based on red-green-blue, they are based on CMYK — cyan, magenta, yellow, and key (black). While most home printers don't specify CMYK and you can print a picture without worrying about primary colors (except perhaps when you change your print cartridges), your printer is making the change for you. Although many commercial printers accept RGB-based files, they do the conversion or accept files you convert to CMYK before submitting them for print. See Lesson 7 for more on printing.

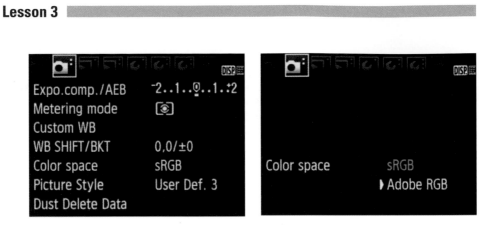

Figure 3-20

Adjusting Color with Picture Styles

Picture styles make the colors in your pictures look good whether you're shooting portraits or landscapes. Some settings boost colors, whereas others make them muted or even monochrome. The picture styles can be edited to your personal preference, and some cameras provide a way that you can set up and name your own. Table 3-2 lists picture styles for a typical dSLR camera.

LINGO

Picture styles, or **picture controls,** allow you to set special color treatments and sharpening for your pictures.

Table 3-2	Typical dSLR Picture Styles
Name	*Description*
Standard	Is a general-purpose picture style suitable for most scenes and prints.
Vivid	Produces strong, saturated colors suitable for flower scenes or if you prefer a more saturated look to your colors.
Portrait	Gives a warmer look to skin tones and also turns down sharpening for a softer look. If you use the Portrait scene control on the exposure mode dial, it uses this picture style.
Landscape	Creates vivid blues and greens in your landscape shots. If you use the Landscape scene control on the exposure mode dial, it uses this picture style.
Neutral	Has reduced contrast, low-color saturation, and reduced in-camera sharpening. It's intended to be used when you want to do most of your image editing on your computer.

Name	Description
Faithful	Is found on Canon cameras and is designed to give a faithful representation of colors under daylight conditions. It's intended to be used when you want to do most of your image editing on your computer.
Monochrome	Creates black-and-white images. If you capture Raw files, you can change them back to color on your computer. Even though there's no color shown in monochrome, the files generated are just as big. Sometimes it's better to shoot in color and then convert your images to black-and-white later. Then you have the option of keeping or using the color version, too.

Your choice of picture style is simply an artistic one. However, if you're shooting JPEGs, you'll probably be more satisfied with the styles not specifically designed for computer-editing purposes.

Picture styles often do away with the need to edit your pictures on your computer by capturing images with the look you want, but if you count on spending lots of time on the computer in post-processing, the Faithful and Neutral picture styles are handy. Editing JPEGs and re-saving them can degrade your images, particularly if you re-save the same image multiple times; using picture styles when you shoot JPEGs can help save a step or two during post-processing.

Setting a picture style

To choose a picture style for your images, follow these steps:

1. **Choose Picture Style from your camera menus, as shown in Figure 3-21.**

 The Picture Style submenu appears, as shown in Figure 3-22.

Expo.comp./AEB	⁻2..1..0..1.⁺2
Metering mode	
Custom WB	
WB SHIFT/BKT	0,0/±0
Color space	sRGB
Picture Style	Standard
Dust Delete Data	

Figure 3-21

2. **Choose the picture style you want by pressing the up and down multi-selector buttons, and then press Set (or OK).**

Editing a picture style

You can edit the picture styles to fine-tune the settings to your preferences, including the sharpness, contrast, saturation, and color tone.

To edit a picture style, follow these steps:

1. **Choose Picture Style from your camera menus.**

2. **Choose a picture style and then press the Disp button to display the picture style details screen, as shown in Figure 3-23.**

 Keep in mind that the options available for your camera may be a little different. Consult your manual if necessary.

3. **Choose the setting you want to change, and then press the left and right multi-selector buttons to adjust the setting.**

Picture Style		○, ◑, ☭, ◐
S Standard		3, 0, 0, 0
P Portrait		2, 0, 0, 0
L Landscape		4, 0, 0, 0
N Neutral		0, 0, 0, 0
F Faithful		0, 0, 0, 0
M Monochrome		3, 0, N, N
DISP. Detail set.		**SET** OK

Figure 3-22

Detail set.	**S** Standard
◐ Sharpness	0 +—+—+—+—+—7
◑ Contrast	◘+—+—+◯+—+—◘
☭ Saturation	◘+—+—+◯+—+—◘
◐ Color tone	◘+—+—+◯+—+—◘
Default set.	**MENU** ↩

Figure 3-23

Moving the sliders to the left decreases the sharpness, contrast, and saturation; moving the sliders to the right increases these settings. Moving the Color Tone control to the left puts more red into skin tones; moving this slider to the right puts more yellow into skin tones.

You might think that if you turn up sharpening to the full amount, your images will look crisper, better, and more in-focus. Actually, sharpening merely exaggerates the contrast along the edges in your image. If you over-sharpen an image, white halos appear at these edges, as shown in Figure 3-24.

If you shoot JPEGs, it's very hard to fix images over-sharpened in the camera, so don't get over-enthusiastic with in-camera sharpening.

4. **(Optional) To reset the picture style to the factory default settings, choose Default Set.**

5. **Press the Menu button to save the edits you've made.**

Original image Oversharpened image

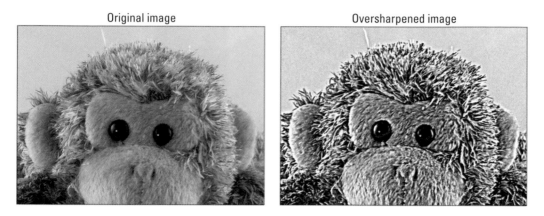

Figure 3-24

Playing with the Monochrome picture style

I call out the Monochrome picture style for special attention because you can put filter effects and tints into your images with it. I really like taking black-and-white images because it takes me back to when I'd work patiently on print after print in the developing lab until I achieved that one striking black-and-white print I was looking for. Although I don't do that anymore, I still capture monochrome JPEG images on my dSLR using the settings available in the picture styles.

Even though you can shoot in color and convert to black-and-white later, some photographers believe shooting *in* black-and-white is a very different artistic experience and affects the type and quality of images you take. Just remember that if you shoot in a monochrome picture style, you can't add color later!

Some cameras have extra picture styles, allowing you to choose a particular look for a black-and-white photo based on different types of film. Most, though, just let you select filter and toning effects for your images, as shown in Figure 3-25.

The Filter Effect setting mimics traditional color filters used with black-and-white film. The filters cut out different wavelengths of light to give more contrast to the parts of your image containing color, as shown in Figure 3-26.

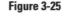

Figure 3-25

Color image — Red filter — Green filter

Figure 3-26

The Toning Effect filter lets you put a color tint into your pictures, such as sepia for an old-fashioned look, as shown in Figure 3-27.

Although most dSLR cameras give very bland and unsatisfying results when using the Monochrome picture style alone, editing the settings lets you capture high-contrast, black-and-white images. I slid the Contrast setting to the maximum right and selected a green filter in the monochrome filter effect menu selection to capture the picture shown in Figure 3-28.

Figure 3-27

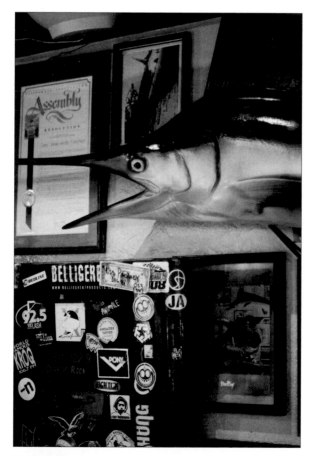

Figure 3-28

Defining your own picture styles

Most cameras allow you to create custom picture styles based on the preset picture styles supplied with your camera. More advanced dSLR cameras allow you to save them to your camera memory card and share them with other compatible cameras. Some camera manufacturers, such as Canon and Nikon, have extra picture styles you can download from their websites. The number of custom picture styles you can have on your camera varies by camera make and model. For example, you can have three picture styles saved on a Canon EOS Rebel T2i and up to nine picture styles saved on a Nikon D7000. I've covered some of the most common ones, and now it's up to you to explore what your camera offers and how you can custom-set your own!

The steps to create a custom picture style vary by camera, but you can follow these general steps:

1. **Choose Picture Style from your camera menus.**

2. **From the Picture Style submenu, choose one of the user-defined picture styles, as shown in Figure 3-29.**

3. **Press the Disp button to display the picture style on the details screen.**

4. **Choose the picture style to base your user-defined style on and adjust the settings for the look you want, as shown in Figure 3-30.**

5. **Press the Menu button to save the edits you've made.**

Picture Style	
N Neutral	0, 0, 0, 0
F Faithful	0, 0, 0, 0
M Monochrome	3, 0, N, N
1 User Def. 1	Standard
2 User Def. 2	Standard
3 User Def. 3	Portrait
DISP. Detail set.	SET OK

Figure 3-29

Detail set.	3 User Def. 3
Picture Style	Portrait
Sharpness	0 +++++++7
Contrast	−+++0+++0
Saturation	−+++0+++0
Color tone	−+++0+++0
	MENU

Figure 3-30

 # Summing Up

You can control the color settings in your camera:

- ✔ You can use the standard white balance settings in different lighting conditions to remove color casts from your pictures.

- ✔ You can use a neutral subject to set the white balance manually in mixed lighting situations.

- ✔ You can decide whether you want to set your camera for the sRGB or Adobe RGB color space.

- ✔ You can select from a variety of picture styles to enhance the colors and tones in your images.

- ✔ You can capture great black-and-white images.

Experiment with these settings on your camera and then come back to start on Lesson 4.

Know This Tech Talk

Adobe RGB: An RGB (red-green-blue), light-based (additive) color space invented by Adobe designed to better represent the colors achievable on a CMYK printer.

CMYK: Cyan-magenta-yellow-key (black), the basic subtractive colors used in printing inks.

color cast: Various types of light sources, when reflected off of objects, produce different color casts.

Kelvin: A unit of measure based on the absolute temperature scale used to describe the color temperature of light. Daylight is 5500K.

sRGB: The standard red-green-blue color space and the default setting on your camera used to define colors so that you can have consistent color from shooting all the way to printing. It was created by Microsoft and HP in the mid-90s.

Lesson 4

Getting Fancy
with Focus

- ✔ Learning how to use autofocus allows you to *capture sharp portraits and fast-moving sports.*

- ✔ Choosing an autofocus point means you can *focus on a subject* even if it's placed at the edge of the viewfinder.

- ✔ Using manual focus lets you *focus even in low light.*

- ✔ Controlling depth of field allows you to *bring the foreground and background into focus* on landscape subjects or *isolate a subject* so other parts of the image are blurred.

until fairly recently, professional cameras didn't have an autofocus feature — everyone thought autofocus was too slow and unreliable to cope with demanding shooting situations. However, this is no longer the case; autofocus is now the main way to focus any dSLR. Manufacturers have designed autofocus lenses that are fast, silent, and accurate when focusing in most situations.

When you focus your camera, you can either do so manually by turning the focus ring on your lens until the subject looks sharply focused, or rely on the autofocus system. Whichever method you use, you need to consider where in the scene to put the focus and whether the subject is moving. The advances in autofocus mean you can choose where to set your focus in the viewfinder and whether you want to track a subject with focus when it moves.

In this lesson, I show you how simple it is to use the autofocus system in your camera so you can capture in-focus shots with confidence in many shooting situations. I also explain how to use manual focus and when you may find it useful.

LINGO

Focus and depth of field are closely linked. **Focus** means how sharp your subject and other parts of your photo appear, based on your looking through the viewfinder and either manually or automatically focusing on that subject. Typically your subject should be in focus; in some cases, that might be the entire photo — such as in the case of a landscape shot of a distant mountain range — without any foreground showing. Or you may shoot a sports team sitting on tiered bleachers, and you want everyone to be in focus. On the other hand, if you're trying to isolate a football quarterback's face in the midst of lots of players on the field, a busy background, and other elements, you may want your focus to be solely on him and nothing else. By working with **depth of field** and how your camera focuses, you can achieve either effect intentionally, improving your overall photo composition.

With a shallow depth of field, parts of the scene in front and behind what you focus on appear blurred, as with the football quarterback. With a deep depth of field, most of the scene in front or behind the subject or an entire image can appear in focus, such as with the team sitting on the bleachers. Lesson 2 explains how the aperture affects the depth of field. I explain in this lesson how other factors affect depth of field.

Choosing an Autofocus Point

To use the autofocus system on your camera, first make sure that the *focus mode* (auto or manual) is set for autofocus. To do that, check that the auto/manual focus switch on the lens is set to autofocus, which is typically labeled M/A or AF, as shown in Figure 4-1. This setting allows the camera to engage the autofocus motor on the lens. Different lenses have a variety of settings and ways of labeling them, so be sure to read your lens manual before shooting.

Auto/manual focus switch

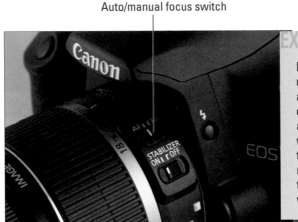

EXTRA INFO

If you know you'll always shoot using automatic focus, it might be a good idea to place a little piece of black electrical tape over the auto/manual focus switch. This way you'll never accidentally flip the switch to manual and then realize after shooting some important shots that the focus wasn't working!

Figure 4-1

Next, press the shutter-release button halfway down to enable autofocus. When you look through your viewfinder, you can see a number of focus points, indicated by brackets or squares, as shown in Figure 4-2. These are the areas of the frame the camera analyzes to establish focus. When you press the shutter-release button halfway, these autofocus points light or blink to tell you where the camera is focusing.

Focus points

Selected focus point

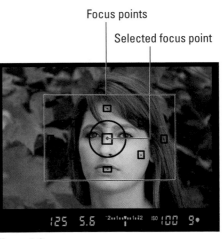

Figure 4-2

Some photographers change the button on their camera used for autofocus, which can be done by applying custom settings available in most cameras' menu systems. Typically, the alternative that camera manufacturers offer is to use one of the buttons on the upper-right corner of the back of the camera. This is so every time you take a photo, the camera doesn't refocus — but technically it is still in autofocus mode.

Every camera is different when it comes to how many focus points you can choose from. Some dSLR cameras have just 3 points; some cameras have 9; and a top-of-the-range dSLR can have more than 60.

Focusing with Automatic Autofocus (AF) Point Selection

Most cameras automatically use the Automatic Autofocus (AF) Point Selection mode when the exposure mode dial is set to Full Auto or most of the other automatic exposure modes, as long as your lens is set to use autofocus. In any of these modes, your camera automatically analyzes all the focus points when establishing focus. The camera typically selects the focus point covering the subject that's closest to you.

Automatic AF Point Selection is the simplest way to use autofocus because your camera chooses the focus point for you. Your camera may guess where you most likely want to set focus and then place it there; however, it may not be precisely where you want it. If you see several focus points highlighted in your camera viewfinder, they're close to the same distance from your camera and in the same focus plane, and moving the camera slightly and refocusing, or changing your focal length some, will affect the camera's guess. The areas within these focus points are all sharply in focus when you take the picture.

If you're using Full Auto or any of the automatic exposure modes, your camera always uses the Automatic AF Point Selection mode, and that can't be changed. If you're using

EXTRA INFO

If your camera supports AF Point Expansion, your camera can expand beyond a single AF Point if it has trouble finding detail or if it loses track of the subject (for example, if your subject moves out of the picture). In this case, you will see other focus points illuminate in the viewfinder, clustered around where the camera thinks it sees more of the subject. This is an excellent option when shooting sports, busy children or moving pets, and other subjects that make it hard to stay focused.

one of the advanced exposure modes, you can either set Automatic AF Point Selection or choose Manual AF Point Selection (described in the next section).

To select Automatic AF Point Selection mode in one of the advanced exposure modes, follow these steps:

Focus Point Selection button

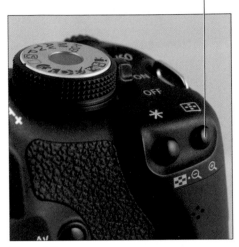

Figure 4-3

1. **Make sure the exposure mode dial is set to one of the advanced exposure modes, such as Programmed Auto, Shutter Priority, Aperture Priority, or Manual.**

2. **Press the Focus Point Selection button on your camera, which should look similar to the one in Figure 4-3. If your camera doesn't have a Focus Point Selection button, choose the setting from the camera menus.**

 The current AF Point Selection mode displays on your camera's LCD screen.

3. **Press the Focus Point Selection button repeatedly until the screen shows that Automatic AF Point selection is set, as shown in Figure 4-4.**

4. **Take a picture.**

Figure 4-4

The Automatic AF Point Selection mode is easy to use and beneficial for people with limited photography experience. This mode has a couple of drawbacks, however:

✔ It's a little slower to focus with than when you manually select a focus point. It may not be enough for you to notice right away, but I don't want to miss *any* shots while waiting for my camera to focus.

✔ It's sometimes difficult to make your camera focus on the subject you want, especially when an object is closer to the camera than the subject, as shown in Figure 4-5. In this photo, the camera focused on the leaves framing the subject because they were closest to the lens. To resolve this focusing issue, you can select a focus point manually, as described in the next section.

Choosing a single focus point

When shooting in one of the advanced exposure modes, you can control what your camera focuses on. You can then manually select the focus point you want the camera to use to keep the subject in sharp focus.

Figure 4-5

To manually select a focus point, follow these steps:

1. **Set the exposure mode dial to one of the advanced exposure modes.**

2. **Press the Focus Point Selection button (refer to Figure 4-3). If your camera doesn't have a Focus Point Selection button, choose the setting from the camera menus.**

 The Manual AF Point Selection mode is selected on your LCD screen, which should look similar to Figure 4-6.

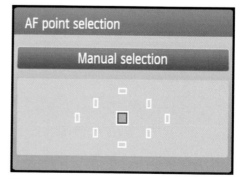
Figure 4-6

3. **Use the up and down or right and left multi-selector buttons to select the focus point you want to use.**

You can also use the main command dial to cycle through the available focus points.

4. **Look through the viewfinder and place your selected focus point over the subject, as shown in Figure 4-7.**

5. **Press the shutter-release button halfway to focus.**

The focus indicator illuminates in the viewfinder when focus is achieved.

6. **Take your picture.**

Selected focus point

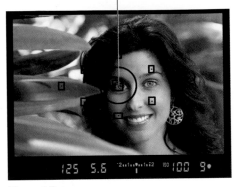

Figure 4-7

Choosing an Autofocus Mode

You can choose how your camera focuses when you press the shutter-release button halfway. This setting is called the *autofocus mode*, and it controls whether your camera locks focus when you press the shutter-release button halfway or continues to adjust focus.

The autofocus mode you choose depends on whether your subject is moving or stationary. dSLR cameras generally have at least two autofocus modes:

EXTRA INFO

Focus points come in two types. Some use cross-type sensors, and some use horizontal or vertical sensors. Cross-type sensors assess horizontal and vertical lines in the focus point, whereas the others assess only horizontal lines or only vertical lines. Cross-type sensors are more sensitive, especially when used with lenses with a maximum aperture bigger than f/2.8. The number of cross-type sensors varies depending on the camera, but usually at least the center focus point is a cross-type sensor. In low-light situations or other difficult autofocus conditions, using the center focus point often gives better results.

✔ One Shot (Canon) or Single-Focus (Nikon) for stationary subjects

✔ AI Servo (Canon) or Continuous-Servo (Nikon) for moving subjects

Canon has a third mode on a few of its dSLR models — called AI Focus — which attempts to detect whether the subject is moving, and then sets the appropriate autofocus method. It switches the autofocus mode from One Shot to AI Servo if a stationary subject starts moving after you focus on it.

AI Focus can be useful when you shoot subjects that are stationary for now, but may start moving without warning. I prefer not to rely on AI Focus because it can be slower to detect movement and, therefore, less accurate than AI Servo.

One Shot or Single-Servo autofocus is good for general use when subjects are mostly static, such as portraits, landscapes, and still life. In this autofocus mode, when you press the shutter-release button halfway, the camera focuses once on the subject at the selected focus point and locks focus until you press the shutter-release button fully. If I walk around a city taking pictures, I'll probably use One Shot or Single-Servo autofocus.

AI Servo or Continuous-Servo autofocus is designed for moving subjects, such as animals or children running, sports, or for shooting from a moving car. When you press the shutter-release button halfway, the camera focuses on the subject at the selected focus point, and then will continue to adjust focus as your subject moves around in the frame. If I'm on a boat taking pictures of a yacht race in the harbor, I'll probably use AI Servo or Continuous-Servo autofocus.

EXTRA INFO

Another, less common autofocus mode on some cameras is Face Detection mode. I first saw this mode on point-and-shoot cameras, but it's available on an increasing number of dSLR cameras. In this mode, autofocus attempts to identify a face in the picture and place focus on it. If the picture contains several faces, the one closest to the camera is chosen for the focus.

COURSEWORK

Whether your camera has a few basic autofocus modes or many more sophisticated ones, the best way to decide what mode to use is to experiment with the modes in different situations.

Focusing on a Stationary Subject

When you and your subject are both stationary, you can set your camera to focus when you press the shutter-release button halfway and lock the focus until you press the shutter-release button fully to take the shot. To do this, you set the autofocus mode to One Shot or Single-Servo autofocus.

Setting up to shoot stationary subjects

To set your camera to One Shot or Single-Servo autofocus, follow these steps:

1. **Press the Focus Point Selection button on your camera. If your camera doesn't have a Focus Point Selection button, you can change the focus mode using the camera menus.**

The autofocus mode screen
appears on the LCD display.
Figure 4-8 shows the screen you
may see on a Canon camera.

2. **From the autofocus mode
screen, choose One Shot or
Single-Servo, depending on
your camera model.**

Your camera is now set to focus
on static subjects.

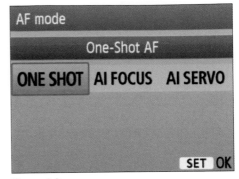

Figure 4-8

Shooting a stationary subject

After you've selected One Shot or
Single-Servo autofocus, you can focus
on static subjects with confidence.
Follow these steps to take a photo of
a stationary subject:

1. **Choose a focus point for your
subject or set the focus point to
the center point.**

2. **Frame the subject in the view-
finder with the focus point over
the subject.**

3. **Press the shutter-release button
halfway to lock the focus.**

Focus confirmation light

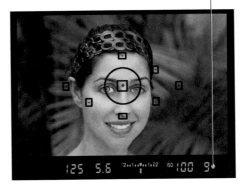

Figure 4-9

When focus is achieved, depend-
ing on your camera, you may
hear a soft beep, and the selected focus point briefly flashes red. If your
camera is focused, a focus confirmation light shows in the bottom of the
viewfinder, as shown in Figure 4-9.

4. **While still holding the shutter-release button halfway, you can
reframe the subject in the viewfinder without affecting the focus,
which is locked on the subject. (See Figure 4-10.)**

5. **Press the shutter-release button fully to take the shot.**

By default, your camera is designed not to take a picture using One Shot/ Single-Servo autofocus if it can't achieve focus. When you try to take the shot, your camera will try to focus, but you won't hear a beep, and the picture won't take. The cause is probably one described in Table 4-1.

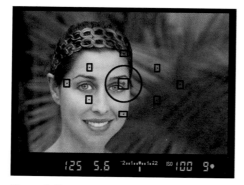

Figure 4-10

EXTRA INFO

Because the focus is locked, you don't have to keep the focus point over the subject. An alternative to choosing a focus point is to keep the center focus point selected, place your subject in the center, press the shutter-release button halfway, and then reframe the shot with the subject off to one side.

Table 4-1	Causes of Autofocus Failure
Cause	*Description and Solution*
Not enough contrast in subject	Blank walls, clear blue sky, commercial gray cards, or subjects lacking detail give your camera no information to focus on. Use manual focus, or try to find an edge at the same subject distance from the camera on which to focus and reframe your shot.
Not enough light	If the ambient light is very low, autofocus can't see what to focus on. Some cameras have an autofocus lamp that tries to aid autofocus in dark situations, so if your camera has one, make sure it's activated. Try using manual focus.
Strongly backlit or reflective subjects	The sun shining into your lens or reflections off a polished car can confuse autofocus. Try holding your hand out to shade the sun from the lens until you acquire focus.
Near and far subjects covered by an autofocus point	Bars in front of an animal's cage, shooting through vegetation or a fence, and other similar objects can make it difficult to focus beyond them. Make sure you use single point autofocus. If you have a zoom lens, zoom in a little so the bars appear more widely spaced, and you can place the focus point on the animal between them. Try using manual focus.
Repetitive patterns	Sometimes the windows in a tall building, the keys on a computer keyboard, or the pattern of a fence can confuse autofocus. Try shifting the point a little or use manual focus.

When taking portraits of people, focus on their eyes initially and reframe the shot, if necessary. The eyes have good contrast and lines for easy autofocus, and crisply focused eyes always make your portraits look better even if the depth of field is shallow.

Practicing with autofocus on a stationary subject

To really get a good grasp on what's happening with One Shot/Single-Servo focus on a stationary subject, try the following exercise:

1. **Check that your camera is set up for shooting a stationary subject:**

 • *Choose a single focus point at the center of your viewfinder.*

 • *Set the autofocus mode to One Shot or Single-Servo.*

2. **Have someone stand about 10 feet away and then frame her in the viewfinder. Zoom in for a tight shot and press the shutter-release button halfway to focus on her.**

3. **Keep the shutter-release button pressed halfway and ask the person to walk toward you.**

 The person goes out of focus as she walks toward you, as shown in Figure 4-11. I locked focus on my subject while she was 10 feet away. Now she's much closer.

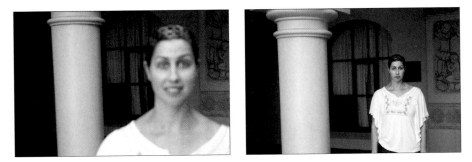

Figure 4-11

As long as you keep the shutter-release button pressed halfway, the focus doesn't change. This allows you to reframe the shot without worrying about choosing a focus point. If, however, you let go of the shutter-release button after you reframe, your camera refocuses on whatever the selected focus point covers when you take the shot.

In the top-left picture in Figure 4-12, I attained focus with the center focus point and took the shot. In the top-right picture, I attained focus with the center focus point and then reframed before taking the shot, keeping the shutter-release button pressed halfway. In the bottom picture, I did the same as in the top-right picture but did not keep the shutter-release button pressed halfway. My camera refocused over the shoulder of my subject.

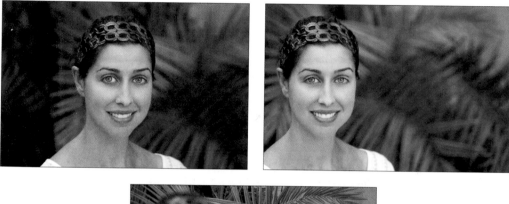

Figure 4-12

Focusing on a Moving Subject

The ability to track and focus on a moving subject is probably the biggest autofocus advantage (see Figure 4-13). Autofocus doesn't always get it right, but most of the time, it does a great job. When autofocus fails, it's often because of user error. The more sophisticated your camera, the more complex and greater the options available for helping track a moving subject with autofocus. In this lesson, I concentrate on the basic system available in the majority of dSLR cameras.

When you or your subject is moving, you can set your camera to focus when you press the shutter-release button halfway and then track the focus on the moving subject until you press the shutter-release button fully to take the shot. To do this, set the autofocus mode to AI Servo or Continuous-Servo autofocus.

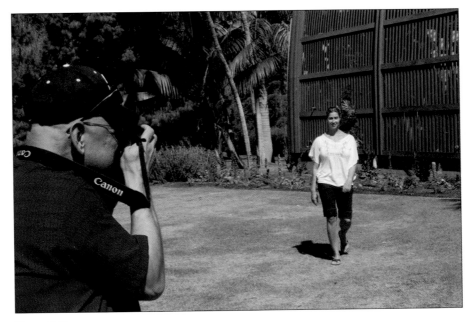

Figure 4-13

Setting up to shoot moving subjects

To set your camera to AI Servo or Continuous-Servo autofocus, follow these steps:

1. **Press the Focus Point Selection button on your camera. If your camera doesn't have a Focus Point Selection button, you can change the focus mode using the camera menus.**

 The autofocus mode screen appears on the LCD display (refer to Figure 4-8).

2. **From the autofocus mode screen, choose AI Servo or Continuous-Servo, depending on your camera model.**

Your camera is now set to focus on moving subjects.

Shooting a moving subject

After you've selected AI Servo or Continuous-Servo autofocus, you can follow these steps to take a photo of a moving subject:

1. **Choose a focus point for your subject or set the focus point to the middle point.**

2. **Frame the subject in the viewfinder with the focus point over the subject, as shown in Figure 4-14.**

3. **Press the shutter-release button halfway to start focus.**

 By default, your camera is designed to take a picture using AI Servo or Continuous-Servo autofocus even if it can't achieve focus. So, you won't hear the beep of the focus locking, and the focus indicator won't light in the viewfinder.

Focus point over subject

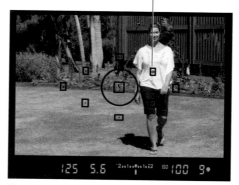

Figure 4-14

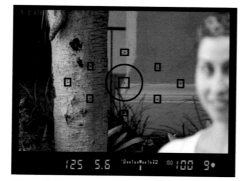

Figure 4-15

4. **Keep the autofocus point over the moving subject.**

5. **Press the shutter-release button fully to take the shot.**

With most Canon cameras, if you have difficulty keeping the autofocus point over the moving subject, set Automatic AF Point Selection to select your autofocus point (as described earlier in the lesson). Then, make sure you put the center focus point over your moving subject before you press the shutter-release button halfway. Even if your subject strays from the center point, as long as it's covered by a focus point, your camera tracks it.

Practicing with autofocus on a moving subject

To really get a good grasp on happens with AI Servo/Continuous-Servo focus on a moving subject, try the following exercise:

1. **Check that your camera is set up for shooting a moving subject:**

 • *Choose a single focus point at the center of your viewfinder.*

 • *Set the AF mode to AI Servo or Continuous-Servo.*

2. **Have someone stand about 10 feet away, and then frame her in the viewfinder. Zoom in for a tight shot and press the shutter-release button halfway to focus on her.**

3. **Keep the shutter-release button pressed halfway and ask her to walk toward you.**

 The person stays in focus because your camera predicts focus and adjusts as she moves toward you.

As long as you keep the shutter-release button pressed halfway, the focus continues to try to track the subject. You can't focus and reframe by holding down the shutter-release button, as you did with One Shot or Single-Servo autofocus. Even with the camera's ability to track a subject, if your focus point shifts too far away from your initial subject, it refocuses on something else it sees.

By default, you can take pictures in AI Servo or Continuous-Servo mode even if your subject isn't in focus. When shooting fast-paced action, some shots might be out of focus but not at the expense of missing a shot because you're waiting for your camera to focus.

Focusing Manually

Even though your camera has a sophisticated autofocus system, you can still focus manually. To focus manually, follow these steps:

1. **Set the auto/manual focus switch to manual, as shown in Figure 4-16.**

 If the switch on your lens is labeled M/A and M, you can focus manually with the switch set to M/A, but the autofocus system still operates when you press the shutter-release button halfway. Therefore, if you want to focus only manually, set the switch to M.

2. **Look through the viewfinder and turn the focus ring on the lens (shown in Figure 4-16) until the scene is in focus.**

Focus ring Auto/manual focus switch

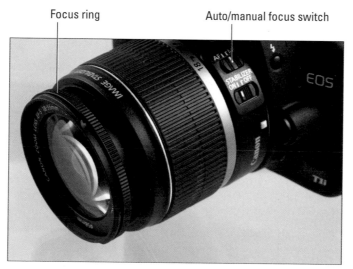

Figure 4-16

If you press and hold the shutter-release button halfway while you focus, the focus confirmation light appears in the viewfinder when focus has been attained at the active focus point. On some cameras, the active focus point also briefly flashes red.

3. **Press the shutter-release button fully to take the picture.**

Manual focus is useful when the following is true:

✔ Autofocus won't perform, such as in low-light or low-contrast scenes.

✔ You have limited time to take a picture and can't wait for your camera to focus (some after-market lenses, in particular, take longer to focus than original manufacturer equipment). For example, if you know someone will appear in a window at any moment for a split second, you can focus manually and be ready to take the shot in an instant.

✔ You perform close-up or macro photography and want to place focus accurately on a small subject.

✔ You don't want your camera to keep focusing between shots. For example, if you take pictures of a speaker giving a lecture, you can set your focus manually and capture every gesture without waiting for your camera to focus each time. In this case, you can use custom settings to change the button used for focusing (as described earlier in this chapter).

✔ You want to set focus to the hyperfocal distance for landscape photography, as I describe in the later section "Focusing at Hyperfocal Distance for Landscapes."

EXTRA INFO

Although I rely mostly on autofocus when focusing my camera, manual focus is still important for some applications. Modern cameras aren't particularly easy to focus manually because some have smaller viewfinders than their 35mm SLR counterparts. They also lack the split-prism focusing system that made it easier for someone with my aging eyesight to judge when something was properly in focus.

Understanding Factors That Affect Depth of Field

Understanding and controlling depth of field is important to gaining creative control over your photography. I introduce depth of field in Lesson 2 when I explain setting apertures for exposure, and here I give you a bit more detail on this subject.

By focusing on your subject using the autofocus methods I describe in this lesson, your subject is crisply in focus, and you can turn your attention to depth of field, which is controlled by the following three factors (see Figure 4-17):

Effect on depth of field	Deeper \longleftrightarrow	Shallower \longleftrightarrow
Aperture size		
Focal length of lens		
Camera-to-subject distance		

Figure 4-17

- ✔ Aperture

- ✔ Focal length

- ✔ Camera-to-subject distance

I describe these three factors in more detail in the following sections.

Factor 1: The aperture affects depth of field

The first factor that affects depth of field is the lens aperture. Wide apertures (remember, that's a small f-number, like f/2.8) make for pictures with a shallower depth of field, as shown on the left in Figure 4-18. Small apertures (remember, that's a large f-number, like f/16) make for pictures with a deeper depth of field, as shown on the right in Figure 4-18. As you can see, focus is extended over a greater distance in the photo on the right.

I'm likely to use wider apertures, such as f/2.8, when taking portraits and small apertures, such as f/16, when shooting landscapes.

f/2.8 f/16

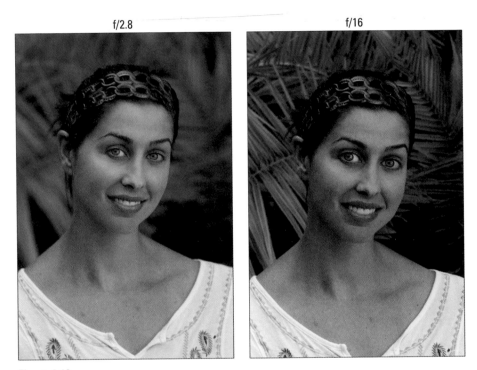

Figure 4-18

Factor 2: The focal length affects the depth of field

The second factor that affects depth of field is the lens's focal length. (See Lesson 6 for more on focal length.) Without getting too technical, the focal length controls the *angle of view* (how much of a scene the lens "sees") by magnifying it more as you zoom in or showing an extended, wide-angle view as you zoom out. In addition to controlling the angle of view, as you increase the focal length the depth of field appears shallower.

Figure 4-19 shows two photos of the same scene taken with an aperture of f/5.6. I took the left photo at a focal length of 38mm, and shown in this

cropped version, the leaves in the background are more clearly visible. As I increased focal length to 70mm in the right photo, only the subject is in sharp focus.

f/5.6, 38mm (cropped) f/5.6, 70mm

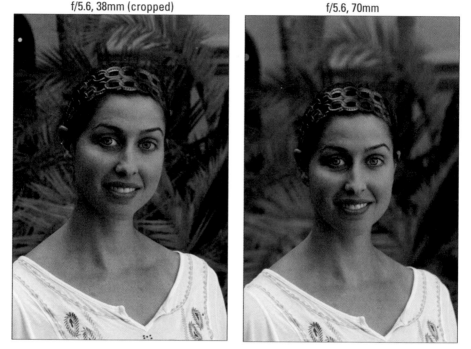

Figure 4-19

Factor 3: The focus distance affects the depth of field

The closer the subject you're focused on, the shallower the depth of field. Macro photographers are fully aware of this factor when taking pictures of subjects, such as insects or flowers. Because the photographer is very close to the subject, the depth of field is very shallow, and he must use a small aperture to maximize the depth of field available. I used a small aperture of f/16 to take the photo in Figure 4-20, but was able to achieve a very shallow depth of field by taking it from a close distance.

Suddenly, controlling the depth of field in your pictures doesn't look so easy, does it? Students often ask what f-stop should be used for portraits. The

answer isn't straightforward because several factors are at play. In fact, the camera you use also has an effect on the depth of field because a camera with a smaller sensor displays a deeper depth of field than a camera with a larger sensor, everything else being equal. (See Lesson 6 for more on sensors.) This is why you have a hard time getting a shallow depth of field on a small point-and-shoot camera with a small sensor than on a professional dSLR with a larger sensor.

The aperture on your camera doesn't close down to the chosen size until just before your camera takes the picture. This way you can view the scene through the viewfinder using the whole diameter of your lens, making the scene as bright as possible. However, you can't normally see the effective depth of field through the viewfinder.

f/16

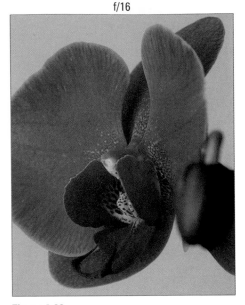

Figure 4-20

Many dSLR cameras have a Depth-of-Field Preview button that closes down the aperture to the correct size so that you can look through the viewfinder and preview the depth of field. If the aperture is very small, the viewfinder view darkens because you're viewing only the scene through a small opening in the lens. I find this button useful when doing macro photography in which the depth of field is very critical; however, most of the time, I just take a test picture and check the depth of field on my camera's LCD screen.

Focusing at Hyperfocal Distance for Landscapes

In many instances, if you focus on the most distant subject in a landscape, the foreground will be acceptably in-focus, especially if you use a small aperture, such as f/16. Sometimes, you may have foreground subjects in your landscape shots and want to be sure you capture the sharpest focus you can across the full scene.

GO ONLINE

The depth of field can change dramatically with just a few minor adjustments to the factors that affect it. To help you understand how the factors work together, depth-of-field calculators are available for free on the Internet. For smartphone and tablet users, several depth-of-field applications can be installed on your phone or tablet and used in the field. pCAM is a popular application available in the Apple App Store for iPhone, iPod touch, and iPad. DOF, or simply Depth of Field Calculator, is available in BlackBerry AppWorld, and DOFMaster is available for Windows at www.dofmaster.com.

When you want to achieve the maximum depth of field for a lens, you need to focus it at the hyperfocal distance. At this distance, everything from half the focus distance to infinity appears in focus, as shown in Figure 4-21. The hyperfocal distance changes depending on the focal length of the lens you're using and the aperture setting.

LINGO

Hyperfocal distance is the closest point your lens can focus where other objects far away, at an infinity distance, will still be focused sharply.

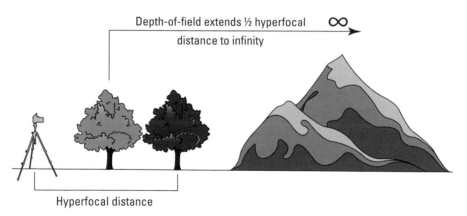

Figure 4-21

Wide-angle lenses with small apertures have a short hyperfocal distance and, therefore, give the deepest depth of field when focused at the hyperfocal distance. For example, on a typical dSLR, an 18mm lens set at an aperture of f/16 when focused at about 3 feet shows everything in focus from 1.5 feet to infinity. The online tools and charts available help you easily calculate the hyperfocal distance for the focal length and aperture of your lens.

Your camera lens probably features a distance scale, where it shows the distance in feet and meters at which you're focused. If you want to set the hyperfocal distance, use manual focusing and the distance scale on your lens to set the focus distance, as shown in Figure 4-22.

Distance scale

Figure 4-22

Old lenses used with film cameras often had a depth-of-field scale so you could set focal distance and aperture to achieve various depth-of-field scenes. Today's cameras do not use a depth-of-field scale and don't show all the distances authored on the scale, so you mostly have to estimate hyperfocal distance to achieve the focus and depth of field you want. Focus a little beyond the hyperfocal distance when estimating the focus point on your camera to ensure you focus all the way to infinity and half the distance from the focus point.

When you look through the viewfinder, near subjects look out of focus because you're viewing the scene through the widest aperture setting until you press the shutter-release button or the Depth-of-Field Preview button.

Manually setting your focus to hyperfocal distance for the focal length and selected aperture ensures that everything is in focus from infinity to half the focus distance. This is very handy if you want to capture street scenes without bringing the camera to your eye. As long as a subject is at least half the focus distance away, it's in focus.

Taking a Portrait with a Shallow Depth of Field

When I ask people in my workshops what they want to achieve for their photography, many say that they want to get that out-of-focus look to the background in their portraits, but have difficulties in doing so with their camera.

If you bought your dSLR as a kit with a lens included, the lens supplied is typically an 18 to 55 millimeter zoom lens with a maximum aperture of f/3.5 when used at a focal length of 18mm, gradually closing down to a maximum aperture of f/5.6 when used with a focal length of 55mm. This is a good general-purpose lens for shooting landscapes, buildings, and people, but

some photographers have difficulty achieving a portrait with a shallow depth of field. A couple of factors work against you:

- ✔ When zoomed in, the maximum aperture available is relatively small and is not conducive to achieving a shallow depth of field.

- ✔ The zoom factor is not very large at the 55mm maximum focal length, which also works against your ability to achieve a shallow depth of field.

To take a portrait with this lens, you therefore want to maximize the factors that result in a shallow depth of field.

To take a shallow depth-of-field portrait with your kit lens, follow these steps:

1. **Position your subject as far from the background as possible, as shown in Figure 4-23.**

Figure 4-23

You won't see an out-of-focus background if you stand your subject close to a door or a wall because it will still be within the sharp range of the depth of field.

2. **Choose Aperture Priority mode or Manual mode, and then set the aperture to f/5.6 to help make the depth of field as shallow as possible.**

If you're using Manual mode, don't forget to balance your camera's meter by adjusting the shutter speed for the chosen aperture.

3. **Zoom all the way in to the 55mm focal length to help make the depth of field as shallow as possible.**

4. **Step toward the subject as close as you can while framing the composition you want.**

5. **Press the shutter-release button halfway to focus on your subject and then press it fully to take the picture (see Figure 4-24).**

Figure 4-24

If you can't balance your meter or you see the shutter speed flashing or indicating *LO,* insufficient light is available, and you need to turn up the ISO or move to a brighter area.

At a focus distance of 8 feet from your subject, you achieve a depth of field of approximately 1.5 feet. If you're focusing on a group of people, step back a little, zoom out a little, or close down the aperture slightly to achieve a deeper depth of field, and make sure everyone is in focus.

TIP

If you're photographing lots of people, such as at a party or sporting event, use an aperture setting roughly equal to or slightly larger than the number of people you're photographing. In other words, if it's a group of four people, try f/5.6. For eight or nine people, try f/11. This should give you sufficient depth-of-field for the group to all be in focus. Remember to adjust your shutter speed and ISO to ensure you have enough light!

COURSEWORK

The best way to get a feel for how depth of field works is to find a scene and practice with different apertures, different distances from the subject, and varying amounts of zoom until you're thoroughly familiar with how your camera and lens perform for different scenes.

 Summing Up

After reading this lesson, you're in complete control of your camera focus. You can

- ✔ Set the focus point manually to capture a sharp image wherever your subject is in the viewfinder.

- ✔ Set the autofocus to focus on static subjects or quickly moving subjects.

- ✔ Focus manually when needed.

- ✔ Control the depth of field to make backgrounds blurred or in focus.

Experiment with these settings on your camera and then start on Lesson 5.

Know This Tech Talk

autofocus: The system your camera uses to automatically focus on the subject.

focus: To adjust the lens to produce a sharp image.

focus point: The point at which your camera is most sharply focused, and onto which you want your camera to lock for a continuous focus while moving.

manual focus: Setting the focus on your lens visually, and turning the focus ring on the lens to accurately and sharply focus on an object. This is especially useful in low light and for macro subjects.

Lesson 5

Using Your Camera Flash

✔ Use flash to *capture more pictures in low light.*

✔ Flash can help *remove unflattering shadows* from portrait subjects in bright sunlight.

✔ *Set your flash manually* to help to become a more creative master of your photography.

✔ Combine flash with slow shutter speeds to *take portraits at night* and capture the background scene.

Most entry-level and consumer dSLR cameras have a built-in flash, which you can pop up when you want to use it. Higher-end, professional dSLRs often don't have a built-in flash because camera manufacturers figure professionals who use these cameras would never bother with it. Instead, the pros use an external flash or studio strobes.

In this lesson, you find out how to use the built-in flash functions with your camera and how you can use flash to improve your pictures in certain conditions. A built-in flash is no substitute for the power and versatility of an external flash attached to the hot shoe of your camera, but it can still be a useful tool for taking better pictures, especially portraits.

By the end of this lesson, you will be able to identify situations where it might be useful to add some light from your camera flash. You will also know how to control your camera's built-in-flash and get the best results.

Getting to Know Your Camera Flash

Your camera flash is housed on the top of your camera, and you can activate it by pressing the Flash button, which typically has a lightning bolt icon on it, as shown in Figure 5-1. Pressing this button causes the flash to pop up and get ready to fire.

In Full Auto mode, the flash pops up automatically if your camera detects low available light conditions. This, of course, limits your creative control over

how your pictures look. In the scene modes, the flash may or may not be activated, depending on the scene setting. Most cameras, for example, don't fire the flash on the Landscape setting or Sports setting because they assume any subject is too far away to be affected by light from the flash.

Therefore, to control whether you want the flash to fire, you need to put the camera in Programmed Auto mode, Shutter Priority mode, Aperture Priority mode, or Manual mode. (See Lesson 2 for more on these advanced exposure modes.)

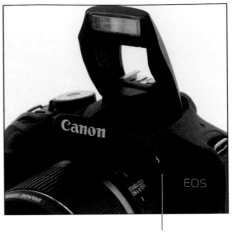

Flash button

Figure 5-1

Many cameras let you set the power of your built-in flash automatically or manually. By default, your camera is set up for automatic flash with Through the Lens (TTL) flash metering. Each manufacturer has its own slightly different TTL system for flash metering, but all do a relatively good job of giving you a flash exposure that works in most cases. (See "Investigating flash range," later in this lesson, for more on TTL flash metering.)

Deciding when to use flash

There are no strict rules on when you need to use flash. As an artist, you can decide to add flash to your picture whenever you think it will look better with it. However, don't bother turning on your flash if your subject is out of flash range (see "Investigating flash range," later in this lesson). All that does is use the camera battery faster.

Typically, you shouldn't count on your flash being useful on any subject beyond about 10 feet from your camera. The light dissipates quickly with distance, especially because it's spreading out as well as shooting forward. Ever seen all the flashes going off at a concert or in a sports stadium when the lights go down? The only thing those flashes are illuminating are the people sitting in front of them; but all the twinkly lights make for a nice star-like effect for everyone else in the audience!

Here are some typical situations when using flash can improve your pictures:

✔ Use your flash indoors in low light when you can't achieve a shutter speed fast enough to handhold your camera. By turning on your camera flash, you can add enough light to the subject to make faster shutter speeds possible, although your camera typically limits you to 1/250 of a second or slower when your flash is operating.

✔ When your subject is backlit, using flash can help improve your photo. Without flash, a backlight subject can often look too dark against a bright background, as shown on the left in Figure 5-2. Using flash brightens the subject and helps you avoid silhouettes in your portrait shots, as shown on the right.

Without flash With flash

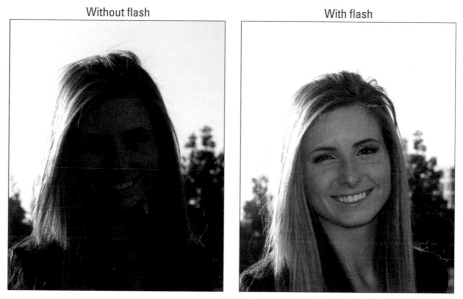

Figure 5-2

✔ When strong shadows cut across your subject, such as when you're taking a portrait outdoors, using your flash helps to fill in the shadows. In Figure 5-3, you can see dark pockets of shadow on one side of the subject's face and hair in the left photo. In the right photo, the photographer used flash to fill in the shadows and make them less distracting.

Without flash

With flash

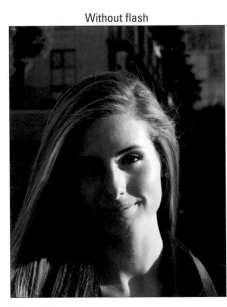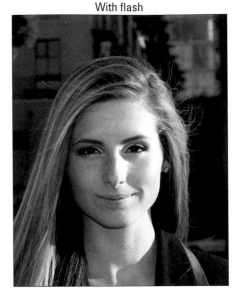

Figure 5-3

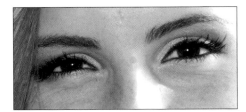

Figure 5-4

Understanding flash sync speed

To find out what the flash sync speed is for your camera, follow these steps:

1. **Select the fastest shutter speed you can in Manual mode or Shutter Priority mode.**

2. **Press the Flash button to make your flash pop up (refer to Figure 5-1).**

On some cameras, you may have to press the shutter-release button halfway before the flash will pop up.

3. **Find the shutter speed in the viewfinder, which is the flash sync speed.**

 The flash sync speed is usually 1/250 of a second or slower; for some professional dSLRs, it can be up to 1/320. You can select shutter speeds slower than the flash sync speed, but not faster.

To explain why this is so, I need to explain a little bit about how the shutter works on your camera. Your camera shutter consists of two individual sliding doors, or *curtains*. The first curtain slides open to let light reach the sensor. When the time is up, the second curtain slides across the sensor in the same direction as the first, closing off light.

During the time that the sensor is revealed, the flash fires to light the scene. The duration of the flash is very short at around 1/2000 of a second, so if you take a picture at 1/60 of a second, the flash has plenty of time to fire and light the scene.

You might wonder why if the flash duration is so short, it can't be used with really fast shutter speeds. The answer is in how the curtains on your shutter work. At faster shutter speeds, the second curtain begins to close before the first curtain is fully open so that the whole sensor is never fully revealed at once. If the flash is fired, only part of your picture will appear lit by it, as shown in Figure 5-5. Your camera, therefore, restricts the maximum shutter speed you can use with flash to correspond with a speed where the sensor is fully revealed when the flash is fired.

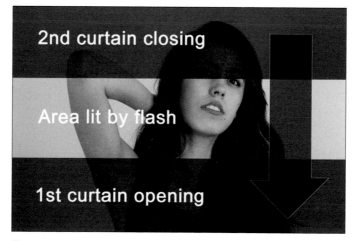

Figure 5-5

Investigating flash range

When your camera is set up to use through-the-lens (TTL) flash metering, it automatically selects the flash power setting that adequately lights the subject and balances the exposure with the ambient light in the scene. Your camera does this by sending test light pulses before the shutter opens and uses the readings to set the flash power, as shown in Figure 5-6. How close you are to the subject, what aperture you've set, and the ISO setting on your camera have an effect on the flash power set by the TTL system.

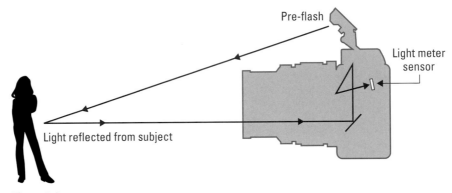

Figure 5-6

REMEMBER

The wider the aperture or higher the ISO setting, the more sensitive your camera is to the light from the flash and the greater the flash range.

The range of your built-in flash varies from a minimum of 2 to 3 feet. A small aperture or low ISO reduces the effective flash range, and a large aperture or high ISO increases the effective flash range. (See Figure 5-7.) Usually, around 8 feet is a good working distance for general portraits, but more than 10 feet is usually inadvisable for fully illuminating a subject in diminished light, especially for a built-in flash (external flashes often are more powerful and can range farther).

EXTRA INFO

The inverse-square law, when applied to photography and flashes, determines how quickly light falls off a subject as it moves away from the point of illumination. Doubling the distance to the subject reduces its illumination to one quarter. Therefore, to keep the subject just as brightly lit when the distance doubles, you would need four times the flash power. Double the distance again and you need 16 times the flash power. This means that the effect of your flash quickly diminishes as the subject moves away.

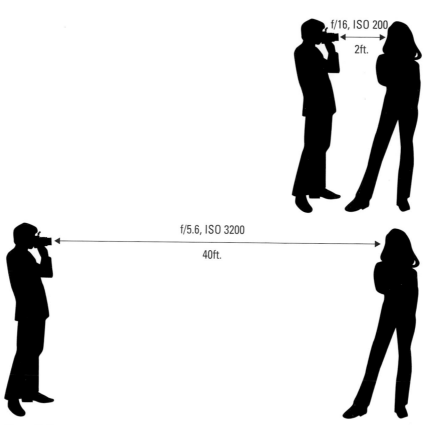

Figure 5-7

Table 5-1 shows how flash range varies for a Nikon D300 when used with different ISO and aperture combinations. You should be able to find a similar table for your camera model in your manual.

Table 5-1				Aperture, ISO, and Flash Range for a Nikon D300		
Aperture ISO Setting					**Range**	
200	**400**	**800**	**1600**	**3200**	**Meters**	**Feet/Inches**
1.4	2	2.8	4	5.6	1.0–12.0	3'3"–39'4"
2	2.8	4	5.6	8	0.7–8.5	2'4"–27'11"
2.8	4	5.6	8	11	0.6–6.1	2'–20'

continued

Aperture ISO Setting					Range	
200	**400**	**800**	**1600**	**3200**	**Meters**	**Feet/Inches**
4	5.6	8	11	16	0.6–4.2	2'–13'9"
5.6	8	11	16	22	0.6–3.0	2'–9'10"
8	11	16	22	32	0.6–2.1	2'–6'11"
11	16	22	32	N/A	0.6–1.5	2'–4'11"
16	22	32	N/A	N/A	0.6–1.1	2'–3'7"

Table 5-1 *(continued)*

Using your built-in flash

When your camera is set to one of the advanced exposure modes, such as Programmed Auto (P), Shutter Priority (S or Tv), Aperture Priority (A or Av), or Manual (M), you can turn on your flash anytime to take flash pictures. To take flash pictures, follow these steps:

1. **Press the Flash button to raise the flash.**

 While the flash charges, the flash symbol may blink, not appear at all, or display Busy next to it in the viewfinder. When the flash symbol displays in the viewfinder without the charging warning, your camera is ready to take a flash picture.

2. **Press the shutter-release button halfway to focus.**

3. **Press the shutter-release button fully to take the picture.**

 Your camera flash fires and immediately starts to recharge, getting ready for the next picture. Wait for the flash to recharge before taking another picture.

In some cameras, the flash icon blinks after the flash fires at full power, indicating that the subject may be out of flash range. If this happens or if the subject looks dark, try increasing the ISO or choose an exposure setting with a wider aperture. Doing so increases the range of the flash.

If you have a lens hood attached to your camera lens, take it off when using the built-in flash. At certain focal lengths, the hood can cast a shadow, darkening the bottom of your pictures.

Making Flash Exposure Adjustments

When you shoot with your built-in flash, your camera sets the flash output to what it thinks is needed to produce a good exposure. However, sometimes you may want a little more or less light than the camera thinks is needed, such as when the subject is heavily backlit or when unwanted highlights or reflections appear on your subject. To manually gain control over the output of the flash, you can use a feature called Flash Exposure Compensation.

When your camera is set to one of the advanced exposure modes, you can adjust the flash exposure up or down in 1/3 stop increments. Positive adjustments to flash exposure brighten the subject, whereas negative adjustments make the subject darker, as shown in Figure 5-8. Changes to flash exposure compensation don't affect the brightness of the background not reached by the flash.

No Flash
Exposure Compensation

Positive Flash
Exposure Compensation

Negative Flash
Exposure Compensation

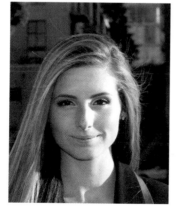 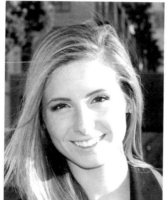 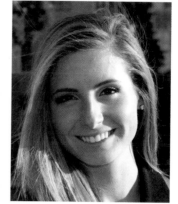

Figure 5-8

Experiment with the flash exposure compensation until you find a brightness setting that looks right for your subject.

To set flash exposure compensation on your camera, follow these steps:

1. **Choose the Flash Exposure Compensation option from your camera's menus, as shown in Figure 5-9.**

The process for accessing the Flash Exposure Compensation option varies by camera. You may need to select Flash Exposure Compensation in your camera's Flash Control menu. Or you may be able to engage the flash control by pressing the Flash Exposure button (normally identified by a lightning bolt and plus/minus combination symbol) and then adjusting your compensation up or down using the general control dial on your camera. Check your manual to see how to use this feature with your camera brand and model.

Figure 5-9

2. **Turn the main command dial to set positive or negative flash exposure compensation, as shown in Figure 5-10.**

 Set the flash exposure compensation to a positive value to increase the flash output or to a negative value to decrease the flash output.

3. **Press the Flash button to pop up your built-in flash and take your picture.**

Figure 5-10

When you're finished taking pictures, be sure to turn off flash exposure compensation by setting the flash exposure compensation amount back to zero.

Locking Flash Exposures

Most dSLRs allow you to lock in a TTL flash exposure value for your subject so that you can recompose the picture and still make sure the subject is properly lighted by the flash.

To lock in a flash exposure value, follow these steps:

1. **Press the Flash button to pop up your flash.**

2. **Frame your subject in the middle of the viewfinder and press the shutter-release button halfway to focus.**

3. **Press the Flash Exposure Lock button, as shown in Figure 5-11.**

 Typically, this button has an asterisk icon next to it. Check your manual if you aren't sure where this button is on your camera.

 When you press this button, your camera fires a pre-flash to measure the flash exposure value, and you see a flash lock indicator in the viewfinder. Subjects can be confused by the pre-flash and assume that you've taken the picture, so you might need to warn them about it.

4. **Reframe the subject in the viewfinder and press the shutter-release button fully to take the picture.**

 The flash exposure value remains set until you press the Flash Exposure Lock button again to lock another flash exposure value, close the built-in flash, or turn off your camera.

Flash Exposure Lock button

Figure 5-11

Reducing Flash Red-Eye

Red-eye is caused by using a flash close to the camera lens in low ambient light conditions, as shown in Figure 5-12. The light from the flash is so fast that the subject's pupils can't close, and light is reflected from the back of the subject's eye straight back to the camera lens, as shown in Figure 5-13. The red color comes from blood vessels at the back of the eye. Red-eye happens most frequently when photographing fair-skinned people with blue eyes.

Figure 5-12

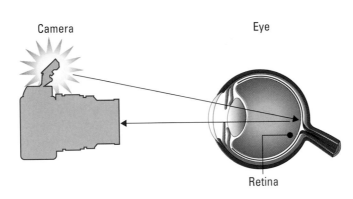

Camera Eye

Retina

Figure 5-13

Red-eye is a pain. Not for the people in the photograph with red-eye — they don't feel a thing — but for you, the photographer, who has to remove it from all the pictures you took of last night's party before you can post them on Facebook.

Thankfully, you can turn on your camera's red-eye reduction feature to help mitigate red-eye when using your built-in flash. This feature works by briefly emitting a bright, pulsing light at the subject prior to the real flash, with the intent that the subject's pupils will be constricted when the picture is taken. You'll notice a brief delay before the picture is taken, and that delay allows the pre-flash time to affect the subject. In some cameras, a countdown displays in the viewfinder after which time you take the picture.

Keep in mind that the pre-flash has a couple potential downsides:

✔ Many subjects blink during the pre-flash, so some of your shots may include people with their eyes closed.

✔ Subjects may think the pre-flash means the photo was taken, so they start walking away before the real flash fires. To avoid the problem of straying subjects, make sure you explain to them about the pre-flash so they stick around for the shot.

You can turn on red-eye reduction in the camera menus, as shown in Figure 5-14. Some cameras allow you to set red-eye reduction with a button and command dial.

EXTRA INFO

If you lock the flash exposure a couple of seconds before taking the picture, your camera sends out a pre-flash. Doing this sometimes works better at reducing red-eye than the red-eye reduction lamp on the camera. Also, using an externally mounted flash helps reduce red eye, because it's physically higher up and away from the direct line of exposure.

Figure 5-14

Diffusing Your Flash

A built-in flash doesn't provide a great look to pictures. The light is hard and flat, because the light source is small and starts close to the camera lens. You generally don't view the world with a flashlight strapped to your head, which is the look you get with a built-in flash. Unfortunately, there's not much you can do about that because the built-in flash is, well, *built in*.

By making the light source bigger, though, you can make it softer. Making the light source bigger provides softer shadows and a more pleasing look than a bare-bulb flash picture. As with most things photography-related, plenty of not-so-cheap gadgets can help you overcome this minor problem, usually in the form of some kind of screen that fits between your flash and the subject, as shown in Figure 5-15. Many of these flash gadgets are available from major photography websites like Adorama (www.adorama.com) and B&H Photo (www.bhphotovideo.com), or locally if you live near a large city with a professional camera store.

These diffusers help to soften the light a little, as shown in Figure 5-16. The image on the left is without a diffuser; the image on the right is with a diffuser.

The bigger the diffuser, the softer the light it produces, but nothing comes without a cost. By scattering light across a large surface area, you make the flash much weaker. You have to get closer to your subject, and your flash uses more battery power to light the subject.

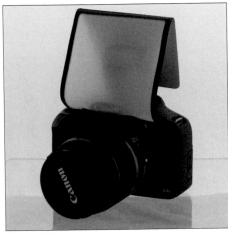

Figure 5-15

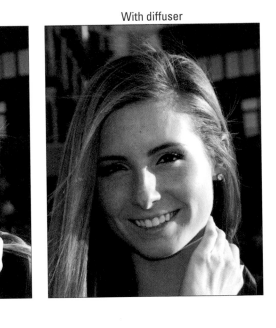

LINGO

The **diffuser** scatters the light from the built-in flash across the surface of a screen, making the light source larger. When choosing a diffuser, it needs to be bigger than the flash head; otherwise, it won't make the light softer.

Without diffuser · With diffuser

Figure 5-16

I have seen many homemade diffusers made of everything from milk cartons to pieces of toilet paper. They all work in some way to soften the light from your built-in flash, but in the end, you will never get professional results from this tiny light source.

Controlling Your Flash Manually

Most dSLR cameras allow you to use the built-in flash manually. In other words, the camera doesn't read a flash exposure and set the flash using its TTL system. You simply dial in a power level for the flash. If you master manual flash, you open the potential for a lot of creative control over your photography.

Setting your flash power level manually

Hard light (or **harsh light**) is simply light that creates strong shadows and high contrast between the light and dark areas of a photograph. This light is caused by the size of the light source in relation to the subject's distance from it. A cloudy day in which the sun's light is diffused across the sky creates a large light source and gives a soft light absent of shadows. On sunny days, the light arrives directly from the sun as a small point in the sky, and the shadows are highly defined.

To set the flash level manually, follow these steps:

1. **Choose the Flash Control for Built-In Flash option from the camera menus.**

 The name of this option may be a little different for your camera. (Check your manual to see how to set flash values manually.)

2. **Choose Manual and then set a power level for your flash, as shown in Figure 5-17.**

 Flash values are usually shown as fractions of full power, 1/1 being full power and 1/128 being 1/128 of full power.

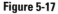

Figure 5-17

When you pop up the built-in flash and take a picture, the flash fires at the selected power level until you change it.

Taking a flash picture manually

Now that you know how to set the power level of your flash manually, you can take a picture with a manual flash setting. To take a manual flash picture, follow these steps:

1. **With the flash turned off, manually set the exposure for the background.**

 Using your camera in Manual mode, adjust the shutter speed and aperture until the background has the exposure you want. You can't exceed the flash sync speed for the shutter, so it's easier to just set the shutter speed at the sync speed and then adjust the aperture to balance your meter.

2. **Take a test shot to see how it looks, as shown in Figure 5-18.**

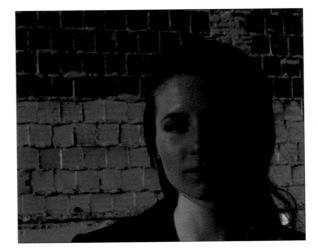

Figure 5-18

Don't worry if the subject looks dark — you're just setting the exposure for the background right now. If necessary, adjust and take another test shot until you're happy with the background exposure.

3. **Set your flash power manually to half power.**

 The actual power level doesn't matter because you're probably going to have to adjust it. Half power is just a handy starting point.

4. **Pop up your built-in flash and take another picture.**

 Don't adjust the aperture or shutter speed; you've already set that perfectly for the background. Just take the picture with your flash set to half power.

5. **Look at the picture you've taken and adjust the flash up or down until you're happy with the brightness of your subject, as shown in Figure 5-19.**

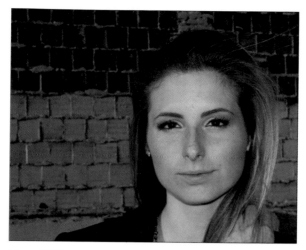

Figure 5-19

You can keep taking pictures with these settings as long as the ambient light doesn't change or as long as you maintain the same distance from your subject with your camera.

You can now take flash pictures manually using your camera in Manual mode to adjust the background exposure and change the flash power to adjust the brightness of the subject.

Using aperture to control flash power

TTL flash works differently from manual flash. With TTL, your camera adjusts the power of your flash to compensate for any changes you make that would affect the flash exposure. These changes include the subject-to-camera distance, ISO, and aperture. If you change the ISO or aperture when using TTL, your maximum flash range is affected, but you don't see a change in the brightness of your subject. Likewise, if you move closer or farther away from your subject, TTL adjusts the power setting of the flash to compensate, as long as you stay within the flash range.

EXTRA INFO

Changing the ISO has the same effect on the apparent flash power as changing the aperture, but it's not a technique I recommend. Because ISO affects the level of electronic noise in pictures, I prefer to keep it set low whenever practical.

With manual flash, you can affect the flash exposure without changing the power output of the flash; you do so by adjusting your distance from the subject or by changing ISO or aperture. Increasing the ISO has the same effect as opening the aperture.

To see how changing the aperture affects the apparent flash power, follow these steps:

1. **Turn the exposure mode dial to Manual (M).**

2. **Set your flash to full power, set your camera to the widest aperture setting, and then set your shutter speed for the background exposure.**

 Adjust the shutter speed until the background has the exposure you want. You can't exceed the flash sync speed for the shutter, so if your background is very bright, you may have to close down the aperture a little to balance your meter.

3. **Take a picture.**

4. **Close down the aperture three clicks and slow down the shutter three clicks to compensate.**

 By closing down the aperture with three clicks of the main command dial and slowing down the shutter speed with three clicks of the main command dial, you maintain an equivalent exposure and background brightness.

5. **Repeat Steps 3 and 4 until your aperture is closed as far as it will go.**

6. **Review your pictures.**

 The background brightness of your pictures stays the same, but the flash power appears to diminish. In the series of pictures in Figure 5-20, the background remains at the same brightness, but the objects on the table and the window frame, which are lit by the flash, get progressively darker as the aperture gets smaller.

Why does changing the aperture make a difference to the apparent flash power? Basically, the flash duration is extremely short, so the shutter speed doesn't make any difference to the flash exposure. The light from the flash has been captured by the sensor before the shutter speed can do anything to restrict it. However, the aperture setting is not time-based. The size of the aperture restricts some of the light from the flash from reaching the sensor. The smaller the aperture setting, the less light from the flash gets through to the sensor, even though the flash puts out the same flash power for each sample picture.

The aperture makes a big difference to the apparent power of the manual flash. You have to consider this if you change the aperture between taking two pictures, by adjusting the flash power up or down to compensate. The advantage is that if your flash is too bright, you can simply close down your aperture a little without changing the flash power. In TTL Flash mode, your camera makes this adjustment automatically, turning up the power on the flash as you close down the aperture.

1/250 second, f/5.6 1/125 second, f/8 1/160 second, f/11

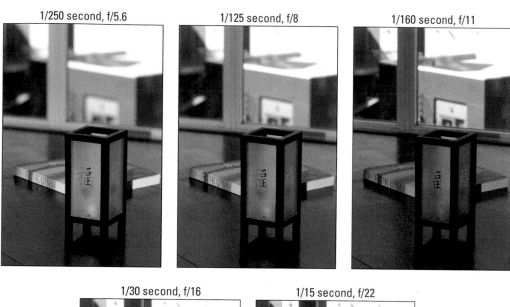

1/30 second, f/16 1/15 second, f/22

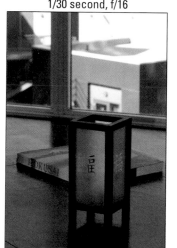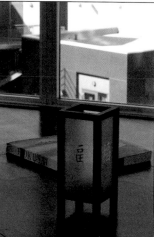

Figure 5-20

LINGO

I often use the term *background exposure* when I refer to the scene not affected by the flash. Technically, this is the **ambient exposure** — the exposure setting for the whole scene before flash is introduced. If you have a bright scene and use only a small amount of flash power so that the subject is mostly lit by ambient light, the effects of adjusting aperture and shutter speed with manual flash are far less apparent.

Using shutter speed to control background brightness

You're now adept at using flash. Even if you never take your flash off the TTL setting, you have a good understanding of how it works. There is just one more manual flash technique I want to show you — using shutter speed to control background brightness.

As I describe in the previous section, the burst of light from your flash happens so fast that the shutter has no effect on the flash exposure. Shutter speed does affect the ambient exposure, however. In the example in Figure 5-21, I slowed down the shutter in increments to brighten the ambient exposure. Parts of the scene mostly lit by flash don't change in brightness.

1/125 second, f/5.6 1/60 second, f/5.6 1/30 second, f/5.6

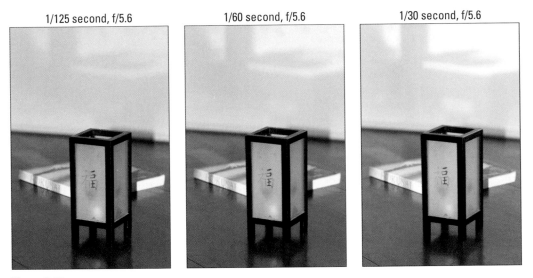

Figure 5-21

Playing with Flash Effects

In normal lighting conditions, where you can use relatively fast shutter speeds, you don't really notice that flash photography actually consists of two exposures — one for the background scene and one for the flash. In low light conditions, however, you can start to separate these two exposures with some interesting results. In this part of the lesson, I introduce you to some of the effects you can achieve with flash in low light. In Lesson 8, I show more examples of using your flash.

Taking portraits at night

If you take a portrait of someone at night with your camera set to Full Auto or Programmed Auto, the person is exposed by the flash, but the distant background is totally black, as shown in Figure 5-22.

Figure 5-22

With some cameras, such as Nikon dSLRs, this also happens if you take the picture in normal Aperture Priority mode. What happens is that your camera wants to set a shutter speed that you can safely handhold, possibly around 1/60 of a second. If your subject is in flash range, your camera can handle the flash exposure, but the shutter speed is too fast to gather the ambient light from the background.

Some cameras have a Night Portrait scene mode (described in Lesson 1) for photographing a person standing in front of a nighttime background. If you select this mode, your camera fires the flash while using a longer-than-normal shutter speed to capture detail in both the person and background.

If you want more control when shooting a portrait at night, you can manually adjust the exposure to expose for the background. With your camera set to Manual, select a wide aperture (that is, a small f number) to achieve an acceptable flash range. Also, set a higher ISO so you can achieve a reasonable shutter speed. Adjust these settings until the exposure meter is one stop or more into the negative. The more negative the setting, the darker the background will be. Figure 5-23 shows a portrait shot in Manual mode with a slow shutter of over 1 second, which exposes the background elements.

As a general guideline, shutter speeds faster than a second typically work best for night portraits. Otherwise, you could see some ghosting or light remnants if your subject moves a lot or walks out of the picture while the shutter

is open, as shown in Figure 5-24; notice how she's partially transparent, as I had her move in and out of the photo during the exposure. Also, make sure you put your camera on a tripod to avoid camera shake. Don't forget to turn off any image stabilization you might be using if you mount your camera on a tripod!

Figure 5-23

Figure 5-24

Dragging the shutter

Using slow shutter speeds with your flash opens many creative possibilities for photographers. A slow shutter speed is a good way to show movement while bringing some definition to the subject, as shown in Figure 5-25.

LINGO

Dragging the shutter means using a very slow sync speed with your flash, something I demonstrate in the preceding section with night portraits.

The combination of handholding your camera at slow shutter speeds and then adding flash can create some fun effects and colors. The colors are caused by the ambient artificial lights being a different color temperature from the flash, which can provide interesting ghosting and shadows that can imply movement and abstract qualities to your photo.

Dragging the shutter also allows you to create some interesting double exposures, as shown in Figure 5-26 where the subject signed her initials with a small flashlight and then stood still while the flash fired.

Figure 5-25

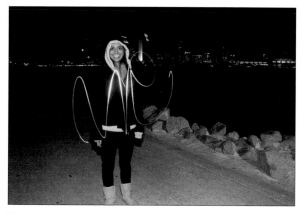

Figure 5-26

Understanding the first and second curtains

Your dSLR can fire the flash at the beginning or the end of the exposure, as shown in Figure 5-27. When the flash fires with the first shutter

curtain, action is frozen first, and then the shutter stays open to collect the ambient light. When the second shutter curtain is selected, the flash fires just before the shutter closes, freezing the action at the end of the exposure. This is possible because the duration of the flash burst in relation to the length of time the shutter is open is very short.

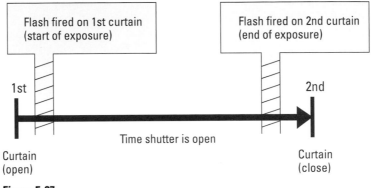

Figure 5-27

When the shutter speed is fast, you really don't notice whether the flash fired on the first or second curtain. If you slow down the shutter, you can see the effect, as shown in Figure 5-28.

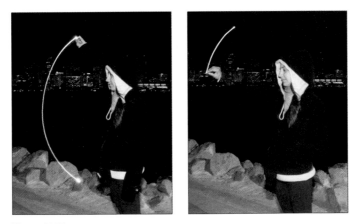

Figure 5-28

In both pictures, the subject is moving her arm down while the picture is taken. In the first picture, the camera is set to fire the flash on the first curtain. You see her arm frozen by the flash at the beginning of the action. The light extends downward because the shutter stayed open to gather the ambient light. In the second picture, the flash is set to the second curtain. You see the subject's arm at the end of the trail of light because the flash fired just before the shutter closed.

Set your flash to fire on the first or second curtain by using the built-in flash function setting menu on your camera, as shown in Figure 5-29.

EXTRA INFO

Although the first-curtain flash is the default setting, the second-curtain flash is much more useful for capturing action because the trails from the ambient light appear behind the moving subject, rather than in front or through it. Seeing a car's lights moving behind it, for example, looks much more real than in front. For moving objects, this creates a good representation of speed.

Built-in flash func. setting

Flash mode	E-TTL II
Shutter sync.	1st curtain
Flash exp. comp	-2..1..0..1.:2
E-TTL II	Evaluative

MENU ↩

Built-in flash func. setting

| Shutter sync. | ▶1st curtain |
| | 2nd curtain |

MENU ↩

Figure 5-29

Solving Flash Exposure Problems

Here are some typical problems you might encounter when doing TTL flash photography with some suggested solutions:

✔ **You're using Aperture Priority mode, and shutter speeds are very slow.** You're using your camera in low ambient light. If your camera is a Nikon, the Flash mode is set to Slow Sync. To fix this issue, try some of the following solutions:

- *If you're using a Nikon, change the Flash mode to normal Flash mode.* Your shutter speed increases to 1/60 of a second, but expect your backgrounds to be dark.

- *Change to Shutter Priority mode and select a shutter speed you can handhold.* If your camera is a Canon, the aperture may continue to flash in the viewfinder, warning that the background will be dark.

- *Change to Manual mode.* Set a wide aperture and a shutter speed you can handhold. The exposure indicator will not balance at zero, indicating that the background will be dark. Using a wide aperture helps increase your flash range.

- *Increase the ISO setting to achieve a fast shutter speed,* but expect some noise in your pictures.

✔ **You have red-eye in all your shots.** You're using your flash in low ambient light, which causes the flash to be reflected in your subject's eyes. Try some of the following solutions:

- *Turn on the Red-Eye Reduction mode.*

- *On some Canon models, wait for the timer in the viewfinder to disappear before you press the shutter-release button fully* to allow the red-eye reduction lamp to have its full effect.

- *Make sure you're not covering the red-eye reduction lamp with your finger.*

- *Turn on lights in the room to increase ambient light.*

- *Have your subject look away from the camera.*

- *Lock flash exposure prior to taking the shot.* This sends a pulse from the flash and makes the subject's pupils smaller.

- *If you have one, use an external flash.*

✔ **All the people in your picture have their eyes closed.** Assuming everyone isn't asleep, you could have red-eye reduction activated. Try taking some pictures without red-eye reduction. If that doesn't work, count down loudly from three before taking a shot to help warn your subject the flash is coming.

✔ **Your subject looks too dark.** The chances are you're out of flash range. Try some of the following solutions:

- *Move closer to the subject.*

- *Set a wider aperture to increase flash range.*

- *Increase ISO to increase flash range.*

- *Take off the polarizing filter if you have one on your camera.*

- *Add positive flash exposure compensation.*

✔ **Your subject looks too bright.** Try moving back from your subject or set some negative flash exposure compensation. You could also set your flash manually to a lower power.

✔ **You see colored halos around your subject.** You're using a slow shutter speed, and the halos are caused by the ambient exposure picking up movement in the subject. The halo is a different color because the ambient light has a different color temperature from your flash. You need to increase your shutter speed to get out of slow-sync flash, assuming it's not an effect you're looking for.

✔ **You see the background through your subject when taking a night portrait.** The shutter speed is slow, and the subject is moving, allowing the ambient exposure to show through areas not obscured by the subject. Try to achieve a faster shutter speed by opening your camera aperture more and increasing ISO. Also, ask your subject to stand still!

✔ **Your subject is sharp, but the background looks blurred.** The flash is freezing action on the subject, but camera shake is blurring the background. Use a higher shutter speed that you can handhold.

 # Summing Up

You've completed Lesson 5 and have mastered the following:

✔ You know when your pictures will benefit from using flash.

✔ You understand flash sync speed.

✔ You know how to use your flash with advanced exposure modes.

✔ You can adjust your flash brightness if necessary.

✔ You can use your flash manually.

✔ You can use your flash with slow shutter speeds.

✔ You can troubleshoot common flash issues.

Practice with your camera and then start on Lesson 6.

Know This Tech Talk

diffused flash: Using a translucent/semi-transparent material (like the plastic on a milk carton) to diffuse the light from your flash, softening it on a subject. There are numerous after-market gadgets made to do this that can attach to your flash.

flash bracketing: Using manual mode or flash compensation, you can take several exposures with your flash set to what you think is the ideal setting, and then one stop up and one stop down.

front-curtain sync: Front- or first-curtain sync occurs when the flash is fired immediately after the shutter opens. The shutter then remains open until the end of the exposure.

rear-curtain sync: Rear- or second-curtain sync occurs when the flash fires just before after the camera shutter closes at the end of the exposure.

Lesson 6
Learning about Lenses

- ✔ Learning about focal length allows you to *select a lens* for your purposes.

- ✔ Working with wide-angle and telephoto lenses lets you *alter the perspective in your pictures.*

- ✔ Use a normal lens to *capture excellent, realistic images of a variety of subjects.*

- ✔ Investigating how lenses work with camera image sensors helps you *select and use the best optics for your shoots.*

- ✔ *Purchase the right lenses* for your needs, budget, and style.

A major advantage of dSLR photography is you're not limited to the capabilities of a single lens. Each camera manufacturer offers a full stable of lenses covering every shooting situation and photographer's budget. This flexibility makes your camera an excellent creative tool whether you're shooting eye-popping close-ups, expansive architectural interiors, intense portraits, infinite landscapes, or extreme sports.

If you're new to dSLR photography, you probably bought your camera and existing lens together as a kit. Manufacturers offer these kits to get you started by supplying one or two lenses at a discount when purchased with the camera body. These lenses are suitable for general family photography and, although not the best lenses in the manufacturer's range, deliver acceptable image quality. As you develop your skills, you will undoubtedly want to add to the number of lenses in your collection.

In this lesson, I explain lens terminology in general terms. I also introduce you to different types of lenses and explain how they can give you different looks in your photography. And finally, I run down some points to consider when buying a lens for your dSLR. By the end of this lesson, you will have all the knowledge you need to get the most out of your lenses.

Understanding Focal Length

The curvature of lens elements, the size and shape of a lens, and other factors affect how much it can bend light and how far behind the lens the subject is focused. The focal length of a lens is the distance from the middle of the lens to the sensor, where the image is focused, as shown in Figure 6-1.

Focal length determines the camera's angle of view, or how much of a scene the lens "sees." With a short focal length, the camera has a wide angle of view (a wide-angle lens), enabling it to capture a large part of the scene. With a long focal length, the camera sees a narrower part of the scene, resulting in a more telescopic image (a telephoto lens) where things far away seem much closer. (See Figure 6-2.)

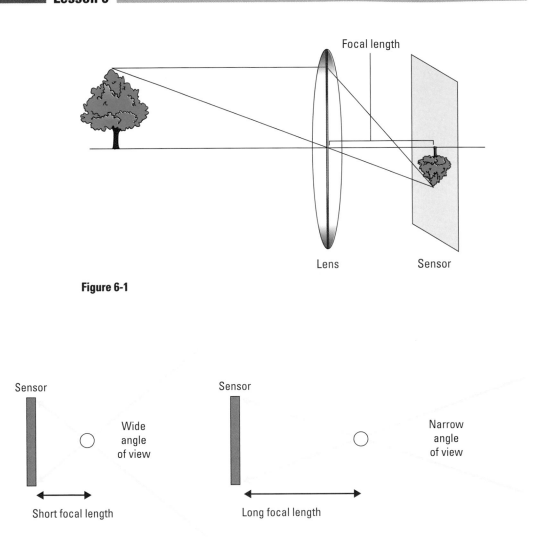

Figure 6-1

Figure 6-2

The focal length of a lens also determines the amount of magnification in an image at a given distance. The longer the focal length, the greater the amount of magnification.

The focal length is stamped on the lens body and referenced in millimeters, and is represented by either a single number or a range of numbers. A single number represents a fixed focal length, or *prime,* lens, and a range of numbers represents the minimum and maximum focal lengths of a zoom lens. Figure 6-3 shows a prime 50mm lens. (For more on prime and zoom lenses, see "Discover Commonly Used Types of Lenses," later in this lesson.)

To better understand what focal length does to your photos, take a look Figure 6-4, which shows four shots of the same scene, taken at different focal lengths. Because the size of the sensor doesn't change, more of the scene is excluded as the focal length increases.

EXTRA INFO

dSLR camera lenses are usually compound lenses made up of several groups of lens elements, so the focal length is the product of how all these elements work together to bend (or *refract*) the light.

Focal length

Figure 6-3

24mm

50mm

100mm

200mm

Figure 6-4

Understanding How Lenses Work

Understanding a little bit about how lenses work helps you understand the terminology lens manufacturers use in their products and help you decide what lenses you want to use. I keep things simple, in fact, so simple that you don't find a single mathematical equation in any of my explanations.

Light travels in a straight line unless it's interrupted in some way. As light passes through optics of different densities and shapes, it's *refracted*. I'm sure you've observed this when you've dipped a spoon into a glass of water. Glass is a different density from air, so it behaves in the same way as water by refracting light passing through it. By shaping lenses and combining multiple lens *elements*, it can make reflected light on a subject converge into a focused image projected onto a digital image sensor (refer to Figure 6-1).

Light captured by the lens is refracted at different angles depending on its wavelength. The shorter the wavelength of light, the more it's refracted. Therefore, wavelengths of light in the shorter violet and blue range are bent more than longer wavelengths in the orange and red range. You can see this when light is refracted in a prism, as shown in Figure 6-5.

Figure 6-5

If these different wavelengths of light from a point on the subject aren't focused back into a single point by the lens, chromatic aberrations occur in the form of fringes of color around the subject, as shown in Figure 6-6. Special lens coatings and low-dispersion glass help reduce chromatic aberrations.

LINGO

Refracted light, for the purposes of photography, refers to rays of light traveling through a lens or combination of lens elements that are bent to achieve a certain effect. This might be taking a wide area and compressing it into what can fit correctly onto your image sensor, or it could be taking an image close-up and focusing very accurately on a small focal plane. Either way, whenever light passes through a lens, it's being redirected using high-tech optics.

Figure 6-6

Pictures show reduced lighting at the edges when vignetting is evident, as shown in Figure 6-7. Even the best lenses can show some signs of vignetting, and the easiest way to deal with it is to close down the lens aperture slightly.

When a strong light enters a camera lens, it can be reflected internally and cause bright areas — or lens flare — to appear in the image, as shown in Figure 6-8. Using a lens hood to shade the lens from the sun and bright lights can help prevent lens flare.

Manufacturers attempt to optimize lens performance by building lenses consisting of multiple elements. Some of the elements are concave, and some are convex, and some lenses even contain special aspherical elements that aren't formed from parts of a sphere. Some of these elements are glued together with optically transparent adhesive to form groups of elements. Each element is used to direct light in a specific way to re-create your subject with as few aberrations as possible. Lenses with

Figure 6-7

significantly better image quality, the ability to maintain a fixed aperture over a range of focal lengths, and fancier features such as image stabilization can all drive the cost of a lens into the stratosphere. In fact, many pro photographers spend much more on their lenses than they do on camera bodies.

Figure 6-8

LINGO

Lens flare is light that enters a lens that gets reflected inside the lens, causing different lens elements to create light patterns in your image. Sometimes these are interesting effects that can look almost like something space-like out of a science fiction movie but more often than not they're an unwanted feature in your photo. Using a hood or turning slightly away from the source of light (like the sun) can help get rid of them.

Putting Focal Length into Perspective

You can use focal length as a strong compositional tool in your pictures because perspective changes with the distance from the camera to the subject. A long focal length appears to compress the distance to the subject, whereas a short focal length appears to expand the distance to the subject.

EXTRA INFO

Professional lenses are sophisticated instruments incorporating precision-ground glass and fluorite elements with specialized coatings, built to extremely fine tolerances inside a tubular housing containing an image-stabilization system, a fast-acting and almost silent-focusing motor, and a micro-processor to control the systems and communicate with the camera body. Not surprisingly, these lenses can be a lot more expensive than your camera body.

In Figure 6-9, I took four shots of the same scene using different focal lengths, but moved away from the main subject to keep it the same size in the viewfinder. The result is that as I moved away and increased my focal length, the scene appears to compress with distant objects getting closer to foreground objects.

I used a long focal length (300mm) to compress my image for compositional effect when photographing a mountain village in Spain. The long focal length makes the buildings pile up on each other, as shown in Figure 6-10.

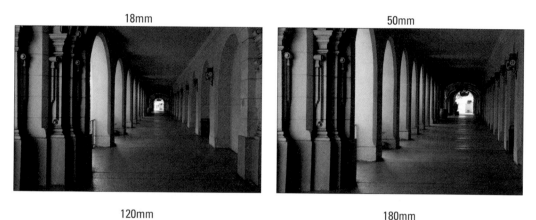

Figure 6-9

Discover Common Types of Lenses

Lenses are grouped into different types according to their focal length, as I describe in the following sections.

Normal lens

A *normal,* or standard lens, creates an image with a natural-looking perspective closest to how the human eye sees it. Lenses with longer focal lengths magnify the image on the sensor and give the effect of compressing distances in the frame. Wide-angle lenses do the opposite; they squeeze more of the scene into the frame and make objects appear smaller and more distant. Between these extremes, a normal lens neither significantly magnifies nor de-magnifies the scene, and spatial relationships appear close to real life, as shown in Figure 6-11.

300mm

Figure 6-10

Different camera image sensor sizes affect how lenses work. Some sensors are *full frame* and allow a lens to behave exactly as it is designed. Other sensors, however, are smaller, or *cropped,* and slightly limit a lens' abilities. A lens where the focal length is equal to the diagonal of the sensor creates a picture closest to a normal or standard lens. The sensor sizes of dSLR cameras vary, but for a full-frame dSLR, a lens with a 50mm focal length is considered a normal lens. For dSLRs with cropped sensors, a lens with a 35mm focal length is conventionally considered a normal or standard lens, even though the true diagonal is closer to 29mm. (For more on full-size and cropped sensors, see "Matching Lenses with your Sensor," later in this lesson.)

Figure 6-11

Wide-angle

A wide-angle lens has a shorter focal length than a normal lens and is typically 18mm or 24mm. A wide-angle lens can do several things:

- **Capture a wide angle of view:** It enables you to see a wide angle of the scene in front of you, making it a good choice both for working in tight spaces and photographing landscapes.

- **Makes objects close to the camera unusually large:** It causes nearby objects to appear overly large, and faraway objects to appear disproportionately small and distant, as shown in Figure 6-12.

Some specialized wide-angle lenses, such as a *fisheye* lens (described later in this lesson), let you capture very wide areas but create significant distortion.

Figure 6-12

Telephoto

Lenses with focal lengths longer than a normal lens are called *telephoto,* and they are used like binoculars or a telescope to make faraway objects look much closer. If you're shooting sports or wildlife, you'll want a telephoto lens so you can get close-up photos without being on the field or in danger of being eaten.

A telephoto lens has multiple features making it unique:

- **Has a long focal length.** It has a longer focal length than a normal lens and is generally 70–300mm or greater.

- **Magnifies the scene.** It brings distant objects closer, so it's ideal to use when you can't get close to your subject, as shown in Figure 6-13.

- **Captures a narrow angle of view.** It has a narrower angle of view than a normal lens, so it captures less of the scene in front of you.

- **Compresses distances.** It gives the effect of compressing distances in the frame so near and far objects appear piled on top of each other (refer to Figure 6-10).

- **Makes the depth of field shallower.**

Figure 6-13

Zoom versus prime

A discussion about the types of lenses would not be complete without discussing zoom and prime lenses.

Zoom lens

A *zoom lens* is a lens with a variable focal length; it can cover many focal length ranges, from wide-angle zooms, such as 12–24mm, to telephoto zooms of 70–200mm. One of the key benefits to a zoom lens is its versatility, giving you access to a range of focal lengths without changing lenses. A zoom lens has a zoom ring showing the available focal lengths, as shown in Figure 6-14.

Early zoom lenses had very poor image quality compared with prime lenses and didn't have as large a maximum aperture available. This has changed with modern zooms, and professionals use them for very high quality

EXTRA INFO

Many people confusing the term *telephoto* with *zoom* lenses. A *zoom lens* always means a lens with a variable focal length, no matter whether it's zooming over a wide-to-normal range, a telephoto range, or something else. A *telephoto* lens always refers to a lens that makes things farther away look closer (like a telescope), even if it is also a prime lens without the ability to zoom.

purposes. Manufacturers are also making "super zooms" covering a wide range of focal lengths, often ranging from as wide as 18mm to as long as 200mm. Although they aren't the sharpest lenses around, to some people, the reduced weight and convenience make zoom lenses the ideal lenses for travel.

Prime lens

Unlike a zoom lens, a *prime lens* has a fixed focal length. A prime lens isn't as versatile as a zoom lens because the focal length is fixed, but a prime lens does offer you several advantages:

Focal length scale

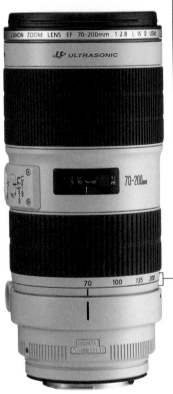

- ✔ The lens quality is generally very high.

- ✔ Buying a quality prime lens isn't typically as pricey as a quality zoom lens.

- ✔ A prime lens is sometimes lighter than a zoom lens, although a prime telephoto lens can be much bigger.

- ✔ Prime lenses often have a wider maximum aperture, making them suitable for low-light photography.

Figure 6-14

Exploring Special Lenses and Attachments

Your dSLR camera gives you very wide choices of style and subject matter that can be captured. For general photography, lenses with normal focal lengths will be all you need to capture pictures of landscapes and people. As your skills and interests develop, you may want to get more specialized in the type of photography you do, or you may wish to add some in-camera effects. In this section, I describe some of the special lenses and attachments available to dSLR photographers.

Macro lenses

The closer you can place your lens to a subject, the more the subject will fill the frame and be magnified in the picture. Imagine taking a picture of a small bird from 15 feet away with a 50mm lens. The bird appears as a small subject

in the middle of your photo. If you were to move your camera to within an inch of the bird's head, you'd get a very large picture of the bird's eye! The problem is that normal lenses don't focus close enough, and telephoto lenses, which would magnify the image further, focus at a greater distance than shorter focal length lenses.

To focus closer to the lens and increase magnification, the lens has to be extended away from the sensor. A *macro lens,* as shown in Figure 6-15, has this extension built into the lens and can focus from a close distance to infinity. Typical macro lenses provide high magnification and are in the 50–200mm focal length range, with a magnification ratio of 1:2 or 1:1. Despite being designed for close-up work, most macro lenses can still be used as a regular lens.

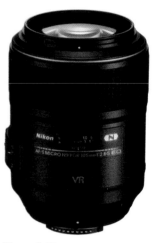

REMEMBER

> The longer-length macro lenses allow you to maintain a greater distance from your lens to your subject.

Figure 6-15

EXTRA INFO

Macro lenses have a ratio associated with them that defines the size of the image produced on the sensor compared with the original subject when focused at the closest focus distance. If the image on the sensor is the same size as the subject, the reproduction ratio is 1:1. This means that your subject will appear life-size on the sensor. Think of photographing a fly with a 1:1 lens, captured by the relatively small area of your sensor and blowing that up into a printed picture. The fly would look huge. If the image is twice the size, the ratio is 2:1. Therefore, if the subject is magnified four times, it appears four times bigger on the sensor than real life, a 4:1 ratio. If the image is half the size, the ratio is 1:2.

Extension tubes

Extension tubes are a less expensive and very effective way of doing macro photography because they convert any lens into a macro lens by extending the lens distance from the sensor to allow closer focusing. They don't contain any optics, so the image quality is excellent. More sophisticated (read: expensive) extension tubes have electrical contacts allowing the camera to control the lens. Cheaper extension tubes are often purchased in sets allowing for different degrees of magnification.

Close-up lens

A *close-up lens* is a simple lens that screws onto the front element of your camera and allows your lens to achieve a closer focus distance for larger magnification. A close-up lens works by decreasing the effective focal length of the lens it's used on.

Because close-up lenses look like filters, some people incorrectly refer to them as close-up filters, which I don't mind because doing so helps remove any confusion between a close-up lens and a macro lens. A +3 lens is ideal for general close-up photography. These lenses are relatively inexpensive, but they don't give the best quality results.

Teleconverter

A *teleconverter* or *extender,* as shown in Figure 6-16, is a second lens that fits between your camera body and lens to increase the magnification of your existing lens. For example, if you're using a 200mm lens, a 2x teleconverter, or a *doubler,* changes it into a 400mm lens for even greater magnification of far-off subjects. Using a teleconverter reduces the amount of light passing through your lens so you require slower shutter speeds or wider apertures to capture your shot, by as much as one or two stops. A teleconverter can also decrease your image quality and autofocus speed.

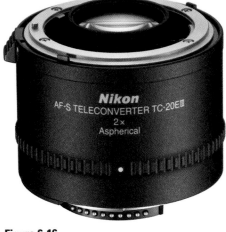

Figure 6-16

You ideally need a "fast" lens with a maximum aperture of f/2.8 or greater to use a teleconverter because it uses a lot of the available light. Also, teleconverters don't work with every lens; they are matched to specific lenses in your manufacturer's lens lineup, so double-check before buying one.

Tilt/shift lens

Tilt-and-shift lenses are popular with architectural photography because they allow you to shift the perspective and plane of focus, and eliminate or

decrease visual effects such as convergence (like train tracks converging over distance). For example, I shot the left image in Figure 6-17 from close up with a small focal length. The building appears to be falling over backward, which is what happens when the camera is tilted upward. But by using a tilt-and-shift lens, I straightened that building, as shown on the right.

Figure 6-17

Tilt-and-shift lenses also allow you to select specific areas of focus in your picture so objects at the same distance can be in or out of focus or the focus can be extended out on a plane. A cheaper version of this type of lens, although not a true tilt/shift, is a Lensbaby, which has become popular among amateur photographers for creating dreamy images, as shown in Figure 6-18.

Figure 6-18

Fisheye lens

Fisheye lenses have a lot of creative uses. Not only do they have a very wide field of view of around 180 degrees, but they also produce images with a very deep depth of field at any aperture.

An 8–10mm lens produces a hemispherical image on a full-frame dSLR. The amount of linear distortion on fisheye lenses is extreme. Subjects in the center of the lens and lines that run through the center are less distorted than those toward the edge, as shown in Figure 6-19.

Figure 6-19

Optical filters

You can place *filters* in front of your lens to alter the properties of your images and improve the quality of your photos. They can either be square and held in place by a special holder, or round and screwed on to the front of your lens. Round filters are more convenient, but if you have several lenses with different diameters, you'll find your filter doesn't fit all your lenses.

Here are some of the more useful filters for digital photography:

✔ **Clear or ultraviolet:** Also known as a *haze* filter, a clear filter is simply a piece of optical quality glass that does not affect the image. An ultraviolet (UV) filter helps reduce haze in landscapes. Both filters protect your lens from dirt, water, and scratches. Having one of these filters on each

of your lenses is a good idea; it can act as a crash helmet for your lens if you bump it against something.

✔ **Polarizing:** A polarizing filter helps reduce glare and reflections as well as deepens contrast and color in landscapes or environmental portraits. In Figure 6-20, I used a polarizing filter to remove the refective glare from the rafts.

Without polarizing filter | With polarizing filter

Figure 6-20

A polarizing filter is most effective when used at 90 degrees to the position of the sun. The effectiveness drops off the farther away it moves from this angle. You should use a circular polarizing filter, not linear; otherwise, your in-camera light metering and autofocus system may not function properly.

✔ **Neutral density:** Neutral density filters are like putting sunglasses on your camera. They help you achieve a slow shutter speed when there's too much light even after you turn down your ISO and close the aperture on your camera. In Figure 6-21, a neutral density filter allowed me to use a shutter speed of over two seconds on this cloudy day to produce a milky look to the waves.

Figure 6-21

Matching Lenses with Your Sensor

I can't discuss lenses and focal lengths without an explanation of *crop factor* or *focal-length multiplier*. You hear these terms frequently when reading about lenses in photography magazines or camera manufacturers' marketing literature. It's important to know what they mean and how they affect your photography. Firstly, they mean the same thing, so that, at least, is a relief!

When camera manufacturers designed dSLRs, they replaced 35mm film with an image sensor. A few high-end dSLRs have full-frame sensors, as shown in Figure 6-22. In most dSLR cameras, manufacturers use cropped sensors because they're less expensive to produce than full-size sensors. Even some professional, top-of-the-line dSLRs have cropped sensors when the models are designed for speed and applications such as journalism and sports, as opposed to studio shooting, where large images aren't as important as catching things that are moving and happening fast. Cropped sensors also help increase the apparent magnification on a telephoto lens, often used by journalists and sports photographers (as I discuss later in this section).

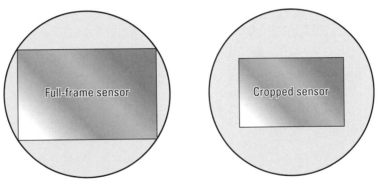

Figure 6-22

Lenses are designed to create an image circle filling 35mm film to its edges, as shown in Figure 6-23. Because most dSLRs have cropped sensors, the portion of the image overlapping the edges of the sensor is lost, and the angle of view is more restricted.

LINGO

An **image sensor** is a digital device sensitive to light. A **full-frame sensor** is the same size as a 35mm frame of film. A **cropped sensor** is smaller than the size of the film being replaced.

Image created by full-frame sensor

Image created by cropped sensor

What the lens sees

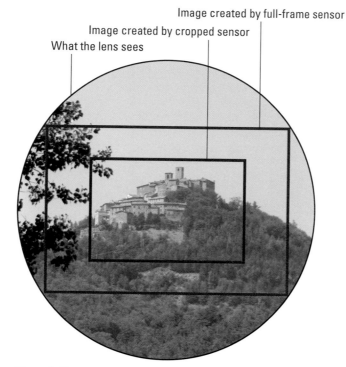

Figure 6-23

The amount of cropping of the digital image depends on the size of the sensor in relation to a full-frame (35mm) sensor. When you use a lens on a camera with a cropped sensor, the lens has a larger equivalent lens size than what's stamped on the lens. What this means is that the smaller sensor captures a smaller area of what the lens actually sees, resulting in an image appearing to have been taken with a longer lens, as shown in Figure 6-24.

LINGO

The image cropping caused by a smaller sensor is referred to as the **crop factor** or **focal-length multiplier**.

If you multiply the focal length of the lens by the sensor's crop factor, you can determine the focal length that's equivalent to the angle of view. For example, a 50mm lens on a dSLR with a crop factor of 1.6x has an angle of view equivalent to using an 80mm lens on a full-frame dSLR.

Figure 6-24

The focal length doesn't change if you use your lens on a camera with a cropped sensor. Only the angle of view changes, making it seem like the focal length is longer than it really is.

Lens manufacturers quickly realized they could make smaller, lighter, and cheaper lenses for cropped-sensor cameras by producing lenses with a smaller image circle. Table 6-1 lists the names that manufacturers give to their range of lenses designed for cropped-sensor cameras.

Table 6-1	Manufacturer Designation for Cropped Sensor Lenses
Manufacturer	**Designation**
Canon	EF-S
Nikon	DX
Pentax	DA
Sigma	DC
Sony	DT
Tamron	Di-II

Using a cropped-sensor camera can be desirable with telephoto lenses because the angle of view is narrower, and the lens acts like a lens with a larger focal length. The longer the actual focal length, the more gain there appears to be. So, a 400mm telephoto lens acts like a 640mm focal length lens when used on a Canon camera with a crop factor of 1.6x. I'm wary of calling this an actual advantage because you're using your lens with a smaller sensor, although it has been used to advantage on some top-of-the-line professional cameras designed especially for sports and journalism, such as the Canon EOS 1D Mark IV. The higher-end cameras typically have less of a crop factor, however, such as 1.3 for the Mark IV. If you crop the image from a camera with a full-frame sensor until it gives you the same angle of view as the picture taken with a cropped-sensor camera, the picture quality could still be better from the camera with the larger sensor. This is because cameras with a full-frame sensor usually create less noise in the image because of the decreased pixel density of the larger sensor.

The opposite side of the coin is that with a cropped-sensor camera, you lose something from the wide-angle side. An 18–55mm zoom lens becomes a 27–82mm zoom with a 1.5x crop factor. Although you might find the extra apparent reach at the telephoto end of the scale, you lose a significant amount at the wide-angle end of the range. For example, you may like the effect of using your 50mm prime lens as a 75mm portrait lens, but you now have to step well back to frame your subject. If you want to shoot an interior, your 18mm lens will no longer give you the wide angle of coverage you need.

Lenses made for the smaller format can't be used on a full-frame camera without dark edges appearing on the picture because the smaller image circle doesn't cover the whole of the sensor. In fact, you can't fit one of Canon's smaller format lenses onto its professional cameras. On a Nikon D3 or D700, you can turn off the outer portion of the sensor when a DX lens is fitted so that you don't see the dark vignetting, but you don't attain the full benefits of having a larger sensor. However, if the reverse is true and you're using a smaller format dSLR, you can mount lenses designed for full-framed cameras. There are advantages in doing so because the smaller sensor cameras use only the center part of the lens, where the image is usually clearer and brighter.

A full-frame dSLR has a larger and brighter viewfinder than a cropped-sensor camera, which can be a big advantage. Also, the depth of field with the same aperture is slightly shallower on a full-framed camera than it is on a cropped-sensor camera.

All these are reasons why professionals frequently gravitate toward using full-framed dSLR cameras and are prepared to pay much higher prices for the privilege of doing so.

Choosing the Right Lens for the Job

Deciding what lenses to buy for your collection is a matter of personal choice (see Figure 6-25). Although some lens sizes are suitable for certain kinds of photography, it's not always so. Some of the most creative photographers bring their own style by selecting lenses and viewpoints that aren't traditional for the type of photography they do. In recent years, I've seen a few weddings shot with a fisheye lens for candid scenes that looked quite good. Experimentation and self-expression are part of the art of photography.

Figure 6-25

Conversely, learning to get the best from the tools you have instead of relying on yet another lens in your bag is very rewarding and will ultimately make you a better photographer. Of course, if you simply have to add a picture of a Pied-billed Grebe to your collection, I'm guessing you've already resigned yourself to a large and expensive telephoto lens purchase that will capture this rare marsh bird in all its glory.

Without further ado, the following sections run down some points to consider when buying a new lens.

Keep in mind that every photographer has different needs, budgets, and styles, making the choice of lenses a very individual decision. I recommend you search reviews online and ask knowledgeable friends to help.

Type of photography

The first consideration when buying a new lens is to ask yourself how it will be used. A large telephoto lens might be great for capturing sports action or birds at a distance, but if the action is in low light, you'll need a faster lens to obtain a fast-enough shutter speed to freeze it. A zoom lens with a large range of focal lengths, such as an 18–200mm, is very handy, but if you need only the larger focal lengths on the zoom, you could be trading quality for a zoom range you don't need. A portrait lens with a maximum aperture of f/3.5 might be fine at the beach, but in low light, you might want a lens that gathers light faster, such as a 50mm f/1.4. All these are reasons to weigh your options carefully.

Table 6-2 lists typical focal lengths for different types of photography. These are for full-frame dSLR cameras, so remember that you need to convert them if you have a cropped-sensor camera.

Table 6-2	Typical Focal Lengths for Photography Types	
Focal Length	*Lens Type*	*Photography Type*
Less than 18mm	Extreme wide-angle	Architecture
18– 35mm	Wide-angle	Landscape
35– 70mm	Normal	Photojournalism and street
70–135mm	Medium focal-length telephoto	Portraiture and closer-up sports
135– 300mm and greater	Longer focal-length telephoto	Sports and wildlife

Like all technology products, dSLR cameras change very quickly. You'll find that your particular camera model will be superseded by a better one in no time at all. However, lenses tend to be around for a long time, and even a few older lenses can be used with a modern dSLR camera, although getting a *really* old, mechanically operated lens to work on a modern-day electronic marvel body isn't easy or even possible. However, with most lenses supporting electronic connections, I tend to think of my dSLR as a quickly depreciating asset, but consider my lenses as an investment.

When you start adding to your lens collection, you're committing yourself to the system of a particular manufacturer because each produces a lens-mounting system unique to them. Unless you're wealthy, you won't want to change to another camera manufacturer after you add lenses to your collection; otherwise, you have to buy all your lenses again. It's worth checking the range and reputation of lenses the camera manufacturer offers before buying one of its dSLR cameras.

Cost

Lens prices vary a great deal. A high-quality lens can easily cost ten times more than a budget lens of the same focal length. If you have special needs, such as long focal-length telephoto (if, for example, you're shooting bears in Alaska) or very fine macro photography (if you're an entomologist shooting tiny insects), lenses can be thousands of dollars. Sometimes saving money with after-market lenses doesn't always produce results or performance you may demand, although in some cases they may work very well. You can also look at a variety of reputable websites where used lenses are for sale, such as www.keh.com, and are rated and priced according to their condition.

TIP I suggest that you begin with a few important lenses, depending on your shooting needs, and spend more on good quality, as opposed to getting a bunch of cheap glass. It's often a good idea to buy a camera body alone and not a kit, as well, because oftentimes you will find the lenses in kits aren't the best quality and you pay extra for them.

Size and weight

Carrying a large lens on your camera can get old very quickly. When I'm on vacation, I take only an 18–200mm compact zoom lens. Although the zoom isn't the crispest, by the end of the day, I'm glad I haven't carried around a 28–70mm zoom and a 70–200mm zoom, even though the quality of those lenses is better. Lenses designed for cropped sensors are smaller and lighter than their full-framed counterparts and make ideal travel lenses; just be sure that your camera supports these lenses. However, if you plan to spend a lot of time shooting, you'll want to find an equipment bag that adequately and safely holds all your gear, and that you can comfortably wear for long periods.

Cropped or full frame

When camera manufacturers started making lenses for their cropped-sensor dSLRs, they could make them smaller and lighter. The disadvantage of these lenses is that they can't be used with dSLR cameras that have different- or full-sized sensors, either at all or without severe limitations. However, lenses made for full-size sensors can be used with cropped-sensor cameras. So, if you buy a DX or an APS-C lens, you're limiting its use to a cropped-sensor camera. Think about this if you think you're likely to upgrade your camera to a full-frame model in the future.

Zoom or prime

Zoom lenses are very convenient because they give you a range of focal lengths in one lens package. Traditionally, zoom lenses were considered lower quality with more apparent aberrations when used at the same focal length as a prime lens. For higher-quality professional zoom lenses, this is no longer the case, with many lenses performing well when compared to an equivalent prime lens. There is still the case for prime lenses, however, because they give exceptional image quality, sometimes (but certainly not always) at a price lower than an equivalent zoom lens.

Maximum aperture

A greater number of available aperture settings on a lens allows for more choices in the depth of field that can be set. Also, a lens with a large maximum aperture (small f-number) that remains fixed at all focal lengths allows you to take pictures in situations with lower light. An f/2.8 lens, for example, is four times faster than an f/5.6 lens, whereas an f/1.4 lens gathers light 16 times faster than an f/5.6 lens.

Fast lenses, as they are called, are more expensive than lenses with smaller maximum apertures because of the higher quality standards of glass and manufacturing needed. I've heard it said that fast lenses are becoming less important as cameras are able to give better and better high ISO performance. The idea is that if you need a fast shutter speed in low light, you can simply increase the ISO sensitivity of your camera without a significant loss of image quality. This might be true for wildlife and sports photography, but for many photographers, the ability to achieve a pleasing out-of-focus background makes fast lenses desirable objects.

Lenses usually perform at their best when stopped down one or two stops from their maximum aperture. Some fast lenses just don't give as sharp a picture when used at their maximum aperture.

Original manufacturer or third-party lenses

Third-party manufacturers also make lenses with mounts made to fit many dSLR brands. Many of these lenses are high quality, but cost less than an equivalent lens from the original camera manufacturer.

Summing Up

You now know

- ✔ The terminology for different types of lenses
- ✔ The relationship between focal length, magnification, and angle of view
- ✔ Why the same focal length gives different results on full-frame and cropped-sensor cameras
- ✔ The features of lenses among different manufacturers

Know This Tech Talk

crop factor: Also known as *focal-length multiplier,* this refers to an image sensor that has been made smaller, either to fit into a smaller camera body or to perform faster. Lenses perform differently with cropped sensors, being able to capture less area and affecting depth of field.

fisheye lens: A special wide-angle lens capable of capturing a very wide field of view, up to 180 degrees, but with significant distortion.

focal length: The distance from the optical center of the lens to the sensor when the lens is focused at infinity. Focal length is usually measured in millimeters. The longer the focal length, the greater the magnification of the image and the narrower the field of view.

maximum aperture: The largest aperture to which a lens can be set, shown as markings on the lens barrel. For example 1:2.8 indicates a maximum aperture of f/2.8. Some zoom lenses have two settings for the maximum aperture, such as 1:3.5–5.6, indicating the maximum aperture varies with the focal length of the lens between f/3.5 and f/5.6.

normal lens: Also called a *standard* lens, of medium focal length and optimized to make images look as the eye would see them, such as for portraits.

telephoto lens: A lens with a longer focal length, capable of making faraway subjects look closer.

tilt-and-shift lens: A lens able to change perspective, such as converging angles in architectural subjects.

wide-angle lens: A lens with a shorter focal length that's able to capture a wide field of view.

zoom lens: A lens that allows you to vary its focal length by turning a ring on the lens body.

Lesson 7

Transferring, Sharing, and Printing Your Photos

- *Connect your camera to a TV* to display slide shows for your family and friends.

- Transferring your pictures to your computer allows you to *edit and organize your pictures*.

- *Save your photos at their maximum possible size* to be sure larger prints look great.

- Family and friends around the world can view and comment on your pictures when you *share your photos online*.

- *Printing from your home printer* gives you direct control over the color-reproduction process.

The immediacy and flexibility of digital photography gives you almost unlimited scope for what you can do with your pictures, either electronically or as prints. Sharing them online; making prints, albums, and slide shows; or even displaying them on mugs and t-shirts is all within your grasp. There is also virtually no limit to the number of pictures you can take because you don't need to buy a roll of film every time you want to take pictures.

The downside, of course, is that you can begin to feel swamped by the all digital images you've captured. Transferring, organizing, archiving, and printing can be confusing even for experienced photographers. This flexibility also makes it difficult for me to write about what you can do with your digital photography because you can achieve the same result in many ways and each combination of camera, computer, and printer is different. Therefore, in this lesson, I offer specific solutions when possible and general advice when appropriate.

Transferring Your Pictures to Your Computer

Moving your pictures from your camera to your computer is a relatively simple operation. Recent versions of Windows and Macintosh operating systems do much to recognize and support digital photography operations on desktop and laptop computers. You can either transfer your files directly from your camera to your computer with a USB cable, or you can remove the memory card from your camera and place it into a memory card reader that's attached to your computer via a USB cable or perhaps integrated with your computer. Both methods work fine, but using a card reader is usually faster than connecting your camera to the computer, and it doesn't drain the battery on your camera, so that's the method I use the most.

Connecting to your computer through a card reader

To transfer your images via a card reader, your computer may have an integrated card reader slot, like the one shown in Figure 7-1. If you have a card reader slot on your desktop computer or laptop, it's probably compatible with a range of card types. Check your computer documentation to see whether your card can be read by your computer.

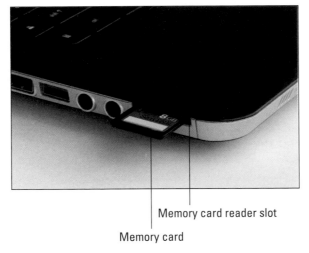

Memory card reader slot

Memory card

Figure 7-1

Most dSLRs use either Secure Digital (SD) cards or CompactFlash cards. Laptops typically only support a limited number of cards, and often just SD; CompactFlash is less common and more typically found on external card readers (but not all) and on desktop computers supporting multiple cards. If your card type isn't supported or you don't have a memory card reader built in to your computer, you should look at buying an external card reader; these are available at most electronics and camera stores for around $15–$25.

To connect your memory card, either insert it into the computer memory card slot, or insert it into a USB memory card reader and attach the reader to an available USB port; then skip ahead to section, "Starting the transfer process," later in this lesson.

Connecting your camera to your computer

If you want to connect your camera to your computer using a USB cable, follow these steps:

1. **With your camera turned off, connect the smaller plug on the USB cable into the A/V Out port behind the rubber door on the side of your camera, as shown in Figure 7-2.**

If you plan to use this method, first check that your camera battery is sufficiently charged. If the battery is low, charge it. Losing power to your camera interrupts the connection with your computer and could cause problems, including losing picture data.

2. **Connect the larger plug on the USB cable to an empty USB port on your computer.**

3. **If your computer is powered off, turn it on and allow it to start normally.**

4. **Set the camera exposure mode dial to any mode (except Video, if it has one).**

5. **Turn on your camera with the On/Off switch.**

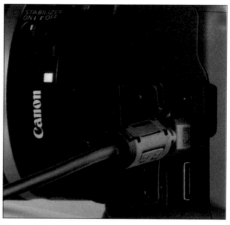

Starting the transfer process

Figure 7-2

After you connect your camera to your computer or insert a memory card into the card reader, what happens next depends on the computer operating system you use and the software tools you've installed. I can't supply steps for every possible downloader, but I can group them into several possible scenarios, as I describe in the following sections.

Transferring with an installed software tool

Your dSLR camera may have been supplied with a software disc containing image transfer and editing tools from the camera manufacturer. Adobe Photoshop Elements, ACDSee, Corel Paintshop Pro, Adobe Photoshop Lightroom, and other image-editing software also have their own transfer utilities. When you connect your camera, whichever tool you have installed opens on your computer and asks whether you want to initiate image transfer with it. On the Mac, iPhoto may open up asking whether you want to transfer the files into the iPhoto library. If you want to learn how to use these applications, refer to the manufacturer-supplied documentation or visit the respective manufacturer websites to find instructional videos on their use.

You can usually turn off the option to automatically start any of these software tools in the preferences for the particular tools you have loaded. If you can't find this option, consult the Help system for the software.

Transferring with your operating system

After your computer recognizes your camera or the memory card you've inserted, a dialog box appears on your computer screen. If you're using Windows 7, for example, you see the AutoPlay dialog box shown in Figure 7-3. The steps for transferring your images varies, depending on the operating system you have installed.

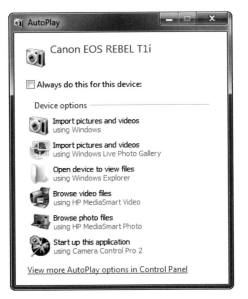

Figure 7-3

EXTRA INFO

If no Import tool or dialog box opens when you connect your camera or insert your memory card, the AutoPlay option might be turned off. If you wish to turn it on in Windows 7, for example, choose Start⇨Control Panel⇨AutoPlay. Then in the AutoPlay dialog box, make sure the Use AutoPlay for All Media and Devices check box is selected.

The rest of these steps assume you're using Windows 7, so if you're using a different operating system, consult your help files for transfer details.

Follow these steps to transfer your photos in Windows 7:

1. **In the AutoPlay dialog box, select the Import Pictures and Videos option.**

 The Importing Pictures and Videos dialog box opens, as shown in Figure 7-4.

2. **If you want, enter a textual tag, which is a word or phrase that describes your photos.**

Adding a tag makes it easier to find the pictures on your computer because you can search for the tag.

3. **If you want to change the Import settings, click the Import Settings link and then change the options shown in Figure 7-5. When you're finished, click OK.**

Figure 7-4

Figure 7-5

4. **Click the Import button to start importing your photos.**

You can watch the progress of the import process onscreen. Windows 7 saves your photos in your Pictures library in a subfolder with the date and tag as the name, as shown in Figure 7-6.

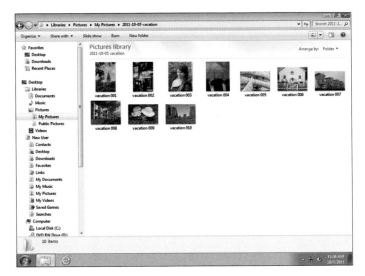

Figure 7-6

If your memory card or dSLR camera is connected correctly, you see it listed as a drive in Windows Explorer. You can then drag and drop the files to wherever you want them on your computer. If you want to use your photography software tool to transfer the images, simply start the tool and select the transfer or import option from its menus to begin the transfer.

Viewing Your Pictures

After you capture some fine pictures with your dSLR camera, you'll want to look at them and share them. In Lesson 1, I explain how you can review pictures on your camera and delete them or lock them so that they can't be deleted accidentally. In this section, I expand on some of the viewing options available on most cameras.

Viewing your images as a slide show

One of the many benefits of digital photography is that with editing software, you can combine your images into slide shows that can be shown on your computer or burned onto DVDs to send to your friends or relatives. You can even add music and slide transitions that create an entertaining experience for your audience. If you don't have the computer and software available, don't have time, or simply want to share your images immediately, you can view a simple slide show of images on the LCD screen of your camera. You

can also connect your camera to a TV and display the slide show on it (as described in the next section).

To set up and run a slide show on your camera, follow these steps:

1. **Choose the Slide Show option from the camera menus, as shown in Figure 7-7.**

 The steps for creating and running a slide show vary by camera, so check your camera manual for specifics for your camera model.

2. **Select the images you want to play in the slide show.**

 For the camera menu shown in Figure 7-8, for example, you can choose one of four options:

 - *All Images:* This option plays all images and movies on the memory card.
 - *Date:* This option plays images and movies recorded on a specific date. Press the Disp button to show all the dates available for selection and then use the up and down multi-selector keys to choose the date you want.
 - *Movies:* This option plays only movies saved on the memory card.
 - *Stills:* This option plays only pictures saved on the memory card.

3. **Choose the Set Up option.**

4. **Set how long you want each slide to display and whether you want the slide show to stop when it's finished or repeat until you stop it, as shown in Figure 7-9.**

5. **Choose Start.**

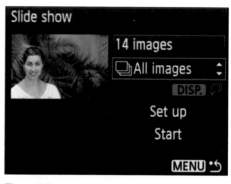

Figure 7-7

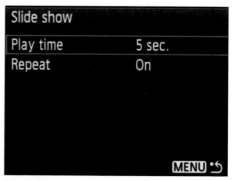

Figure 7-8

Figure 7-9

If some of the images you took with your camera in portrait orientation don't display the right way, select the Auto Rotation option from your camera menus.

During the slide show, you can control playback with the following options, which vary by camera:

- **Pause the slide show.** To pause the slide show, press the Set (or OK) button; press Set (or OK) again to resume.

- **End the slide show.** Press the Menu button to stop the slide show and return to the slide show setup screen.

- **Change the display screen.** Press the Disp button (or press the multi-selector up or down) to change the still image display to one of the information screens.

- **Move to the next or previous image.** Use the left and right multi-selector keys to skip to the next or previous photo in the slide show.

- **Return to shooting mode.** Press the shutter-release button halfway.

Connecting your camera to a TV

You can make your slide show–viewing experience better and share it with a larger audience by displaying it on a TV screen. Your camera is equipped with video-out ports for connecting your camera to your TV. Most dSLRs have two ports: one for a standard-definition connection and one for a high-definition connection. You can find the video outlets on the side of your camera, as shown in Figure 7-10.

If your television isn't high-definition and doesn't have HDMI inputs, you need to use the standard A/V connection. Most cameras come with an A/V cable as standard, so connection is easy.

To connect your camera to your TV, follow these steps:

1. **Make sure your camera is turned off.**

2. **Choose the method to connect your camera to your TV and select the correct cable for the job.**

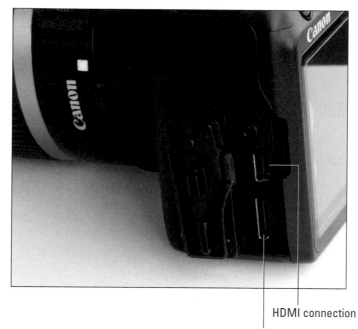

HDMI connection

Standard AV connection

Figure 7-10

The A/V cable, which usually comes with your camera, has from one to three connectors at the TV end, depending on whether your dSLR shoots video. The yellow connector carries the video signal, and other connectors carry the audio channels. The cable looks similar to the ones shown in Figure 7-11.

Figure 7-11

If you have an HD television, connecting your camera to your TV with an HDMI cable gives you better picture and audio quality. You'll need to buy the HDMI cable separately. Some cameras use a standard HDMI cable found in your existing home entertainment system setup, whereas other cameras use a Type C mini-HDMI cable or a standard Type A HDMI connector. Check the accessories section in your camera instruction manual for a part number.

3. **Open the rubber cable cover on the side of your camera to access the video-out ports. Then connect the A/V or HDMI cable to the correct port on your dSLR.**

4. **Connect the other end of the A/V or HDMI cable to your TV.**

If you're connecting to a standard TV, connect the A/V cable to the TV's Video IN terminal and the Audio IN terminal. If you're connecting to an HDTV, connect the HDMI cable to the TV's HDMI IN port.

Look in your TV instruction manual for information on where to connect the cable for your TV model.

Don't use an A/V connection and an HDMI connection together. Connect only one type!

5. **Turn on your TV and switch to the correct video input for your connection.**

6. **Turn on your camera to send the signal to your TV.**

7. **Press the Play button on your camera.**

The first image will then appear on your TV screen. Use the camera Slide Show controls (described in the preceding section) to control the display on your TV.

Video system ▶ NTSC
 PAL

Figure 7-12

EXTRA INFO

You may need to change the video output system format on your camera, as shown in Figure 7-12. The NTSC video standard is used in North America as well as some countries in South America and Asia. SECAM is also used in parts of Asia and Africa, and PAL is used more commonly in Asia, as well as Africa and South America.

Sharing Your Pictures Online

You have all these great pictures on your dSLR and want to send them out into the world to gather praise for your skills as a photographer and delight your friends and family. In this section, I describe some of the options available and discuss some points to consider when sending pictures over the web or putting pictures on websites.

Sharing via e-mail

When you want to e-mail someone a picture, knowing what the recipient of the e-mail will do with the photo helps. If she's simply going to view the picture within the e-mail message, it requires a different approach than if she needs to print a good resolution copy of it.

Computer screens can't display the large number of pixels available in the images you capture with your dSLR, so if you insert a large image into your e-mail, the recipient won't be able to view the whole picture without scrolling, as shown in Figure 7-13, or downloading it into an image viewing and/or editing program like Photoshop Elements.

Figure 7-13

A large image also takes much longer to send and receive, especially on a smartphone, so unless your recipient needs a large picture for printing, resize the image before sending it. Keep in mind that most e-mail service providers restrict the size of attachments that can be received, so if you send large files, you can fill the recipient's server allocation and prevent him from receiving further e-mails until he downloads your pictures.

If you have to e-mail large picture files, put each picture file into an individual e-mail. Warn recipients that they're about to receive some hefty data and try to space the e-mails apart so they have time to download them. Compressing JPEG files with programs, such as WinZip, has very little effect on the size of them because these files already contain compressed data.

You can resize images using any picture-editing application. I try to resize my images for e-mail to a maximum of 640 pixels on the largest dimension, as shown in Figure 7-14. Then when you insert the image into your e-mail message, your family and friends won't have to scroll across or down to see the whole photo, as shown in Figure 7-15.

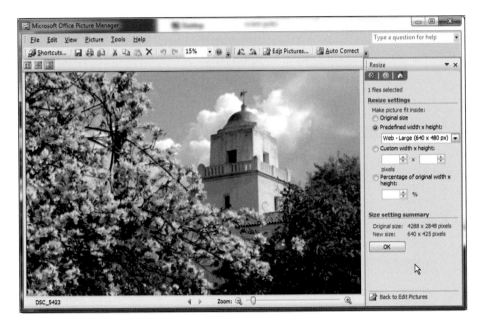

Figure 7-14

Adobe Photoshop has a special option for resizing images: Save for Web & Devices. When you select this option, Photoshop saves an image optimized for the web and mobile phones by stripping a lot of non-viewable data. The Save for Web & Devices option makes the file size of a resized image much smaller than the normal Save As option. Other applications, such as ACDSee, also have similar options to easily resize images for various applications; for instance, in ACDSee Pro, you can select Send and the program automatically resizes your image for e-mail (you can customize the size), launches your e-mail application, and attaches it to an e-mail for you.

Figure 7-15

Sharing pictures through photo-sharing sites

Photo-sharing sites enable you to upload your images so you can store and share them with family and friends. Most of these sites also offer the ability to order prints. Some of the well-known photo-sharing sites are Flickr (www.flickr.com), SmugMug (www.smugmug.com), Shutterfly (www.shutterfly.com), Photobucket (http://photobucket.com), Fotki (www.fotki.com), and Webshots (www.webshots.com), all shown in Figure 7-16. Check out these sites and others by searching for *best photo-sharing sites* on the Internet and comparing the features and reviews.

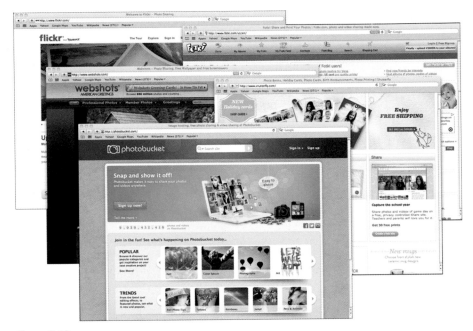

Figure 7-16

These sites are communities, so unless you make sure to keep your pictures private, they can be viewed by anyone on the Internet. Some issues to consider when choosing to put your pictures on the Internet include the following:

- ✔ **Photo-sharing sites can go away if the company hosting them ceases to exist, taking all your online pictures with them.** Some free sites delete your images if you don't order prints from them after a set amount of time. Make sure you have local copies of your pictures.

- ✔ **Many sites censor images and accept only family-friendly content.** This vague definition can confuse many people. For instance, the definition of *family-friendly* may vary in different countries.

- ✔ **Some sites download malware,** such as toolbars that cannot be removed by normal means, to your computer.

- ✔ **The U.S. Department of Homeland Security routinely monitors popular photo-sharing sites.** You might see this as a good or bad thing.

- ✔ **Some free photo-sharing sites reuse your images in any way they see fit.** Make sure you read the terms and conditions.

- ✔ **Others can pirate your images.** One Missouri family, for example, found their Christmas photo used to advertise a grocery store in the Czech Republic.

Photo-sharing sites are often free services supported by advertising and printing, or subscription services supported by user subscriptions and printing. Some, including SmugMug (www.smugmug.com), offer a complete range of site customization tools and features in support of professional photographers. SmugMug doesn't have an in-house printing lab but does give users a choice of two labs: a quality quick-print service and a professional-quality lab. You can upload high-resolution images and download them again, or order a backup DVD of your pictures.

Sharing pictures via social networking sites

Social networking sites, such as Facebook and Twitter, make it possible to share your photos instantly with all your family and friends, even from a mobile phone. On Facebook, friends can also tag photos you appear in to make a collection of pictures in which you and your friends appear together.

You can upload photos to your Facebook Wall to appear in your News Feed, or you can create albums of photos that people can browse.

To upload pictures (without creating an album), follow these steps:

1. **Log in to Facebook at** www.facebook.com **and then click Add Photo/Video, as shown in Figure 7-17.**

Figure 7-17

2. **Click Upload Photo/Video, click the Choose File button, and select the photo you wish to upload to your Facebook Wall from your computer. Then click OK.**

3. **(Optional) Enter a comment to say something about this photo.**

4. **Choose who can view the photo from the Friends drop-down list, as shown in Figure 7-18.**

Figure 7-18

5. **Click the Post button to post the picture on your Wall.**

To upload multiple pictures to an album, follow these steps:

1. **Log in to Facebook and click Add Photo/Video.**

2. **Click the Create Photo Album link and then click the Select Photos button.**

3. **In the Open dialog box, select the photos you want to include in the album and then click OK.**

You can choose multiple pictures to upload by holding down the Ctrl key (Windows) as you select files from your computer.

4. **Enter an album name and location, and choose the quality and privacy settings for the album, as shown in Figure 7-19.**

If you intend to print your pictures from Facebook, upload your photos with the High Resolution setting.

Figure 7-19

5. **Click the Create Album button.**

6. **In the Edit Album screen that appears, edit the album information as desired and click the Publish Now button to post your album.**

Links to pictures and albums appear in your Facebook Wall and in your profile, as shown in Figure 7-20.

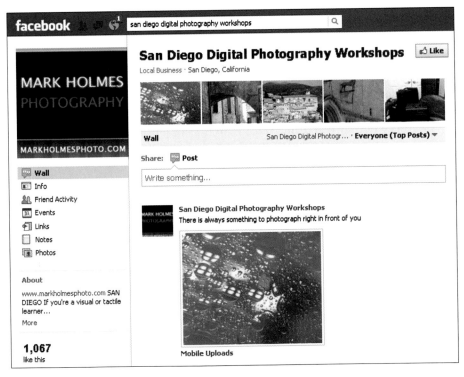

Figure 7-20

If you want to print pictures from your Facebook account, you need to install one of the third-party photo-printing services that Facebook makes available. For example, if you type **Qoop** in Facebook's search engine, you get a photo-printing application that lets you print more effectively from Facebook; see Figure 7-21. There are other Facebook-specific apps you can find to help you print.

Printing Your Pictures

Getting the best prints from your pictures requires a little bit of knowledge and planning. In this section, I give you some tips on preparing your images for printing and give an overview of some printing methods.

Preparing your pictures for printing

Figure 7-21

Whether you print your pictures on your own printer or send them to a printing service online or in a store, you need to be aware of a couple things prior to a print run.

The quality of your prints is directly related to the number of pixels in the image. If you try to print a large copy of a small image, the picture will come out fuzzy with jagged lines because you've blown up the picture beyond its usable resolution, as shown in Figure 7-22. The highest pixel count gives you the best flexibility over print sizes and resolution, so try to use the highest file size and quality setting in your camera when taking the pictures. (See Lesson 1 for details.)

Figure 7-22

Figure 7-23 shows the Photoshop Image Size dialog box. To change the print size, change the Height and Width dimensions, but do not manually change the value in the Resolution box. The resolution changes as you change the print size. As long as the resolution stays greater than 180 pixels per inch and preferably greater than 200 pixels per inch, you'll achieve a good quality print for typically sized photographs. I don't advise that you change the print size or resolution of your images if you send the file to be printed by a commercial or online printing service. Keep the image at the value it came out of the camera, and the printing service will optimize it for their printers.

When you print your pictures, you usually do so in a number of standard formats, with popular formats being 4 x 6, 5 x 7, and 8 x 10 inches. The issue with these different formats is that your images require trimming to fit some of them. The proportions of your pictures from your dSLR camera are in the ratio of 2:3, which is an exact fit for 4 x 6 (or 8 x 12) prints. So, the images you shoot fit this format without any trimming. To print in the two other popular formats, some of the image will be cropped, as shown in Figure 7-24.

LINGO

If you resize your print in an editing program like Photoshop, don't **resample** the image. Doing so adds pixels if the image is made bigger and takes pixels out of the image if the image is made smaller. Resampling always detracts from the image quality. However, making an image smaller has less of a detrimental effect because it's easier for the program to work out how to delete pixels than it is to calculate how to add pixels if you make the image bigger.

Figure 7-23

8 x 10 crop

5 x 7 crop

Figure 7-24

If you leave at least a small margin around the subjects you shoot, it helps you avoid losing critical details when printing in these different formats. For portraits in particular, I tend to shoot the subject with her eyes between the halfway point and the top third when I plan to print 8 x 10 portraits. That way her head doesn't get cut off at the top of the picture, and her eyes fall on about the top-third line when cropped, as shown in Figure 7-25.

Whether you choose to create cropped versions of your pictures for printing in different formats or allow the printer to crop in the printing options is up to you, but be sure to save a copy of your original file so that you don't discard details that you might want later.

Figure 7-25

Printing on your home printer

Modern inkjet printers do an excellent job of printing your pictures in vibrant colors that won't fade and are resistant to water splashes. Just about any office or home inkjet printer can print pictures, but if you're a photography enthusiast, consider the following few points in your pursuit of the best prints possible.

Deciding on a printer

If you don't already own a photo printer, that's a good thing because you can take time to investigate the options to find a printer that's right for you and the type of printing you do. Maybe you have your own home business, so you need a fax, copier, and scanner, or maybe you have a house full of kids who all need a printer to print homework projects. In those cases, you might want to consider a home office all-in-one printer that offers all the functions you need. A printer like that will still do a credible job of printing your pictures, but it might lack the speed, printing flexibility, and depth of color that you can attain with a printer optimized for photo printing.

EXTRA INFO

You can print images directly from your camera to a compatible printer without needing to first transfer your pictures to a computer. This feature can be very useful when traveling. You could, for example, take pictures at an event or meeting and print them immediately to leave with the attendees. Some very compact travel printers allow you to take a printer with you wherever you go.

Two printer formats that help you print directly from your camera to a printer are PictBridge and DPOF. Look for these formats in the specifications for your printer, if printing directly from your camera is something you think you'll be doing:

- **PictBridge** allows your camera to be connected directly to your printer with a USB cable. Your camera and printer then communicate with each other to allow you to select JPEG pictures to print. You control this from the LCD screen on your camera while you review pictures. Unless both your camera and computer are PictBridge compatible, you don't see the PictBridge symbol enabling you to select pictures for printing during playback.

- **Digital Print Order Format (DPOF)** creates an electronic order form of JPEG pictures you want to print and saves it on the camera card with your images. You can then plug your camera memory card into the card reader slot on your printer, which reads the print order and outputs the selected images.

If you're interested in using these features, your printer and camera manuals should provide details.

Photo printers fall into two types:

- ✔ **Inkjet:** A very common type of printer, where different colored inks are combined by the printer and jetted onto photo paper made for photo ink. These can be very good-quality photo prints, depending on your printer's resolution and if it uses multiple ink colors (six or more) individually to combine in a full-color photo. Ink can get expensive, however!

- ✔ **Dye sublimation:** A more mature technology than inkjet, it works by fusing colored dye from different colored sheets onto the paper with heat. It's a very reliable technology and produces great results. However, because dye sublimation works by transferring colors from a cellophane ribbon to the print medium, print sizes are more limited. The ribbon needs to be the same size as the medium you're printing on. Also, if you print just one dot of color on a page, you use up exactly the same amount of dye as printing a whole page of color because the part of the ribbon used to print the dot can't be reused.

The flexibility of inkjet printers makes them a good choice for most photographers, with Canon, Epson, and HP offering dedicated photo printers up to a professional level. The Canon PIXMA Pro9500 MkII printer, shown in Figure 7-26, uses ten pigment-based ink colors and can print professional-grade prints up to 13 x 19 inches.

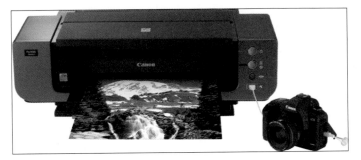

Figure 7-26

When deciding on a printer, consider not just the price of the printer, but also print quality, printer features, the cost of ink cartridges, the number of prints you can expect from ink cartridges, supported media types, and support options. To compare printers, it's important to work out the total cost of ownership of each printer against the quality, flexibility, and features offered. An inexpensive printer might look like a bargain but can turn out to be expensive when you add the price of consumables. Some printers use all their ink and paper running periodic print cartridge cleaning and alignment routines, even if you print nothing on them! Other options to minimize cost exist for high-end inkjet printers, such as after-market ink tanks delivering a steady flow of ink to your printer and allowing you to use larger quantities of ink purchased by the liter or gallon.

> **EXTRA INFO**
>
> Dye sublimation used to be better at printing photos than inkjet technology because of the smooth tones it produces, but advances in inkjet technology over the years have mostly eliminated this advantage except with very high-end, professional printers. (In fact, many professional printing labs today still use film and film chemicals with photo-sensitive paper.) The extra color cartridges in some inkjet printers allow them to produce vibrant colors and deep blacks.

Getting the color consistent

In Lesson 3, I touch on how to maintain consistent color from capture to print. I describe how each step of the process can change how a color looks to you. If the colors on your computer monitor are slightly cold with blue tints, for example, color-correcting your pictures on your monitor can result in prints with too much red in them. This is because you need to calibrate your computer monitor so that the colors that appear on-screen are representative of how they will look when printed.

Monitor brightness is also important. Computer displays are usually very bright, making them great for displaying web pages. However, your photos can look brighter than they actually are on a computer screen, so when you print them, they look underexposed.

When the colors of a print don't match the ones on your computer screen, it's a good idea to make sure your computer monitor is properly calibrated using the color calibration tool for your operating system. Otherwise, the colors you're viewing won't be a true representation of the colors in your images.

For a Windows 7 system, follow these steps to calibrate your monitor:

1. **Click the Start button and open the Control Panel.**

2. **Click Personalization.**

3. **Click Display.**

4. **Click the Calibrate Color link on the left.**

 If you're not logged in to your administrator account, you'll be prompted to do so.

 The Display Color Calibration window appears, as shown in Figure 7-27.

Figure 7-27

5. **Follow the onscreen prompts to step through the calibration process. Click Next when you're finished with each screen.**

6. **When you're finished calibrating your monitor, click the Finish button.**

Macintosh users can run the color calibration tool by follow these steps;

1. **Open System Preferences and click the Displays icon.**

2. **Click the Color button.**

3. **Click the Calibrate button.**

 The Apple Display Calibration Assistant appears, as shown in Figure 7-28.

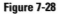

Figure 7-28

4. **Follow the onscreen prompts to run the Apple Display Calibration Assistant.**

5. **When you're finished running the calibration assistant, click Done.**

Dealing with other printing problems

After you have your computer screen calibrated properly, dramatic shifts in color are usually relatively easy to track down. If you see changes in color when you print, check the following:

LINGO

When you have finished the calibration process, the data is stored in a **profile** file that loads each time your computer starts. Because colors can drift over time, perform this process monthly.

✔ **Is an ink cartridge blocked?** This is common with inkjet printers that use microscopic nozzles to spray ink onto the print medium. Run the Printer Cleaning and Alignment utility to correct this. Some printers run this utility periodically without intervention.

✔ Is the wrong paper setting selected?
The type of paper you select in the Print Setup dialog box is important because the ink is added to the page differently depending on the type of media you use, and will produce poor results on the wrong paper.

✔ Are you using cheap printing stock?
You won't get as good results from inferior off-brand photo paper than you will with paper designed specifically for your printer.

✔ Is there a color management conflict?
Either your software should control color or the printer should control color, but not both. In most cases, you want the photo-editing software to control the print colors so that they reflect what's onscreen. In Photoshop, set this in the Print dialog box and disable it in the print settings page, as shown in Figure 7-29.

GO ONLINE

These utilities do a fair job of calibrating your computer screen, but if you want something more accurate, you may want to invest in a hardware and software combination solution, such as a spectrophotometer or colorimeter. The ColorMunki (www.colormunki.com) is a spectrophotometer that costs around $499. ColorMunki can profile your printer and screen as well as a projector, if you use one. A simpler colorimeter like the Spyder3Express (http://spyder.datacolor.com) costs around $89 and accurately profiles your screen.

Figure 7-29

Printing online or at a photo store

You have many options for online printing or in-store printing, and they're very cost-effective, especially when printing 4 x 6 or 5 x 7 prints. Some allow you more control than others. Costco.com, for example, supplies printer profiles online that can be loaded into Photoshop to provide you with an accurate rendition of the colors on your computer screen. You can then submit them to be printed at a local Costco store, where you can go pick them up (you can also have them mailed to you). Note you have to be a Costco member to patronize their photo-printing services.

Many retailers have photo kiosks that allow you to print your pictures by inserting your camera memory card or even connecting to it with your Bluetooth cellphone. Walmart has complete installations of HP photo centers where you can create albums or calendars, or simply print batches of photos. At some of its stores, you can use an online photo-sharing site, such as Snapfish, to print in the store.

Printing at home versus via commercial services

The quality and speed of home printers keeps getting better, but contrary to what you'd think, printing photos at home isn't necessarily cheaper than sending your pictures to a lab. With prices around 19 cents for a 4 x 6 print, commercial printers compete very favorably on price with at-home printing. An equivalent 4 x 6 print from your home printer is more difficult to price accurately because you have to figure in the cost of the printer, ink, electricity, and repair over the life of the printer. I've seen average costs of 40 cents per 4 x 6 print quoted in many online forums for printing at home. The cost goes down depending on how large the print is until you reach the maximum print size for your printer, often making it cheaper to print at home for larger prints.

Cost is not the only consideration for whether you print at home, however. Some of the other advantages and disadvantages include the following:

- ✔ **Printing at home is fun!** Some people just like to do things for themselves and like the extra control provided when creating their own prints.
- ✔ **The results are immediate.** Printing at home means you get the print immediately. On the flipside, commercial printers are very fast. If you use one of the in-store kiosk systems found at large retailers, the chances are you can print 100 4 x 6 prints while doing your shopping and still get home with your prints long before your home printer would finish.

✔ **Printing at home is limited.** The size of the prints is limited to the size of your printer. Commercial printers offer print sizes up to giant banners and wall coverings. They also print on a variety of media, such as canvases or mugs.

✔ **The experts know what they're doing.** Commercial print labs deal with prints all day, every day. They can correct bad colors, interpolate data to make big prints, and use the best quality ink and paper. If you're an enthusiast or professional, you can build a good relationship with your lab to get exactly the output you want. Even consumer-type labs usually offer responsive customer service.

✔ **Sharing and printing can be linked.** With photo-sharing websites, you can easily set up galleries that allow your friends and family to choose the pictures they want to print and have the prints sent directly to them. Imagine what a pain it'd be to print wedding pictures on your own printer and mail them to relatives.

I'm not a big fan of home printing. As a commercial photographer, I don't find it cost-effective when I factor in my time. But if you like to print photos for scrapbooks, albums, and so on, printing from a home printer is convenient and useful. Don't let my opinions sway you from having fun with your printing!

 Summing Up

You now know how to move pictures to your computer and select the best printing and sharing method for you:

✔ You can transfer photos to your computer by connecting your camera or inserting your memory card into a reader.

✔ You can review your pictures and display them as a slide show.

✔ You can prepare your pictures for printing.

✔ You understand the options available for printing and sharing.

Know This Tech Talk

card reader: A USB device used to transfer images from a camera memory card to a computer.

CompactFlash: A memory card used mostly by dSLRs and offered in a wide range of capacities and speeds (for faster image storage from your camera).

dye-sublimation printer: A photo printer using thermal transfer of colored sheets to special photo paper, yielding professional-quality print images.

ink jet printer: A common type of printer using a set of inks sprayed through high-pressured nozzles onto photo paper to generate high-quality print images.

memory card: A CompactFlash, Secure Digital, or other type of memory card, which is inserted into your camera and used to store the images you shoot.

print resolution: How high-quality your image looks on paper, depending on the number of dots-(of ink)-per-inch, or dpi, you specified and are using. You typically need 300 dpi to have a typical print photo.

SecureDigital: A memory card used in a wide variety of digital cameras, including point-and-shoot and dSLRs. SD cards are small and come in a wide variety of capacities. Some SD cards with more capacity, called SDHC, can be incompatible with older cameras.

Lesson 8

Capturing the Shot

- ✔ Basic picture-taking options *make sure you're always ready to capture the shot.*

- ✔ Knowing how to *control exposure* puts you in control creatively.

- ✔ Make your pictures look professional by *posing portraits properly.*

- ✔ *Use a shallow depth of field* and control your aperture to make your portraits look great.

- ✔ Use flash to *improve your portraits.*

- ✔ Being in control of your shutter lets you *be creative with action shots.*

*I*n previous lessons, you have accomplished the following:

- ✔ Learned about the mechanics of your camera and how to adjust the shutter speed, aperture, and ISO to achieve a properly exposed picture.

- ✔ Experimented with the secondary effects of these settings, adding motion blur or freezing action through your shutter speed selection, or adjusting the depth of field with the aperture to bring more or less of the background into focus.

- ✔ Explored the different settings available for adjusting the white balance and color choices in your pictures.

- ✔ Worked with different focus settings to successfully capture still or moving subjects.

- ✔ Discovered how adding flash to your pictures can improve them or give a different creative look in certain situations.

- ✔ Learned how different types of lenses can affect your pictures creatively.

In fact, you now have all the tools you need to be a creative photographer. In this lesson, I show you how to bring together everything you've learned to capture the shots you're looking for in different situations.

Setting Basic Picture-Taking Options

When I put my camera strap around my neck, the first thing I do after turning on my camera is to check basic settings. These are settings I don't change very often, so I like to make sure everything is okay before I shoot. Otherwise, if I don't pay attention, I might find I've taken all my shots with a setting I didn't want.

If you're in Full Auto mode or have a scene mode selected, you probably can't change any camera settings because these automatic modes select settings for you. Because you want to be a creative photographer, all the settings I mention in this lesson assume you have your exposure mode dial on your camera set to one of the advanced modes (Programmed Auto, Shutter Priority, Aperture Priority, or Manual).

I detail the basic camera settings I recommend in Table 8-1.

Table 8-1	Recommended Basic Camera Settings	
Setting	**Recommended**	**Description**
Image Quality	Large/Fine JPEG, Large/ Fine JPEG+ Raw, Raw	If you shoot JPEGs, I recommend setting the best quality and largest size JPEG. If you shoot Raw files, either use Raw or JPEG+Raw. (See Lesson 1.)
Metering Mode	Evaluative/ Matrix	Evaluative/Matrix metering gives the most consistent results in normal situations. (See Lesson 2.)
Multi-Shot (or Drive) Mode	Continuous (Slow)	For continuous (multi-shot) shooting, some dSLRs offer you the option of shooting more or fewer frames per second. For now, leave it on the Slow setting. I often want two or three exposures anyway, so I use the Slow Continuous mode most of the time. This is sometimes called *drive mode,* a reference to film cameras using a motor-drive to quickly advance film to take lots of photos in rapid succession.
Autofocus Mode	One Shot/ Single-Servo or AI Servo/ Continuous- Servo	Use One Shot/Single-Servo focusing for static subjects, and AI Servo/Continuous-Servo for moving subjects. You could also use the intelligent switching option: AI Focus or Auto Area, but I prefer to select the focusing mode myself. (See Lesson 4.)
AF Point Selection	Single or Single Expanded	As personal preference, I set my camera to the center focus point and move focus points as I require. If your camera has expanded point selection, which allows your camera to expand beyond a single focus point if it finds sufficient detail to focus on, you can experiment with it. (See Lesson 4.)
White Balance	Auto	Auto White Balance does an okay job in most conditions. It's better to use Auto than have the wrong white balance selected, especially if you're shooting JPEGs. (See Lesson 3.)
Picture Style	Standard	I leave the picture style set to standard unless I'm shooting in-camera black-and-white pictures. (See Lesson 3.)
ISO	100	I always start with ISO set to as low as possible, which is usually 100 or 200 ISO, and elevate it only when the shot dictates it or if I know ahead of time I will need a higher ISO. I never use Auto ISO. (See Lesson 2.)

Create a mental checklist of the basic settings you use most commonly every time you turn on your camera. Although the current settings are usually available to see somewhere on your camera when taking the shot, it's amazing how many times you can overlook them. When I turn on my camera, I check the picture quality, white balance, and ISO, the controls for which are all conveniently positioned in one place on my camera, as shown in Figure 8-1. Take a moment to note how to access these important controls on your camera.

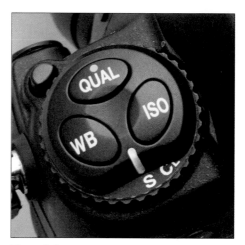

Figure 8-1

 You don't have to keep turning your camera on and off between shots as you walk around. If you leave your camera on, it turns off the metering and LCD display after a short period and enters a standby state until you press the shutter-release button halfway again. Your camera uses up very little battery power in the standby state and will always be ready when you want to shoot.

Mastering Exposure

In Lesson 2, I explain how an exposure is made by controlling the light that enters your camera with the shutter speed and aperture, while controlling your camera's sensitivity to light using the ISO (see Figure 8-2). If you change one of these three variables without compensating by setting another to counter it, your picture will become brighter or darker as you expose the sensor. Mastering these three variables and how they work together to create a good exposure gives you complete creative control over your camera.

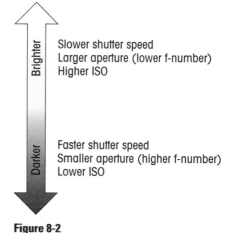

Brighter
Slower shutter speed
Larger aperture (lower f-number)
Higher ISO

Darker
Faster shutter speed
Smaller aperture (higher f-number)
Lower ISO

Figure 8-2

Your camera has a light-sensitive meter that calculates how much light it needs to make a good exposure. You don't

have to guess how much light your camera needs because, in the majority of instances, the camera meter gives a good estimate. In fact, once you're practiced at using your camera in a variety of lighting situations, you should be able to read a scene visually and come up with a reasonably good guess of what your best exposure should be. At the same time, you should be thinking about the type of light, situation, and subject you're about to shoot, and apply exposure settings accordingly.

For example, if you want to shoot a fast-moving car outside, you know you'll want a fast shutter speed — your priority exposure component — combined with a low ISO and then whatever aperture allows for the best exposure. You can let the camera set your aperture automatically in Shutter Priority mode, or you set it yourself in Manual mode.

All you have to do is set the variables of shutter speed, aperture, and ISO until the total amount of the light gathered satisfies what the camera's meter says it needs, which can be a very handy tool.

Controlling shutter speed

Consider making an exposure on a bright, sunny day. Suppose you want to take a picture of a waterfall and plan on using 1/60 of a second shutter speed to capture a little movement in the water. Because you're interested in shutter speed, you set your exposure mode to Shutter Priority (Tv or S) mode and dial in 1/60 of a second for the shutter speed. In Shutter Priority mode, you control the shutter speed (1/60 in this example), and the camera controls the aperture:

- ✔ With the ISO set to 100, your camera sets an aperture of f/22, as shown in Figure 8-3.

- ✔ If you increase the ISO to 200, your camera is twice as sensitive to light and needs only half the amount of light to make the same exposure. Your camera closes down the aperture to f/32 to restrict the light and make sure the light-sensitive buckets shown in Figure 8-3 are filled with just the right amount of light when the shutter opens.

EXTRA INFO

Setting the ISO higher than needed to achieve a usable shutter speed or aperture doesn't offer any advantage and just adds noise into your pictures.

- ✔ If you double the ISO setting to 400, you again double the sensitivity of the camera, and your camera — in theory — wants to close down the aperture to f/45. In reality, your lens probably can't close down to an aperture that small. Instead, the aperture setting flashes or displays Hi in the viewfinder because if you take the picture, you overfill some of the light-sensitive buckets and overexpose your picture.

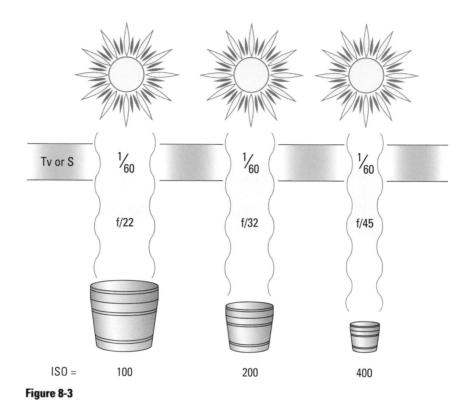

Tv or S	$\frac{1}{60}$	$\frac{1}{60}$	$\frac{1}{60}$
	f/22	f/32	f/45
ISO =	100	200	400

Figure 8-3

Controlling aperture

Suppose you want to take a portrait on a bright sunny day and want to set an aperture of f/5.6 to partially blur the background. Because you're interested in setting a particular aperture, you can set your exposure mode to Aperture Priority (Av or A) mode and dial in f/5.6. In Aperture Priority mode, you control the aperture, and the camera controls the shutter speed. It's a bright, sunny day, so the camera sets a shutter speed of 1/800 of a second because the ISO is set to 100, as shown on the left in Figure 8-4. The shutter speed changes if you change the ISO, in the same way that I describe in the preceding section.

Note that all the exposures shown in Figures 8-3 and 8-4 are equivalent. In these scenarios, the resulting exposure does not vary; only the variables (aperture, shutter speed, and ISO) are adjusted.

EXTRA INFO

You could easily do this exercise using Manual exposure mode, except you'd have to vary the shutter speed, ISO, and aperture because your camera doesn't automatically adjust one for you when you adjust the other.

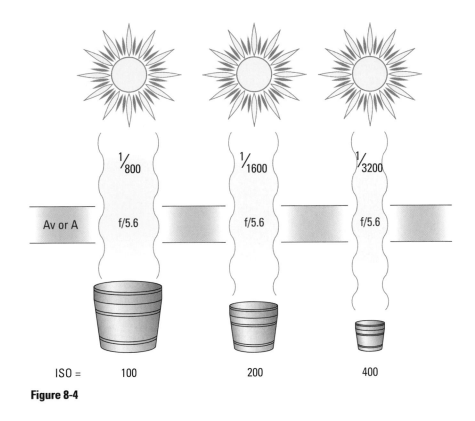

ISO = 100 200 400

Figure 8-4

> **WARNING!**
>
> When shooting in Aperture Priority mode, you need to watch the shutter speed so that it doesn't fall out of a usable range. Likewise, when shooting in Shutter Priority mode, watch the aperture setting that the camera sets. So many photographers get wrongly exposed or blurry pictures just because they forget to watch what the camera is doing.

Working with Exposure Variables to Take Great Photos

Working with the three exposure variables — shutter speed, aperture, and ISO — gives you complete creative control over your camera. Every picture is a problem for which the solution exists within the camera. Remember, however, that your camera isn't a magic box, so if you want to take the best pictures, you need to present your camera with the lighting conditions it can handle successfully.

Working with Exposure Variables to Take Great Photos

When deciding how to take any picture, you might typically follow this process:

1. **Think about what you want to achieve creatively.**

 Do you need a fast shutter speed to freeze action, a slow shutter speed to show movement, a wide aperture for a shallow depth of field, or a small aperture for a deep depth of field? What you want to do creatively determines whether aperture or shutter speed is the primary variable you need to set.

2. **Set the ISO to the lowest setting available on your camera.**

 You can start with ISO at its lowest setting for the best-quality pictures. As you become more experienced, you'll know when you need to raise ISO from the beginning of your shoot.

3. **Set the aperture or shutter speed based on your creative need.**

 If you want to control the shutter speed, set your camera to Shutter Priority or Manual mode and dial in the desired shutter speed. If the shutter speed is too slow to handhold, consider using a tripod or monopod. If you want to set the aperture, set your camera to Aperture Priority or Manual mode and choose the desired aperture.

4. **Decide whether your setting is a good exposure.**

 Chances are what you've set is a normal exposure. However, remember to dial in some exposure compensation to the plus side if the scene is mostly white like snow, or if your overexposure warning is blinking in your LCD image review (assuming you have the overexposure warning feature turned on). Or set exposure compensation to the minus side if the scene is mostly black like night. (See Lesson 2 for more on exposure compensation.)

5. **Watch the secondary variable (aperture or shutter speed).**

 Setting the aperture or shutter speed as the primary variable means you lock in its value and it won't change, but the secondary exposure variable is set by your camera, and it changes as the metered light changes (assuming you're not shooting in Manual mode). Therefore, if you set the shutter speed as the primary variable, make sure the aperture doesn't indicate it's out of range by flashing or indicating Lo or Hi. If you set the aperture, watch that the shutter speed doesn't drop below a speed where you can handhold your camera.

 If you're in Manual mode and you can't balance your meter when setting your secondary variable, your primary variable setting is out of range for the available amount of light.

6. **If the secondary variable is out of range, consider changing the ISO or using a different primary variable.**

 If you set a fast shutter speed and the aperture is out of range, or you set a small aperture and the shutter speed is too slow, you can increase the ISO until the secondary variable is within a usable range.

Alternatively, you might be able to adjust your primary variable (such as by taking the shot at 1/400 instead of 1/500 of a second). If you can do so and still get the effect you want, adjusting your primary variable is preferable to increasing the ISO.

If the problem is that the scene is too bright, turn down the ISO. If the ISO is already as low as it will go, you can put a neutral density filter on your lens to cut out some of the light. (See Lesson 6 for more on neutral density filters.)

7. **Take your shot.**

Keep watching your meter or the secondary variable to see whether you need to make adjustments between shots.

This general process can be applied to many natural-light situations. Now that I've reviewed the process of setting up for the shot, the rest of this lesson takes you through some typical types of picture-taking opportunities and explains successful strategies for capturing the shot you want.

Portraits

Portraits traditionally mean pictures taken or painted when someone is sitting or standing still, and the word is related to the word *portray*, meaning to "depict." Because painting a portrait traditionally took many days to weeks, you'd pose your model in a repeatable and comfortable position while you applied paint to canvas. Today, portraits typically mean a depiction of a person or group — either standing or sitting — but typically where they are posing for the photograph.

With cameras, you can take portraits of people however you want, but I stick with the traditional portrait term here and cover moving subjects in a later section.

> **EXTRA INFO**
>
> The terms *portrait* and *landscape* are sometimes mixed and matched, so don't get confused. For printing and image-editing purposes, refer to all *vertical* images (where the width is narrower than the height) as *portrait* orientation, and *horizontal* images (where the height is longer than the width) as *landscape* orientation. Of course, you might very well take a portrait of a group of people posed in a landscape orientation — but it's still a portrait. Similarly, you might take a vertical photo of a mountain landscape.

Posing portraits

Before I get into the technical details of camera settings for taking indoor and outdoor portraits, I give you some tips on posing your subjects. You're welcome to ignore these tips, but I find them to be effective for posing individual subjects.

Tip 1: Don't crop at joints

The three basic poses are head and shoulders, three quarters, and full length. Don't crop people at the elbows, knees, or ankles. You want full length to include the feet, three quarters to crop above the knees, and head-and-shoulder views to crop above the elbows, as shown in Figures 8-5 and 8-6.

Figure 8-5

Tip 2: Pose people at a 45-degree angle to the camera

Whether sitting or standing, a person usually looks better posed with her body at a 45-degree angle to the camera, as shown in Figure 8-7.

Tip 3: Have ladies bend the front leg

With the weight on the back foot for standing shots and the body turned 45 degrees, point the front foot slightly toward the camera and bend the front knee. This gives a slimming effect and puts shape in the figure. You've seen actresses and models do it automatically any time they're on a red carpet in front of photographers. It's also a good idea to bend the arms at the joints, too. Generally speaking for poses, bent joints often look better than not.

Figure 8-6

Figure 8-7

Tip 4: Set the camera height

Put your camera lens at about eye level for head and shoulders portraits. Put the camera lens at chin to upper-chest level for three-quarter length portraits and chest to waist level for full-length portraits.

Tip 5: Tilt the subject's head

Men should tilt the head slightly toward the lower shoulder (the shoulder away from the camera), as shown in Figure 8-8. Women can tip their head toward either shoulder.

Tip 6: Balance the whites of the eyes

Ideally, you want the pupils centered so that you can see the whites of the eyes on both sides, as shown on the left in Figure 8-9; otherwise, the picture might look a little strange, as shown on the right.

Figure 8-8

Figure 8-9

Tip 7: Have the subject sit up straight

Slouching is exaggerated by the camera. Having the subject tilt slightly forward at the waist can look good.

Tip 8: Avoid photographing the backs of hands

Anything closer to the camera looks bigger, so keep any hands appearing in the shot in about the same plane as the subject's face. Also, shoot the edges, not the backs of hands, as shown in Figure 8-10.

Figure 8-10

Tip 9: Experiment with the Twos rule

You can make up your own poses and have fun with them. Poses that look interesting often follow the Twos rule.

LINGO

The **Twos rule** states that any part of the body that a person has two of should be on different horizontal levels. For example, you can tip the subject's head so their eyes are on different levels, have one hand in their lap and one by their side, one foot on the floor and one raised on a low stool, and so on.

I could give you many more tips, but I don't want to overwhelm you with a lot of rules. Formal portraits like these should look balanced and natural, so play around with them. When all else fails, you can go to what I call the emergency pose, as shown in Figure 8-11, which hides a lot of problems!

Shooting portraits

After you have some ideas about posing a portrait, you can get on to the actual business of shooting it. In deciding how to take the shot, you can use the guidelines I describe in "Working with Exposure Variables to Take Great Photos," earlier in this lesson. Therefore, the first step is to consider what you're trying to do creatively.

Figure 8-11

In still portraits, most subjects are sitting still, obviously, so you aren't too concerned about the shutter speed you're going to use (dogs and children being the exception). As long as the shutter speed is fast enough to avoid camera shake, it should be fine for capturing a sharp image of the subject. The aperture is more important with portraits because you generally want to put the background out of focus to emphasize the subject and de-emphasize any background clutter.

Having decided you're mostly interested in setting the aperture, you can follow these steps to take the picture:

1. **Set your camera to Aperture Priority mode by turning the exposure mode dial to Av or A.**

2. **Select an aperture by turning the main command dial until the aperture you want is displayed in the viewfinder or LCD display.**

 You probably want to select the widest aperture possible to attain a shallow depth of field. This aperture setting varies depending on your lens, but for a kit lens, the aperture is usually f/5.6 when the lens is at its maximum focal length, meaning it's zoomed in on the subject.

If you're using a lens with a wider maximum aperture, such as f/1.8, be careful that that all the subjects are in focus. You might want to close the aperture to at least f/5.6 if you're photographing several people at different distances from the camera. Traditionally, you're aiming for a depth of field that keeps the subject in focus and the background out of focus. As long as the subject's eyes are in focus, it's up to you to decide whether you want the subject's hair or ears to drop softly out of focus.

3. **Zoom in to the subject, get up close, or both.**

The closer you are to the subject and the more zoom you use (or the longer the focal length), the shallower the depth of field will be. Using a kit lens with an f/5.6 maximum aperture means you have to get in very close to your subject to have any chance of blurring the background. Also, stand the subject as far away from the background as possible to help put the background out of focus.

Figure 8-12

EXTRA INFO

Avoid using wide-angle lenses for portraits. You'll have a hard time achieving a shallow depth of field with a short focal-length lens. Wide-angle lenses also distort the image by giving your subject a big nose and distorted features, as shown in this extreme example taken with a fisheye lens in Figure 8-12. Even smaller amounts of distortion in a regular wide-angle lens can distort a portrait in an unattractive way.

4. **Look through the viewfinder, frame the subject, and press the shutter-release button halfway to focus.**

When shooting portraits, you can set the autofocus mode to One Shot or Single-Servo, as described in Lesson 4. After pressing the shutter-release button halfway, you can reframe the shot. Frame your subject loosely so that you can later crop the picture for different print sizes.

5. **Check the shutter speed and take action, if necessary.**

 You have locked in an aperture setting, so it will not change, but you have to watch the shutter speed. If the shutter speed is too low to hand-hold your camera, you can either press the Flash button to raise your flash or increase the ISO until a shutter speed is available that's fast enough to prevent camera shake. (See Lesson 5 for more on flash.)

6. **Press the shutter-release button to take the shot.**

Lighting portraits

I'm sure you want the people in your pictures to look good, so put yourself in a position to take great portraits by working with the light.

For outdoor portraits, avoid shooting your subjects in bright sunlight, as shown on the left in Figure 8-13. Cloudy days or shade help you create portraits with a much better look, as shown on the right. Make sure to set the white balance for the ambient light or Auto white balance, as described in Lesson 3. This ensures a more natural look to skin tones. When you're outside, your Auto white balance should work well because there is only a single light source (the sun).

Figure 8-13

If you make sure that the background is in the same tonal range as your subject, meaning they both have the same lighting, your picture will come out much better than if it's taken with a brighter background.

When the subject is backlit, has a brighter background, or is lit in bright sunshine, use your flash to bring the subject up in brightness or soften the harsh shadows, as shown in Figure 8-14. Your camera tries to balance the amount of flash with the available light when flash is used automatically, or you can adjust your flash manually.

Indoor portraits should be lit by natural light whenever possible. You can put your subject next to a window where the sun doesn't shine in directly. You may also want to use something reflective, such as a large piece of white cardboard or a photographic reflector on the opposite side from the light source, so that it reflects window light back on the subject. This softens the shadows on the subject's face, as shown in Figure 8-15; the first example only has window light, and the second has window light plus illumination from a reflector.

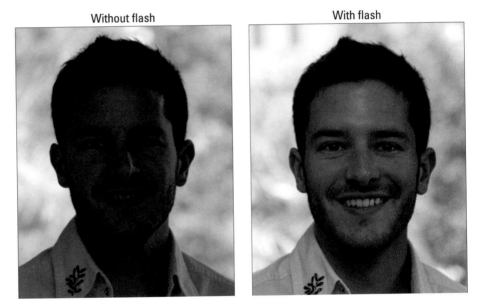

Without flash **With flash**

Figure 8-14

If there isn't enough light in the room to achieve a fast enough shutter speed, you can try turning on more lights and increasing the ISO on your camera. If you need to use your flash, having bright room lights helps reduce the chance of red-eye in your pictures because your subject's pupils constrict and your flash doesn't fire as strongly in the brighter light.

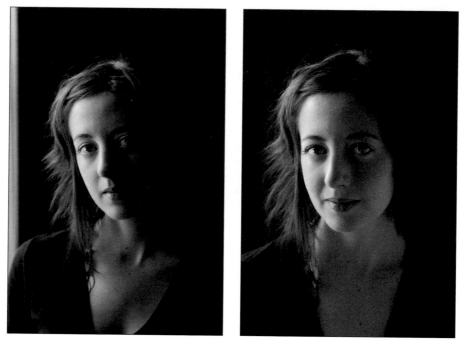

Figure 8-15

Your portrait pictures are improved greatly if you use an external flash with a moveable flash head. A built-in flash can only be fired directly at your subject, creating a washed-out look and putting a shadow behind her (as shown in the inset image of Figure 8-16). An external flash can be bounced off the ceiling or a wall to remove strong shadows and give a more natural look to portraits, as shown in the main image of Figure 8-16.

TIP

If you pose a subject with a corner behind the subject (but not too close), you can benefit from the walls bouncing light at the subject from both sides, avoiding some problems with shadows.

If you use any flash — either pop-up or external — and hold the camera vertically, you run the chance of having much harsher shadows along one side of your subject. In these cases, you can try moving the subject farther away from anything in the background, or, with an external flash, you can pivot the flash so that light bounces off the ceiling.

Figure 8-16

Capturing Action

Action shots require you to use different shutter speeds. Slow shutter speeds blur action, whereas fast shutter speeds freeze action. You have the creative freedom to put as much blur into an action shot as you want. I can't tell you what exact shutter speed is needed to freeze or blur action because it's dependent on the relative motion of the subject to the camera. From experience, I have found that 1/250 of a second is fast enough to freeze the motion of many common objects and subjects coming quickly toward you.

EXTRA INFO

As shutter speeds slow, you begin to capture movement not only in the subject, but also in your camera. If you want to use a shutter speed below 1/60 of a second at a focal length of 50mm, consider supporting your camera firmly. Sometimes, just bracing yourself against a convenient wall or column is enough. A bean bag is also very useful, especially when shooting from ground level, and a monopod is used by a lot of sports photographers. If you're considering buying a tripod, don't buy a cheap one. The whole point of a tripod is that it holds your camera firmly and without movement. Many cheaper tripods move significantly when you touch your camera, which isn't very useful in low light with long shutter speeds. Mounting a pricey dSLR on a flimsy tripod can even be downright dangerous on a windy day!

To fire your camera without jostling or even touching it, a remote control can be useful. With a self-timer, you press the shutter-release button, but the actual shutter release takes place several seconds later, giving you time to step away from the camera.

Focusing can become an issue when capturing action, especially when the subject moves rapidly toward or away from the camera. Your dSLR can focus continuously on moving subjects, as described in Lesson 4. For moving subjects, place your camera in AI Servo or Continuous-Servo autofocus mode.

Blurring action

If you want to imply motion in your pictures, use a relatively slow shutter speed to blur the moving parts of the picture. The shutter speed you use depends on how fast the subject is moving, so it pays to experiment. To set the shutter speed, either place your camera in Shutter Priority (Tv or S) or Manual exposure mode. If you set the shutter speed in Shutter Priority mode, the shutter speed doesn't change, but the aperture varies with the light. Keep an eye on the aperture to make sure that it doesn't stray out of range because your pictures will be under- or overexposed. Most likely, if you use a slow shutter speed in bright sunlight, your pictures will be overexposed.

The effects of slow shutter speeds are easy to demonstrate by using a *Star Wars* lightsaber, which I just happen to own and sometimes use in my work-shops. The slower the shutter speed, the more blur that appears, but if you use too slow a shutter speed, the moving object can disappear almost totally from the picture. Figure 8-17 shows the effects of a slow shutter speed on action.

1/60 second, f/2.8 1/40 second, f/5

Figure 8-17

As you use a slower and slower shutter speed, you run the risk of camera shake being added to the picture. If you use a very slow shutter speed, consider using a tripod to steady the camera and ensure the blur is only from movement. Just be sure to disable any anti–camera shake/ image stabilization you may have enabled on your lens (if it has that feature); keeping any stabilizing mechanism on while the camera is on a tripod can actually *increase* camera shake.

If you add flash to the exposure, you can freeze the subject and get blur at the same time, making it possible to create a trail of motion blur behind your subject. To do this, set your flash to second- or rear-curtain, as explained in Lesson 5. Figure 8-18 shows how this affects the lightsaber shot. When I slowed the shutter speed to 1/15 of a second, the lightsaber all but disappeared, as shown in the left image, but adding flash froze it for an instant so that even at the slow shutter speed, it can be seen in the shot on the right.

1/15 second, no flash

1/15 second, with flash

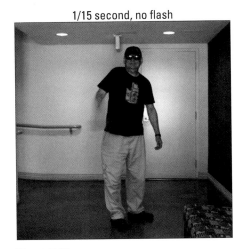
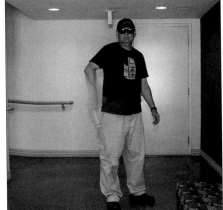

Figure 8-18

Freezing action

Freezing action requires you to use a relatively fast shutter speed. The shutter speed you use depends on how fast the subject is moving, so it pays to

experiment. To set the shutter speed, place your camera in Shutter Priority (Tv or S) mode or Manual exposure mode, and then select a fast shutter speed. Remember that a fast shutter speed requires a wide aperture to let in enough light to obtain a properly exposed shot, so very fast shutter speeds require very bright conditions, unless you increase the ISO setting on your camera.

To capture an action shot, follow these steps:

1. **Set the autofocus mode to AI Servo or Continuous-Servo, as described in Lesson 4.**

 For fast-moving subjects, you may want to set the autofocus point selection to Auto.

2. **Set the drive mode to the Fast Multi-Shot setting.**

 Setting up your camera to take multiple pictures while you hold down the shutter-release button gives you a better chance of capturing a good picture of a moving subject.

3. **Set your camera to Shutter Priority mode by turning the exposure mode dial to Tv or S.**

4. **Select a shutter speed by turning the main command dial until the shutter speed you want displays in the viewfinder or LCD display.**

5. **Look through the viewfinder, frame the subject, and press the shutter-release button halfway to focus.**

6. **Check the aperture and take action, if necessary.**

 You've locked in a shutter speed setting, so it won't change, but you have to watch the aperture. If the aperture is out of range, increase the ISO or select a slower shutter speed.

7. **Press the shutter-release button to take the shot.**

I took the pictures shown in Figure 8-19 by using Continuous-Servo autofocus mode and Fast Multi-Shot drive mode so I could take multiple pictures as this Girl Scout troop ran toward me. The autofocus tracked them and kept them in focus. The day was bright and sunny, and they were out of flash range, so I put the sun behind me to help with the exposure.

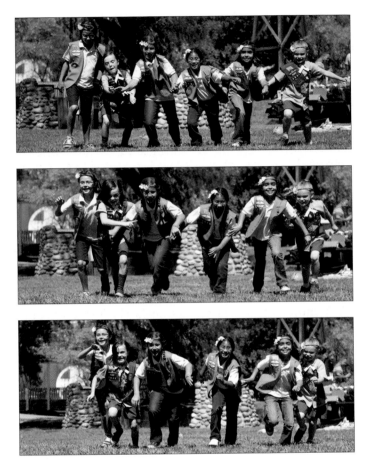

Figure 8-19

Freezing action indoors

When working in low-light situations, such as an indoor basketball court, I use a different strategy to capture action. Even though lighting seems bright inside a gym, it's not usually bright enough to maintain a fast shutter speed that freezes action and keep your ISO low. You may not be allowed to use your flash, and in any case, the action will be too far away for your flash to be effective.

For this kind of shot, turn your camera to Aperture Priority mode and select the widest aperture you can. With an average-quality lens, this is typically f/5.6 at the extended zoom range, which is why a faster lens with a maximum aperture of f/2.8 is useful in this situation.

Having set the aperture as the primary variable (which is now a constant because you've dialed it in), see what shutter speed the camera sets for you as you look around the gym through the viewfinder. To do this, press the shutter-release button halfway and then release it to start the camera meter. You can then see the aperture and shutter speed values in the viewfinder. Increase the ISO setting of your camera until your camera gives you an acceptable shutter speed. You may have to turn up the ISO as far as you can, just to achieve 1/125 of a second.

Having set the aperture and ISO to their maximums, the shutter speed the camera sets will be the fastest possible in the low light of the gym. As you move your camera around, the shutter speed varies in response to the available light, but it is always the fastest you can achieve.

You now have to make a creative decision: Do you go with the highest ISO to attain the fastest shutter speed, or do you decrease the ISO and risk getting some motion blur in your shots because of a slower shutter speed? Shoot when a player is at the top of a jump and moving the least, or take shots of individuals when play is not active. This reduces the noise in your pictures because you're shooting at a lower ISO. When the action heats up, you can increase ISO, knowing that your picture quality isn't as good, but the action is frozen with a higher shutter speed.

You can see that this is actually the opposite of what I told you earlier — that you set the shutter speed as the primary variable if you're interested in freezing action — because in this case, the light is low, and you need to have your camera attain the highest shutter speed it can while remaining in normal exposure range for the light available. This method allows you to achieve this.

Panning your camera

One of the easiest ways to capture motion is to pan your camera. Doing so freezes the subject while blurring the background and giving the impression of speed, as shown in Figure 8-20.

To pan your camera on a subject, follow these steps:

1. **Put your camera in Shutter Priority exposure mode and choose a shutter speed fast enough to handhold.**

When shooting in an auditorium remember to set your white balance. You might have to test a couple settings to find the right one. Many gyms use sodium vapor lighting, or similar. You can also use Auto white balance, because even with a preset white balance, many venue lights feature fluctuating color temperatures, so your white-whites will inevitably appear as a series of cream-blue-white-yellow shades. The good news is you can often batch-process white balance aberrations such as these in common image-editing applications optimized for digital photography workflow, such as Adobe Lightroom and ACDSee Pro.

I recommend a shutter speed no slower than 1/60 of a second, faster if you use a telephoto lens. The faster the subject is moving in relation to the background, the faster shutter speed you can use and still achieve the effect.

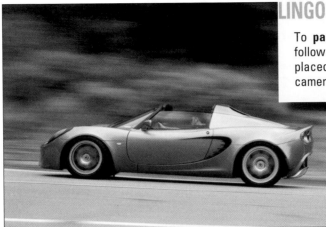

LINGO

To **pan** your camera means to follow your subject by keeping it placed in the same area of your camera viewfinder as it goes past.

Figure 8-20

2. **In your autofocus settings, engage the AI Servo or Continuous-Servo autofocus mode.**

3. **Put your camera drive mode in Fast Multi-Shot so you can fire several shots as the subject passes.**

4. **Press the shutter-release button halfway to track the subject with the center focus point and, when you're ready, press the button fully and hold it down to take your pictures.**

EXTRA INFO

For people running and cycling, you can use a faster shutter speed to take the blur out of moving arms and legs, or use slower speeds to allow some motion blur in arms and legs.

Hold your camera firmly and keep your elbows pressed into your torso for support. As the subject passes, swivel at the waist keeping your camera level vertically.

Photographing Scenery

You can capture beautiful and diverse pictures of scenery in many ways, and there are no strict rules for the settings you use to do so. Setting the

aperture allows you to decide whether you want the whole scene in focus or just part of it.

For large vistas, you most likely want to use a deep depth of field to have as much of the scene in focus as you can. See Lesson 4 for information on focusing and how to set the hyperfocal distance for maximum depth of field. For smaller scenes, you might want a shallower depth of field that concentrates your attention on an old tree in the foreground.

Movement can also be captured by using long shutter speeds on city streets, as shown in Figure 8-21.

Figure 8-21

In the picture shown in Figure 8-21, I wanted strong movement in the trolley, so I used a shutter speed of 1.3 seconds because the trolley was already moving quite fast. The key to this picture is the position of the tripod and camera, which I placed to obscure the bright streetlight behind the crosswalk sign so that it lit the building without appearing in the shot. My camera was in Manual exposure mode and exposed one stop on the negative side to make the sky appear naturally dark. I used a focal length of 18mm. The wide-angle lens helped give me a deep depth of field and made focus distance less critical.

Working with Close-Ups

Photographing small objects up close requires a lens that can focus up close, so to do this, you need a macro lens, lens extension tubes, or close-up filters. See Lesson 6 for more information about these specialized lenses.

Depth of field is critical in close-up photography because the closer the focus distance, the shallower the depth of field. When you're taking a portrait, a 50mm lens with an aperture of f/8 focused at a distance of 10 feet has a depth of field of approximately 4 feet. The person you take a picture of will be comfortably in focus. If that same lens is used to focus at a distance of 3 feet, the depth of field reduces drastically to about 4 to 6 inches.

This is why when photographing small objects at close distances, you need to use smaller apertures to make sure the whole subject is in focus. Smaller apertures allow less light into your camera, so you need to use correspondingly slower shutter speeds to gather more light. Slower shutter speeds, along with the fact that tiny movements in your camera are magnified when working with close-up photography, mean that most macro photographers use specialized tripods with very fine controls and digital cable releases to fire their cameras remotely without risking any movement.

Photographing small objects

When you want to sell your valuable personal items on eBay, perhaps so you can afford to buy more camera lenses, it helps to have clear, well-lit photographs to help sell them. Even, bright lighting is a must, and to achieve this, you can use a light tent, such as the one shown in Figure 8-22.

You can use your light tent either outdoors in natural light or indoors with daylight fluorescent lights, placed on either side of the tent. Whichever lighting method you use, set a manual white balance with a gray card, as described in Lesson 3. You need to place your camera on a

Figure 8-22

tripod to get really sharp pictures. Figure 8-23 shows a picture of a watch I took with this method.

To capture this photo, I used a 90mm macro lens and a dSLR mounted on a tripod. The watch was placed on a black Perspex base (also known as Lucite, a transparent and often colored plastic or acrylic glass) to create a reflection beneath it. Two 30-watt fluorescent lamps with a 5000K color temperature (similar to the one shown in Figure 8-24) were placed on each side of the light tent.

I took the picture in Manual exposure mode, first balancing the meter at zero and then adjusting the shutter speed faster to slightly underexpose the shot by 2/3 of a stop. I did this because the background was all black and the camera would try to adjust the scene to mid-gray if I didn't add some exposure compensation. If you shoot on a white background, you need to slightly overexpose the shot to prevent the background from looking gray. The final exposure for this shot was 1/13 of a second at f/16.

1/13 second, f/16

Figure 8-23

Figure 8-24

Soft toys and other non-reflective objects are easy to photograph. Jewelry and small glass or metal objects can be more of a problem. When photographing vases, for example, you can often see a dark band on the front of the vase, and you might even see the camera reflection. To reduce these reflections, most light tents have a white curtain, which has a slit through which you can poke your lens, to block the opening of the tent. For glass, I often light it from beneath by standing the light tent on a glass table and shining a light up from the bottom.

Capturing flower shots

Taking pictures of flowers in the open air isn't quite as simple as you might think. As already mentioned, you need fairly small apertures (large f-numbers) when working close up to get a deep enough depth of field. This means that you often need to use slower shutter speeds. If you try to take pictures of flowers on a windy day, you can end up with a lot of blur!

Avoid bright sunlight for your flower pictures, if possible. Bright sunlight causes hard shadows and has much the same unflattering effect as taking someone's portrait in sunlight. The dark shadows have little detail, and the highlights lack color as they blow out to white. I carry a small *scrim* (a frame of light, translucent material available from camera stores) that I can place over a flower to diffuse the light falling on it and soften any harsh edges. This creates a nice open-shade effect. To avoid blowing out the background, I try to make sure that my background is also in the shade of the scrim.

> **EXTRA INFO**
>
> Get up early and head out to take pictures of your flowers in the first light of day. At this time, the wind is usually not so strong, the light is favorable, and the flowers look fresh. You may be lucky enough to get a sprinkling of dew on petals or a silver cobweb connecting two buds.

Use your camera in Aperture Priority mode and experiment with apertures to achieve the depth of field you find pleasing. Nothing is wrong with having only part of the flower in focus; it's up to you as the artist to decide how your pictures will look.

Flash is very useful in outdoor situations. The fast burst of light from the flash can bring an extra crispness to the flower pictures and make the flowers pop out from the background. Flashes have a minimum flash range, so if you get very close, you may have to use a flash extension cable to place your accessory flash away from the camera lens. Taking your flash off the camera allows you to try different effects, such as the backlit orchid shown in Figure 8-25. There are also special external flashes designed specially for use in macro photography.

Figure 8-25

Painting with Light

You can take some fun pictures with your camera even if it's totally dark. In fact, when you're painting with light, the darker it is, the better. Painting with light uses very long exposures to capture light from whatever source — such as accessory camera flash, flashlights, fireworks, candles, or laser pointers — you prefer to use.

If you want to paint with light, you need a tripod to keep your camera steady during the long exposure times you need to use. Most cameras have a maximum shutter speed of 30 seconds, so you need to put your camera in Bulb mode. The name has nothing to do with electric light bulbs, but refers to the rubber bulb photographers had to squeeze to open the camera shutter in the vintage days of photography. As long as the bulb was squeezed, the shutter stayed open. Today, in Bulb mode, the shutter stays open for as long as you hold down the shutter-release button. Many photographers use a remote (wireless or wired) shutter release so they don't move the camera during a long exposure. For long bulb settings, you can actually lock some of these remotes so your thumb doesn't get too tired holding the shutter release for long periods.

I describe the two kinds of painting with light in the following sections.

Using light to make patterns

One method for painting with light is to work in a dark place with a long exposure and a small aperture, so very little ambient light is collected. Then, you simply draw in front of the camera with a bright light. You can try this easily in your garage or a darkroom as follows:

1. **Put your camera on a tripod.**

2. **Attach a cable release, or wireless remote control, if possible.**

3. **Set your camera to Manual exposure mode and then set your camera to Bulb.**

 Some cameras require you to set Bulb mode from a menu or by using a dial, whereas others just require you to move the shutter speed slower than 30 seconds when your camera is in Manual exposure mode.

4. **Set a small aperture, such as f/22.**

5. **Open the shutter and lock it open with the cable release or remote (you cannot lock it without the remote device).**

6. **Do some painting.**

 If you're in a dark space, there's no big rush. Try drawing in the air with your light. LED key-ring lights work great because they don't spread the light or reflect off anything.

7. **When you're finished, unlock and close the shutter.**

 Don't fall over your tripod in the dark! The great thing about digital photography is that you can see your results straightaway. You can experiment and make adjustments in the aperture until you get the look you want.

LINGO

A **cable release** prevents your camera from shaking while the shutter is being held open because you aren't touching the camera. An electronic **remote control** does the same thing but is more expensive. You can find a cable release for your camera quite cheaply on the Internet. Make sure you get one that you can lock down the button to keep the shutter open, rather than holding it down.

Figure 8-26 shows a simple example of painting with light. I did this quickly by writing in the air with an LED key-ring light, and then by drawing the flower and camera on the cupboard behind me with a laser pointer. Obviously, I'm no good at drawing, put you get the idea!

Using this technique, and sometimes combining it with other tools such as your flash, you can find many interesting, creative, and artistic ways of photographing everyday things.

Figure 8-26

Using light to illuminate dark objects

The second method of painting with light uses exactly the same method to make the picture as I just described in the preceding section, but instead of using light to make patterns, you use lights to illuminate dark objects. Your light source can be a large flashlight or a handheld camera flash.

Figure 8-27 shows an example of painting objects with light. I photographed this statue of a Gomphotherium, a prehistoric elephant, on a dark night in Borrego Springs, California. I chose to use a Nikon SB-900 Speedlight and set the flash manually to 1/8 power. Having opened my camera shutter, I walked around the statue firing the flash by hand, lighting up parts of the statue and the grass underneath it. Using less power on the flash allows you to build up the light in your picture like building up layers of paint on canvas.

I actually made two exposures, the first one using the flash at full power. This allowed me to see how bright the picture was and how I wanted to adjust it for the second exposure. Being able to immediately review the results and make adjustments is a big benefit of digital photography. The angle you fire your flash from creates different shadows and a different look to the picture. I could have also made this picture using a large flashlight, by just painting in the details and keeping the flashlight moving until enough light built up to make the picture.

Notice how bright the sky looks in the picture. The night was dark, but light pollution from a distant town added light to the faint clouds. The Earth turned slightly in the time the shutter was open causing star trails to begin to form.

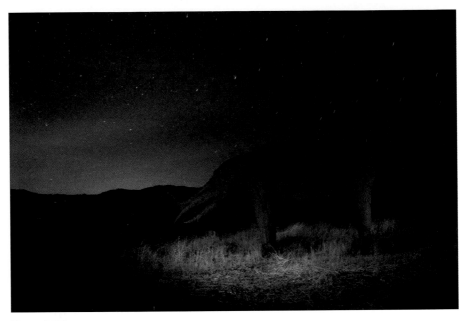

Figure 8-27

Just Having Fun

Who says pictures always have to be tack sharp and clear? As the artist, you decide how your pictures should look. If you want something that's just a blur of color like an impressionist painting, go for it!

You can simply use a long shutter speed and purposely shake your camera to blur your subjects. You can also try turning your zoom while you take the shot to put radial blur into it, as shown in Figure 8-28. This picture was taken at 1/40 of a second at f/8.

If you add flash into the shot, you can create some more interesting effects because even if the camera moves when the flash fires, everything in the flash range is frozen in the instant flash fires. In the picture shown in Figure 8-29, I turned my camera while taking the picture. The flash captured the flowers in the foreground while the long exposure, 1/10 of a second at f/8, meant that the lights of the room made trails in the picture.

1/40 second, f/8

Figure 8-28

1/10 second, f/8, with flash

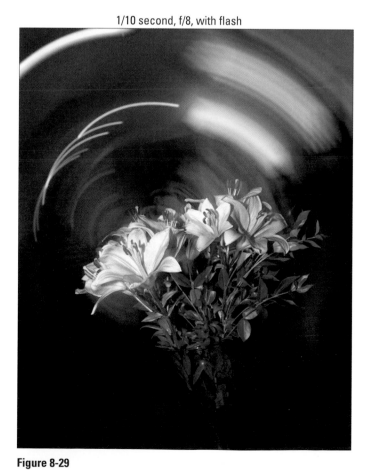

Figure 8-29

Summing Up

In this lesson, you reviewed many of the previous lessons and applied them to specific types of pictures:

- ✔ You can control the shutter speed and aperture and use them creatively.
- ✔ You have some tips on posing portraits.
- ✔ You know how to use shutter speed to blur or freeze action.
- ✔ You know how to shoot close-up pictures.
- ✔ You've applied what you've learned into having fun with your camera.

That, my dear friend in photography, was the last lesson! Thank you for staying the course. My plan was to give you an introduction and grounding in the basics of dSLR photography. Instead of having the camera control you and good photographs that result as a happy accident, you now have the tools you need to control your camera and use it like a painter uses his box of paints. With a little practice, your pictures will get better and better and you'll have a high percentage of keepers.

Digital photography will give you many years of enjoyment. Not only does photography get you out of your armchair and make you think like an artist, but over the years, you'll build a valuable library of memories documenting your family, travels, pets, and hobbies. My photography is a passion that through perseverance developed into something more than a hobby. I hope that it will be a constant joy to take pictures wherever you go, and that you'll apply and build upon the lessons in this book as you develop as a photographer.

Know This Tech Talk

Bulb: A shooting mode where you camera's shutter remains open as long as you want it to, often using a remote-control shutter release.

light tent: A translucent, cocoon-like small tent used to house an object to photograph. External light is directed at the tent, which provides diffused illumination on the object. A common way to shoot jewelry and other small things.

monopod: A single telescopic leg that can be attached to the bottom of a camera for support. More convenient and transportable than a tripod, but not as stable. Often used by sports photographers.

reflector: Any flat board or material with reflective properties, used to reflect light from the sun or a bright light onto a subject, in order to balance how it or they are illuminated.

About the CD

This README file contains information to help you get started using *For Dummies* eLearning. This course requires no installation.

System Requirements

For Dummies eLearning will provide all required functionality on the following Microsoft operating systems: Windows 7, Windows Vista, Windows XP, Windows 2000, and Windows 2003 Server.

The following browsers will be supported under Windows: Microsoft Internet Explorer 6.0 or higher, and Mozilla Firefox 2.x or higher.

To run a QS3 CD-ROM, the system should have the following additional hardware/software minimums:

- ✔ Adobe Flash Player 8
- ✔ A Pentium III, 500 MHz processor
- ✔ 256MB of RAM
- ✔ A CD-ROM or DVD-ROM drive

A negligible amount of disk space must be available for tracking data. Less than 1 MB will typically be used. Your purchase of this *For Dummies* eLearning Kit includes access to the course online at the *For Dummies* eLearning Center. If you have purchased an electronic version of this book, please visit www.dummies.com/go/getelearningcode to gain your access code to the online course.

Launch Instructions

Keep in mind that course functionality relies heavily on mini-windows known as *pop ups* for delivering its content. Many web browsers have *pop up blockers,* on the (mistaken) assumption that all pop ups must be advertising that no one really wants to see. These browsers also let you enable pop ups if you so desire. Please make sure to enable pop ups before starting to use the CD or the course online. If you don't enable pop ups, some pop up blockers may restrict the course from running.

Setup instructions for Windows machines:

1. **Put the CD in the CD drive.**

2. **Double-click on the My Computer icon to view the contents of the My Computer window.**

3. **Double-click the CD-ROM drive icon to view the contents of the *For Dummies* eLearning CD.**

4. **Double-click the start.bat file to start the *For Dummies* eLearning CD.**

 Your computer may warn you about active content. Click Yes to continue starting the CD. The CD may create new tabs in your browser. Click the tab to see the content.

The browser offers the option of using the lessons from the CD or from the website, as spelled out in the next sections.

Accessing the course on the website

When you launch your *For Dummies* eLearning CD, you have two options for accessing your eLearning course: Access Course(s) Online and Access Course(s) on CD. To access the course online, do the following:

1. **In the Activate Your FREE Online Course Now! section, click the Access Course(s) Online button.**

 Note: You will need the online course access key found behind the CD-ROM in this book to complete your online registration.

2. **In the new browser page that appears, click the blue Here link found in the sentence "Click here for the online course."**

 On the resulting *For Dummies* eLearning Home page, notice the Access Key field for entering your personal access key.

3. **Enter your personal access key (found behind the CD-ROM in this book) into the Access Key field and then click the Send button.**

You'll be brought to a Terms and Conditions of Use browser page.

You only have to use the access key once. In fact, if you try to enter an access key after it has already been accepted, you'll end up getting an error code.

4. **Read through the terms and conditions of use for the online course, then click the Accept button.**

5. **On the Registration page, fill in the required personal information (including user name and password); then click the Submit button.**

You are brought to the My Courses page of the *For Dummies* eLearning website.

6. **In the My Courses page, click the link for the course you want to work on.**

The course launches.

The opening page for your online course gives you a nice overview of the course. To actually get started, click the Content tab to see a list of course topics. Click to select any topic from the list. When the topic opens, it plays an introductory animation. To watch more animations on the topic, click the Next button (the arrow pointing right) at the bottom of the screen to play the next one.

If you want to switch to another lesson or another topic, use the list on the left side of the topic window to open a lesson and select a topic.

Some topics have an active tab for resources on the right side of the window. By default, Windows opens this content in a new window. If you have another compressed file manager installed, such as WinZip, your system may behave differently.

Here are some things to keep in mind when working with your online course:

✔ You can come back and resume your course as many times as you like over the six-month subscription period.

✔ Your online course "home base" can be found at `www.dummies elearning.com`. Whenever you want to return to your online course, just point your browser to that address. (You may want to use your browser's Bookmark feature to store this address for quick access later on.)

✔ After landing at the dummieselearning.com site, just enter your username and password in the appropriate fields in the upper right and then click the Login button to return to your My Courses page. (If you click the Remember Me checkbox, the dummieselearning.com site will store your username and password for you, so when you return, all you need to do is click the Login button to get to your My Courses page.)

✔ Once back at your My Courses page, you can click one of your courses and either start over from the beginning or pick up where you left off.

✔ For a quick overview of other online courses available from the dummieselearning.com site, click the Catalog tab on the site's Home page to access the online catalog. From there, you can choose to purchase new courses.

Accessing the course on the CD

When you launch your *For Dummies* eLearning CD, you see a browser page that offers you *two* options for accessing your eLearning course (online or on CD). If you choose to use the CD version of the course, do the following:

1. **In the Activate Your FREE Online Course Now! section, click the Access Course(s) on CD button.**

2. **On the resulting Add User page, enter your username in the Add a New User Account field and then click the Add a New User Account button.**

3. **In the new page that appears, select your username from the Learner Name list and then click the Enter button.**

 You are brought to the Home page of your *For Dummies* eLearning course. From here, you can choose a lesson (or topic within a lesson) to work with.

Whenever you want to return to the CD version of your eLearning course, just launch the CD, click the Access Course(s) on CD button, select your username from the Learner Name list in the page that appears, and then click the Enter button. (No need to add a new user account, in other words.)

After you enter your user name, the eLearning course displays a list of topics similar to what you would see if you were working with the course online. Here, however, you select a topic from the list by clicking its Launch button. When the topic opens, it plays an introductory animation. To watch more animations on the topic, click the Next button (the arrow pointing right) at the bottom of the screen to play the next one.

As is the case with the online version of the course, if you want to switch to another lesson or another topic, use the list on the left side of the topic window to open a lesson and select a topic.

Troubleshooting

What do I do if the page does not load?

It is possible that you have a security setting enabled that is not allowing the needed Flash file to run. Be sure that pop up blockers are off, ActiveX content is enabled, and the correct version of Shockwave and Flash are on the system you are using.

Please contact your system administrator or technical support group for assistance.

What do I do if the Add User window appears when the course loads and there are no names in the Learner Name list, but I have previously created a user account?

The course stores your information on the machine on which you create your account, so first make sure that you are using the *For Dummies* eLearning course on the same machine on which you created your Learner account. If you are using the course on a network and using a different machine than the one on which you created your account, the software will not be able to access your Learner record.

If you are on the machine on which you created your account, close the course browser window. Depending on the configuration of your machine, sometimes a course will load before accessing the user data.

If this still does not work, contact your network administrator for more assistance.

What do I do if I click on a Launch button but nothing happens?

This may occur on machines that have AOL installed. If you are using the course from a CD-ROM and you are an AOL subscriber, follow the following steps:

1. **Exit the course.**
2. **Log on to AOL.**
3. **Restart the course.**

What do I do if the Shockwave installer on the CD says that I have a more recent version of the plugin, but the software still says that I need to install version 8.5 or higher?

Download the latest version of the Shockwave plugin directly from Adobe's website:

```
www.adobe.com/downloads/
```

If prompted to install Flash Player to view the CD's content, you can download the latest version from the same URL.

End-User License Agreement

READ THIS. You should carefully read these terms and conditions before opening the software packet(s) included with this book "Book". This is a license agreement "Agreement" between you and John Wiley & Sons, Inc. "WILEY". By opening the accompanying software packet(s), you acknowledge that you have read and accept the following terms and conditions. If you do not agree and do not want to be bound by such terms and conditions, promptly return the Book and the unopened software packet(s) to the place you obtained them for a full refund.

1. **License Grant.** WILEY grants to you (either an individual or entity) a nonexclusive license to use one copy of the enclosed software program(s) (collectively, the "Software") solely for your own personal or business purposes on a single computer (whether a standard computer or a workstation component of a multi-user network). The Software is in use on a computer when it is loaded into temporary memory (RAM) or installed into permanent memory (hard disk, CD-ROM, or other storage device). WILEY reserves all rights not expressly granted herein.

2. **Ownership.** WILEY is the owner of all right, title, and interest, including copyright, in and to the compilation of the Software recorded on the physical packet included with this Book "Software Media". Copyright to the individual programs recorded on the Software Media is owned by the author or other authorized copyright owner of each program. Ownership of the Software and all proprietary rights relating thereto remain with WILEY and its licensers.

3. **Restrictions on Use and Transfer.**

 (a) You may only (i) make one copy of the Software for backup or archival purposes, or (ii) transfer the Software to a single hard disk, provided that you keep the original for backup or archival purposes. You may not (i) rent or lease the Software, (ii) copy or reproduce the Software through a LAN or other network system or through any computer subscriber system or bulletin-board system, or (iii) modify, adapt, or create derivative works based on the Software.

 (b) You may not reverse engineer, decompile, or disassemble the Software. You may transfer the Software and user documentation on a permanent basis, provided that the transferee agrees to accept the terms and conditions of this Agreement and you retain no copies. If the Software is an update or has been updated, any transfer must include the most recent update and all prior versions.

4. **Restrictions on Use of Individual Programs.** You must follow the individual requirements and restrictions detailed for each individual program in the "About the CD" appendix of this Book or on the Software Media. These limitations are also contained in the individual license agreements recorded on the Software Media. These limitations may include a requirement that after using the program for a specified period of time, the user must pay a registration fee or discontinue use. By opening the Software packet(s), you agree to abide by the licenses and restrictions for these individual programs that are detailed in the "About the CD" appendix and/or on the Software Media. None of the material on this Software Media or listed in this Book may ever be redistributed, in original or modified form, for commercial purposes.

5. **Limited Warranty.**

 (a) WILEY warrants that the Software Media is free from defects in materials and workmanship under normal use for a period of sixty (60) days from the date of purchase of this Book. If WILEY receives notification within the warranty period of defects in materials or workmanship, WILEY will replace the defective Software Media.

(b) WILEY AND THE AUTHOR(S) OF THE BOOK DISCLAIM ALL OTHER WARRANTIES, EXPRESS OR IMPLIED, INCLUDING WITHOUT LIMITATION IMPLIED WARRANTIES OF MERCHANTABILITY AND FITNESS FOR A PARTICULAR PURPOSE, WITH RESPECT TO THE SOFTWARE, THE PROGRAMS, THE SOURCE CODE CONTAINED THEREIN, AND/ OR THE TECHNIQUES DESCRIBED IN THIS BOOK. WILEY DOES NOT WARRANT THAT THE FUNCTIONS CONTAINED IN THE SOFTWARE WILL MEET YOUR REQUIREMENTS OR THAT THE OPERATION OF THE SOFTWARE WILL BE ERROR FREE.

(c) This limited warranty gives you specific legal rights, and you may have other rights that vary from jurisdiction to jurisdiction.

6. **Remedies.**

(a) WILEY's entire liability and your exclusive remedy for defects in materials and workmanship shall be limited to replacement of the Software Media, which may be returned to WILEY with a copy of your receipt at the following address: Software Media Fulfillment Department, Attn.: *Digital SLR Photography eLearning Kit For Dummies,* John Wiley & Sons, Inc., 10475 Crosspoint Blvd., Indianapolis, IN 46256, or call 1-800-762-2974. Please allow four to six weeks for delivery. This Limited Warranty is void if failure of the Software Media has resulted from accident, abuse, or misapplication. Any replacement Software Media will be warranted for the remainder of the original warranty period or thirty (30) days, whichever is longer.

(b) In no event shall WILEY or the author be liable for any damages whatsoever (including without limitation damages for loss of business profits, business interruption, loss of business information, or any other pecuniary loss) arising from the use of or inability to use the Book or the Software, even if WILEY has been advised of the possibility of such damages.

(c) Because some jurisdictions do not allow the exclusion or limitation of liability for consequential or incidental damages, the above limitation or exclusion may not apply to you.

7. **U.S. Government Restricted Rights.** Use, duplication, or disclosure of the Software for or on behalf of the United States of America, its agencies and/or instrumentalities "U.S. Government" is subject to restrictions as stated in paragraph (c)(1)(ii) of the Rights in Technical Data and Computer Software clause of DFARS 252.227-7013, or subparagraphs (c)(1) and (2) of the Commercial Computer Software - Restricted Rights clause at FAR 52.227-19, and in similar clauses in the NASA FAR supplement, as applicable.

8. **General.** This Agreement constitutes the entire understanding of the parties and revokes and supersedes all prior agreements, oral or written, between them and may not be modified or amended except in a writing signed by both parties hereto that specifically refers to this Agreement. This Agreement shall take precedence over any other documents that may be in conflict herewith. If any one or more provisions contained in this Agreement are held by any court or tribunal to be invalid, illegal, or otherwise unenforceable, each and every other provision shall remain in full force and effect.

Index